Lee Hammond's
big book of
ACRYLIC
PAINTING

Fast and easy techniques for
painting your favorite subjects

NORTH LIGHT BOOKS
CINCINNATI, OHIO
www.artistsnetwork.com

Contents

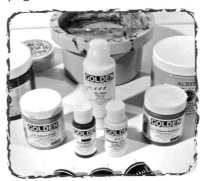
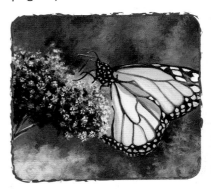

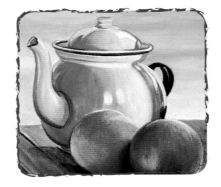
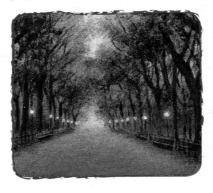
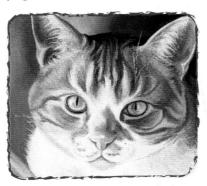
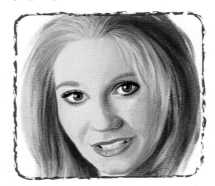

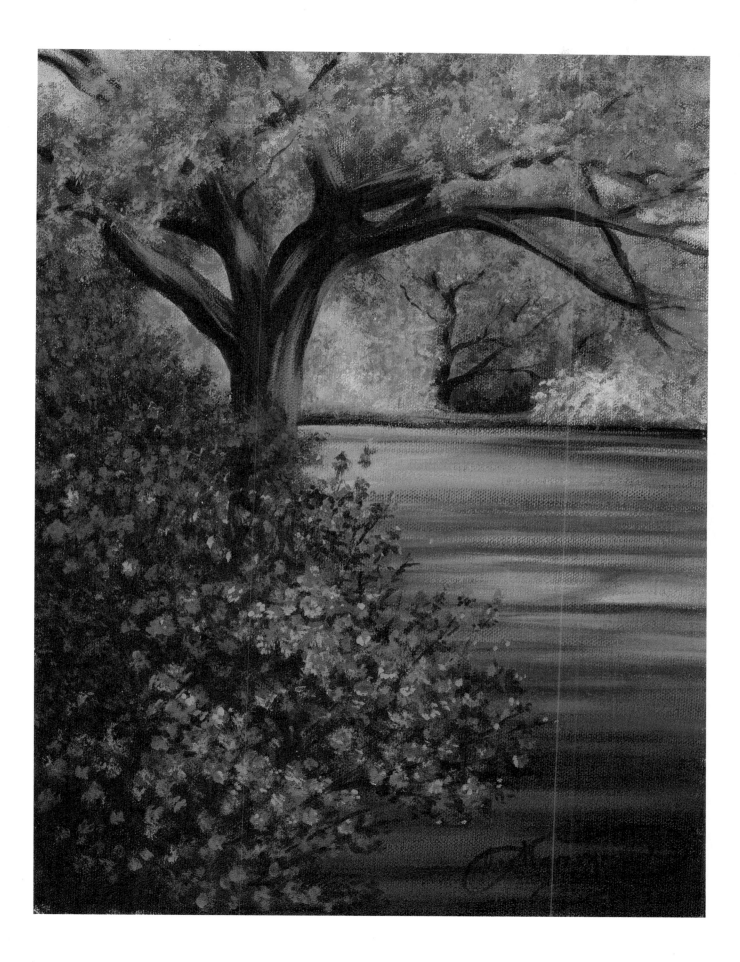

Introduction

I have been writing art technique books for more than a decade. Some publications have dubbed me the "Queen of Drawing." As flattering as that title is, I want people to know that I do more than just draw.

I love to paint, and the more I write about painting in acrylic, the more I've come to love it. This medium is extremely versatile and user-friendly.

In this book you'll find a collection of colorful projects designed to help you learn to paint with acrylics. The step-by-step projects will also give you a wide range of subject matter—still lifes, animals, people and landscapes—to enjoy.

Some of the projects may look complex, but remember that painting with acrylic is all about painting in layers. Since acrylics dry rapidly, it's easy to keep adding details or to cover up previous applications a little at a time. You're never "stuck" when you work with acrylic paint; it's a very forgiving medium.

It's also important to remember that every painting goes through what I call "the awkward stage." The initial layers of a painting, applied when you're essentially creating a "color map," will be sloppy, and the watered-down pigments will look weak. Don't become discouraged and stop too soon! By adding more layers and details with thicker paint, you'll achieve the realistic look you're after.

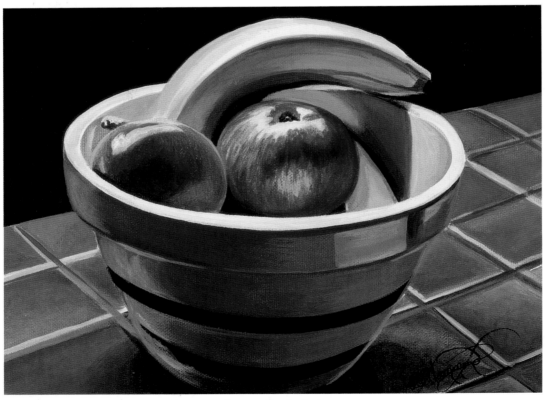

Bowl of Fruit
9" × 12" (23cm × 30cm)

PATIENCE HAS ITS REWARDS
This is an example of what you can do if you keep practicing. If you look closely, you will see places where colors are placed on top of other colors. After you have painted some of the projects in this book, you may want to come back to this painting and try to paint it yourself.

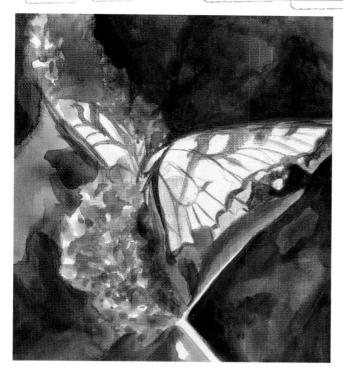

THE AWKWARD STAGE

This example shows the typical stopping point for most beginning acrylic painters. The paint looks watercolor-like, the colors look weak and the canvas shows through. However, this painting looks unfinished because it is. This important "awkward stage" is merely a color map for the more detailed layers to come.

DON'T GIVE UP

This painting looks much more professional. Thicker, undiluted paint and layered details create a realistic look. The canvas now is totally covered, and the colors are much more vibrant. Everything comes together in the final stages of the painting. The effort is definitely worth it!

**Tiger Swallowtail on
a Butterfly Bush**
16" × 12" (41cm × 30cm)

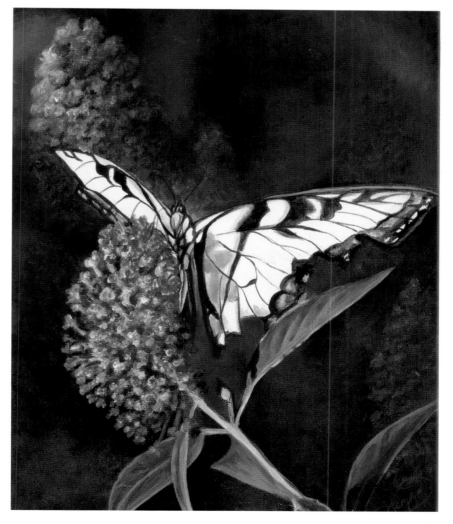

Getting Started:
Paints, Tools and Supplies

YOU DON'T NEED A ROOM FULL OF SUPPLIES TO BEGIN PAINTING WITH acrylics. I use a very small number of colors on my palette and only a few different brushes. Keeping it simple makes me feel more relaxed in my work area.

A tackle box is a great place to keep your painting supplies. It's easy to carry with you when you want to paint on location, and it acts as a storage unit when you're not painting. Have fun creating your own custom acrylic painting kit! The materials you'll need to do the exercises and demonstrations in this book are listed on this page.

Start-Up Kit

Below is a list of essentials you should have on hand to get you started on the painting projects in this book. Happy painting!

Paints: Prussian Blue, Ivory Black, Titanium White, Cadmium Yellow Medium, Cadmium Red Light, Cadmium Red Medium, Alizarin Crimson, Dioxazine Purple

Palette: A plastic palette with a lid is best.

Brushes: ¾-inch (19mm) filbert, no. 3 filbert, no. 4 filbert, no. 6 filbert, no. 8 filbert, no. 3/0 liner, no. 2 liner, no. 1 liner, no. 2/0 liner, no. 2/0 round, no. 3/0 round, no. 1 round, no. 2 round, no. 4 round, no. 6 round, ¾-inch (19 mm) sable or synthetic flat, 1-inch (25 mm) flat, no. 2 flat bristle, no. 6 flat, no. 4 flat, hake

Surfaces: Prestretched canvases, canvas panels and/or canvas sheets (Sizes are sometimes listed with individual exercises and demonstrations, but you can adjust to any size you wish.)

Other Materials: Cloth rags, wet wipes, cans or jars, spray bottle of water, palette knife, masking or drafting tape, mechanical pencil with 2B lead, ruler, kneaded eraser

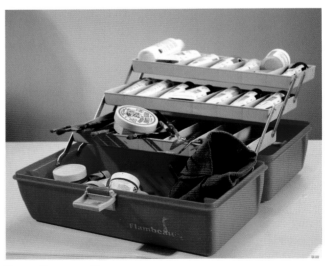

PAINTS, TOOLS AND SUPPLIES
A simple set of tools and a limited palette of colors are all you need to start painting in acrylics. A tackle box makes a great storage unit.

What Is Acrylic Paint?

Acrylic paints are made of dry pigment in a liquid polymer binder, which is a form of acrylic plastic. Acrylics are water-based, so they require no paint thinners as oil paints do, though they can be diluted with water while painting.

Acrylic paint dries quickly to a waterproof finish. Because of its plastic, waterproof quality, it can be used on a variety of surfaces. It's a favorite for painting on windows, outdoor signs, walls and fabric. It's permanent, so items painted with it are washable.

Varieties of Acrylic Paint

Many varieties of acrylic paints are available. Your choice depends partly on the project you're planning to do. There are acrylics formulated for folk art, fine art, even for painting on fabric, walls or signs.

For the projects in this book, look for paints labeled "high viscosity" or "professional grade." Other kinds of acrylic paint will be too thin, with a pigment concentration too low for satisfactory results.

Student-grade paints and those in squeeze bottles generally have a lower concentration of pigment. The pigment is still high quality; there is just a little less of it. Many student grades are so good that professionals use them as well. They are very fluid, easy to work with and easy to mix.

Professional-grade paints have a higher concentration of pigment. They are usually a bit thicker than student-grade paints, and their colors may seem more deep and vivid. Professional grades are found in tubes or jars.

You will find paints in tubes, jars and squeeze bottles. I prefer using paint from a jar rather than from a tube or bottle. Acrylic paint dries quickly, so if I have some uncontaminated color left over on my palette, I return it to the jar to avoid wasting it. This is not possible with paint from a tube or bottle. I also like jars because I can mix my own custom colors for a particular painting and store them in separate jars. This is helpful if you are working on a large project and need to keep your colors consistent as you work.

For the projects in this book, I used a palette of nine colors: Ivory Black, Cadmium Red Medium, Cadmium Red Light, Burnt Umber, Cadmium Yellow Medium, Alizarin Crimson, Prussian Blue, Dioxazine Purple and Titanium White. (For more information on color, see chapter 2, Understanding Color.)

TUBES, JARS OR BOTTLES?
Acrylic paints come in tubes, jars and squeeze bottles. I prefer to use the jars so I can reuse leftover paint. I can also mix special colors for specific projects and place those colors in empty jars.

Paint Properties

As we just discussed, each form of paint—jar, tube or squeeze bottle—has different characteristics. Once you've selected the paint you prefer, you will find that individual colors have their own properties as well.

Opacity: Some colors will cover better than others, appearing more opaque, while some will be more transparent. With time and practice, you'll get to know your paints. Play and experiment first by creating some color swatches like the ones on this page. This will give you a better understanding of how each color on your palette behaves.

The swatches on this page show how some colors are opaque and completely cover the canvas, while others are more transparent and seem streaky.

Permanence: Certain colors are more prone to fading over time than others. Most brands will have a permanency rating on the package to let you know what to expect. A color with an "Excellent" rating is a durable color that will hold its original color for a long time. A color rated as "Good" or "Moderate" will have some fading, but not a huge difference over time. A color rated as "Fugitive" will tend to fade significantly. You can see this most often with yellows and certain reds. Try to avoid fugitive colors, but regardless of a color's permanence rating, never hang a painting in direct sunlight. Ultraviolet rays in sunlight are the primary cause of fading.

Toxicity: Good-quality paint brands will include some toxic colors. Some of the natural pigments that produce vivid colors are toxic, such as the Cadmium pigments and some blues. Never swallow or inhale these colors. Certain colors should never be spray applied; check the label. If you're working with children, always find a brand that substitutes synthetic, manufactured pigments for the toxic ones.

ALIZARIN CRIMSON
This red is dark but transparent in nature. It has a streaky appearance, letting some of the canvas show through.

CADMIUM RED MEDIUM
This red is opaque and completely covers the canvas. Can you see the difference between this and the Alizarin Crimson?

PRUSSIAN BLUE
This blue is dark but transparent.

Tip: Don't Eat Your Paint

Because some colors are toxic, never hold brushes in your mouth. Also, use a jar or other distinctive container to hold water for painting so that you never mistake a cup of paint water for iced tea!

PRUSSIAN BLUE + TITANIUM WHITE
Just by adding a touch of Titanium White to Prussian Blue, you can create an opaque version of it.

Thinning Acrylics With Water

Mixing acrylic paint with water makes it more transparent. This is useful for the beginning stages of a painting when you are creating the basic pattern of colors.

Thinned acrylics are often used to create a look very similar to that of watercolor paints. The difference is that acrylic paint is waterproof when it dries. You can add more color without pulling up previous layers. Regular watercolor will rehydrate when wet paint is applied on top of it, usually muddying the colors.

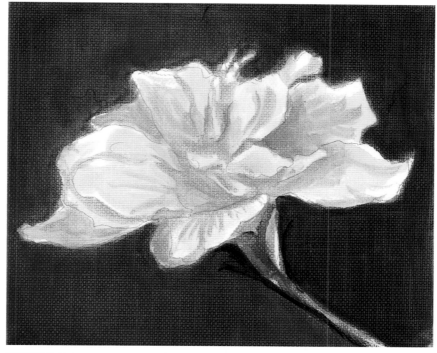

JUST THE BEGINNING
This example shows how I begin my painting. It looks very underdeveloped, but it gives me a good foundation to work on. The colors of the flower and the background are established, allowing me to then add more color for the details.

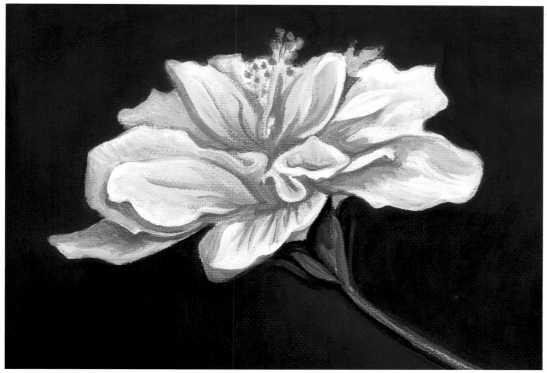

THE FINISHED PAINTING
The second example shows how I reduced the amount of water I added to the paint, and added details. The thicker paint covers up the existing layer. You can see how the look of the paint changes here. The full-strength paint is much more opaque.

Study of a Flower
5½" × 7½" (14cm × 19cm)

Choosing Brushes

Read all about brush basics here, and see "Start-Up Kit" at the beginning of this chapter for the basic set of brushes needed for the projects in this book.

Bristle Type

The way paint looks when applied to canvas largely depends on the type of brush you use. Brushes come in a variety of bristle types.

Stiff bristle: These brushes are made from boar bristle, ox hair, horsehair or other coarse animal hairs.

Sable: These brushes are made from the tail hair of the male kolinsky sable, which is found in Russia. This very soft hair creates smooth blends. The scarcity of the kolinsky makes these brushes expensive, but they are worth it!

Squirrel hair: These soft brushes are a bit fuller than sable brushes and are often used for watercolor because they hold a lot of moisture.

Camel hair: This is another soft hair that is used frequently for both acrylic and watercolor brushes.

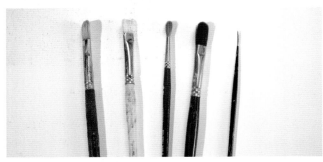

BRUSH SHAPES
From left to right: flat, bright, round, filbert and liner brush shapes.

BRISTLE TYPES
From left to right: stiff bristle, sable, squirrel hair, camel hair and synthetic bristle types.

Synthetic: Most synthetic bristles are nylon. They can be a more affordable substitute for natural-hair brushes, but paint is very hard on them. They tend to lose their shape and point faster than natural-hair brushes. Good brush cleaning and care (see next section) is essential to making synthetic brushes last.

Natural-hair brushes can be quite pricey. However, if cleaned properly, they will last longer than synthetic ones.

Brush Shape

Brushes come in different shapes, and some shapes are better for certain paint applications. Below is a quick list of the different brush shapes and the best uses for each.

Flat: A flat brush is used for broad applications of paint. Its wide shape will cover a large area. The coarse boar-bristle type is a stiff brush that can be used to literally scrub the paint into the canvas. A softer sable or synthetic bristle is good for smooth blending with less noticeable brush marks.

Bright: Brights are very similar to flats; however, the bright's bristles are a bit shorter, which gives the brush more spring.

Round: Use round brushes for details and smaller areas. The tip of a stiff bristle round is good for dabbing in paint or filling in small areas. A small soft round can be used in place of a liner brush for creating long, straight or curved lines.

Filbert: This brush shape is my personal favorite. Also known as a cat's tongue, the filbert is useful for filling in areas, due to its rounded tip.

Liner: The liner's small, pointy shape makes it essential for detail work. You can create tiny lines and crisp edges with a liner.

Hake: a hake (pronounced hah-kay), a wide flat oriental brush made from natural hair, is excellent for soft blending.

Tip: Long or Short Brushes?

Long-handled brushes are designed for use while standing at an easel so you can paint at arm's length and have a better overall view of your work. Short handles are better for painting while seated or for working on small details.

Brush Maintenance

Acrylic paint is hard on brushes. Remember, once acrylic paint dries, it is waterproof and almost impossible to remove. Paint often gets into the brush's ferrule (the metal band that holds the bristles in place). If paint dries there, it can make the bristles break off or force them in unnatural directions. A brush left to dry with acrylic paint in it is as good as thrown away.

Follow these pointers to keep your brushes like new for as long as possible.

- Stick to a strict and thorough brush-cleaning routine. See "Tip: How to Clean Brushes" for my favorite cleaning procedure. (Note: Some paint colors stain synthetic bristles. This staining is permanent, but normal and harmless.)

- Never leave a brush resting in a jar of water. This can bend the bristles permanently. It can also loosen the ferrule, causing the bristles to fall out. (Sometimes a brush with five hairs is good for small details, but not if the poor brush started out with a hundred!)

- Always store your brushes handle-down in a jar, can or brush holder to protect the bristles.

PROPER BRUSH STORAGE
Always store brushes with their bristles in the "up" position!

Tip: How to Clean Brushes

1. Swish the brush in a clean jar of water to loosen any remaining paint.

2. Take the brush to the sink and run lukewarm water over it.

3. Work the brush into a cake of The Masters Brush Cleaner and Preserver until it forms a thick lather. At this point, you will notice some paint color leaving the brush.

4. Gently massage the bristles between your thumb and fingers to continue loosening the paint.

5. Rinse under the warm water.

6. Repeat steps 3 to 5 until no more color comes out.

7. When you are sure the brush is clean, apply some of the brush cleaner paste to the bristles and press them into their original shape. Allow the paste to dry on the brush. This keeps the bristles going the way they are intended and prevents them from drying out and fraying. It's like hair conditioner for your brushes! When you are ready to use the brush again, simply rinse the soap off with water.

MY FAVORITE BRUSH CLEANER
The Masters Brush Cleaner and Preserver will remove all of the paint from your brushes and condition the bristles. I've used it for many years and swear by it.

Painting Surfaces

Many students ask me what the best painting surface is. That depends on your preference and what kind of painting you are doing. Acrylic paint can be used on everything from fine art canvases to wood, fabric, metal and glass. For the sake of this book, I will concentrate on surfaces normally used for paintings.

Stretched Canvas

Stretched canvas provides a professional look, making your work resemble an oil painting. Stretched canvas is easily framed and comes in standard frame sizes from mini (2" × 3" [5cm × 8cm]) to extra large (48" × 60" [122cm × 152cm] or larger). You will notice a bit of "bounce" when applying paint to stretched canvas.

Stretched canvas comes "primed," which means it is coated with a white acrylic called gesso to protect the raw canvas from the damaging effects of paint.

Stretched canvas can be regular cotton duck, excellent for most work; extra-smooth cotton, often used for portrait work; or linen, which is also smooth.

Canvas Panels

Canvas panels are canvas pieces glued onto cardboard backings. They are a good alternative to stretched canvas if you would prefer to spend less. A canvas panel is very rigid and will not give you the bouncy feel of painting on stretched canvas.

With canvas panels, unlike stretched canvas, you have the option of framing with a mat. A colored mat can enhance the look of artwork. A canvas panel also allows you to protect your painting with glass.

Canvas Sheets

Another alternative is canvas sheets. Some brands are pieces of actual primed canvas, not affixed to anything. Others are processed papers with a canvas texture and a coating that resembles gesso. Both kinds can be purchased individually, in packages or in pads.

With canvas sheets, as with canvas panels, framing can be creative. Sheets are lightweight and easy to mat and frame. For the art in this book, I used mostly canvas sheets.

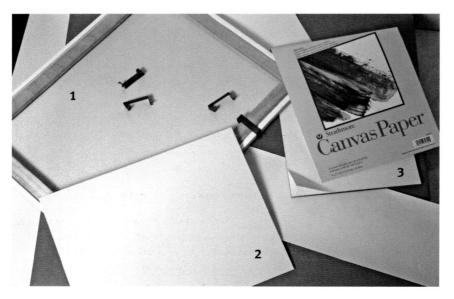

PAINTING SURFACES
Stretched canvas (1) is the most popular surface for fine art painting. It must go into a frame "as is" and is held into place with frame clips. These are metal brackets that snap over the wooden stretcher frames and grip the inside edge of the frame with sharp teeth.

Canvas panels (2) are canvas on cardboard backings. They are more rigid than stretched canvas, and the finished piece can be matted and framed.

Canvas sheets (3) can also be matted and framed. They are found in single sheets, packages and pads.

Palettes and Other Tools

Palette

I prefer a plastic palette with a lid, multiple mixing wells and a center area for mixing larger amounts of paint. Because acrylic paint is a form of plastic, dried acrylic can be peeled or soaked from a plastic palette. I find this more economical than disposable paper palettes.

However, you don't have to spend a fortune on state-of-the-art materials. Many artists make their own palettes using old dinner plates, butcher's trays or foam egg cartons. You can use your creativity to make do with what is around you.

Other Tools

The following items will make your painting experience more organized and pleasurable. None of them is expensive, and they can usually be found around the house.

Cloth rags: Keep plenty of these handy. You can use one near your palette to wipe excess paint from your brush. You can also use them to wipe excess water from your brush as you paint, which keeps your painting from getting unexpectedly watered down by a loose drip. Paper towels work too, but they can leave lint and debris.

Wet wipes: I usually have a container of wet wipes or baby wipes handy for cleaning my hands, my brushes or the floor if I drop paint.

Assorted containers: Collect jars, cans and plastic containers to use as water containers or for storing brushes.

Spray bottle of water: Use this to mist your paints to prevent them from drying out as you work.

Palette knife: This is useful for transferring acrylic paint to or from a jar as well as for mixing paint on your palette.

Masking or drafting tape: If you work with canvas sheets, you will need to tape them to a backing board as you work. Use drafting tape or easy-release masking tape to tape the edges of the sheet down. These kinds of tape will not damage or rip the sheet.

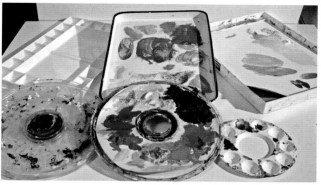

PALETTE CHOICES
Palettes come in many varieties. It is also easy to make your own with plates, egg cartons or plastic containers. Be creative!

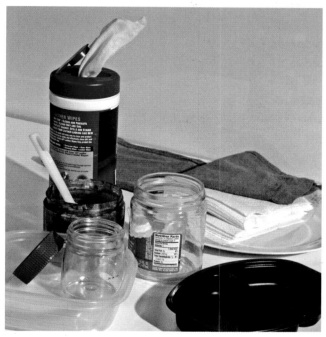

ADDITIONAL MATERIALS
Additional handy studio items, such as jars, plates, plastic trays, wet wipes and rags, can usually be found around the house.

Tip: Storing Leftover Paint

A palette with a lid makes it easy to preserve leftover paint. Spray a fine mist of water over the paints on your palette, then seal the lid. The extra moisture acts like a humidifier and will keep the paint from drying out for a couple of days. If you put the misted, sealed palette in the freezer, the paint will keep for weeks. It may skin over, but it will still be wet inside.

Understanding Color

ACRYLIC PAINTING IS A GREAT WAY TO EXPLORE COLOR THEORY. ITS BRIGHT, rich pigments are fun to experiment with. Artists tell a lot about themselves by the colors they choose. But color is much more than just experimenting or choosing colors based on the mere fact that you "like" them. Color is scientific.

Colors react to each other, and placing certain colors together can make quite a statement. To fully understand how colors work, the color wheel is essential. You'll learn about the color wheel and some important color terms in this chapter.

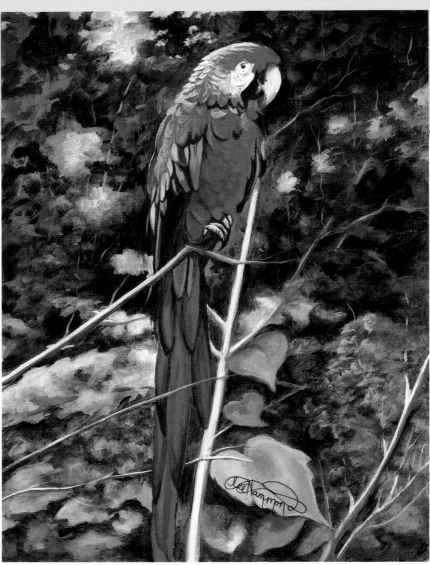

Color Basics

The Color Wheel

The color wheel is an essential tool for understanding and mixing color. Having one handy can help you pick out color schemes and see how different colors affect one another. For color mixing practice, create a color wheel of your own with the paints on your palette. Here are the basic color relationships to know.

Primary Colors: The primary colors are red, yellow and blue. They are also called the true colors. All other colors are created from these three. Look at the color wheel and see how they form a triangle if you connect them with a line.

Secondary Colors: Each secondary color is created by mixing two primaries together. Blue and yellow make green; red and blue make violet; and red and yellow make orange.

Tertiary colors: Tertiary colors are created by mixing a primary color with the color next to it on the color wheel. For instance, mixing red and violet produces red-violet. Mixing blue with green makes blue-green, and mixing yellow with orange gives you yellow-orange.

Complementary colors: Any two colors opposite each other on the color wheel are called complementary colors. Red and green, for example, are complements. The painting of a parrot at the beginning of this chapter is an example of a complementary color scheme used in a painting. The red and green contrast beautifully, each color making the other one really stand out.

Other Color Terms to Know

You'll find familiarity with the following color terms to be helpful as you read through this book and discuss your work with others.

Hue: Hue simply means the name of a color. Red, blue and yellow are all hues.

Intensity: Intensity means how bright or dull a color is. Cadmium Yellow, for instance, is bright and high-intensity. Mixing Cadmium Yellow with its complement, violet, creates a low-intensity version of yellow.

Temperature: Colors are either warm or cool. Warm colors are red, yellow and orange or any combination of those. When used in a painting, warm colors seem to come forward. Cool colors are blue, green and violet and all of their combinations. In a painting, cool colors will seem to recede.

Often there are warm and cool versions of the same hue. For instance, I use Cadmium Red and Alizarin Crimson. While both are in the red family, Cadmium Red is warm, with an orangey look, and Alizarin Crimson is cooler, because it leans toward the violet family.

Value: Value means the lightness or darkness of a color. Lightening a color, either with white or by diluting it with water, produces a tint. Deepening a color by mixing it with a darker color produces a shade. Using tints and shades together creates value contrast.

THE COLOR WHEEL
The color wheel is a valuable tool for learning color theory. Red, yellow and blue are the primary colors; orange, green and violet are the secondaries. The rest are called tertiaries.

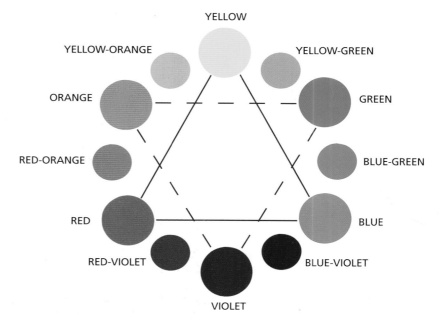

YELLOW
YELLOW-ORANGE
YELLOW-GREEN
ORANGE
GREEN
RED-ORANGE
BLUE-GREEN
RED
BLUE
RED-VIOLET
BLUE-VIOLET
VIOLET

Your Basic Palette and How to Expand It

Artists love to have all of the toys associated with their craft. I am no different. I would love nothing more than a set of art supplies with a hundred different colors to choose from. But while it sounds like artistic nirvana, it really is not necessary. Color mixing is much more rewarding, educational and economical.

YOUR BASIC PALETTE

With a very small palette of only seven colors, you can create an endless array of color mixes.

Cadmium Yellow Medium Cadmium Red Medium Prussian Blue Alizarin Crimson Burnt Umber Ivory Black Titanium White

THREE PRIMARY COLORS **TWO ADDITIONAL COLORS** **TWO NEUTRAL COLORS**

TINTS

Mixing a palette color with white produces a tint.

Cad. Yellow + white = pale yellow | Cad. Red + white = peachy/coral color | Aliz. Crimson + white = pink | Burnt Umber + white = beige | Prussian Blue + white = sky blue | black + white = grays

SHADES

Mixing a palette color with black produces a shade.

Cad. Yellow + black = dark olive green | Cad. Red + black = maroon | Aliz. Crimson + black = plum | Burnt Umber + black = dark brown | Prussian Blue + black = dark blue

GREENS

Greens can be difficult to mix due to the hundreds of possible variations. You can achieve green with yellow and blue or with yellow and black. Adding brown yields an earthy green.

Cad. Yellow + Ivory Black = olive green

olive green mix + white = grayish green

Prussian Blue + Cad. Yellow = green

blue/yellow mix + white = mint green

VIOLETS AND PURPLES

Shades of violet and purple can be created by mixing Cadmium Red Medium and Prussian Blue or Alizarin Crimson and Prussian Blue. Adding white to these mixes will give you shades of lavender, orchid, mauve and so on.

Cadmium Red Medium + Prussian Blue = maroon

maroon mix + white = warm gray

Aliz. Crimson + Prussian Blue = plum

plum mix + white = lavender

ORANGES

Cadmium Red Medium or Alizarin Crimson mixed with Cadmium Yellow will produce various shades of orange. Adding white to these colors will give you coral, peach, melon and so on.

Cadmium Red Medium + Cadmium Yellow = orange

orange mix + white = peach

Alizarin Crimson + Cadmium Yellow = orange-red

orange-red mix + white = coral

EARTH TONES

Earth tones can be created by adding different colors into Burnt Umber. All of these colors can be turned into a pastel by adding white. These swatches show the earth tone mix (top swatch), and what it looks like with white added (bottom swatch).

Burnt Umber + yellow

Burnt Umber + red

Burnt Umber + blue

Burnt Umber + black

Burnt Umber + yellow + white

Burnt Umber + red + white

Burnt Umber + blue + white

Burnt Umber + black + white

Color Schemes

The right color scheme is one that represents the subject yet also adds interest for the viewer. Experiment to achieve the exact feel you want your painting to have.

Complementary

Complementary colors, you'll recall, are colors that lie opposite each other on the color wheel.

When complements are used near each other, they contrast with and intensify each other, as seen in this section.

When complementary colors are mixed, they gray each other down. You can use this knowledge to darken a color without killing it. When darkening a color to paint shadows, for example, you may instinctively reach for black. But black is a neutral color and will produce odd results in mixtures. Instead, darken a light color with its complement.

Yellow + violet = pleasing shadow color

Yellow + black = green

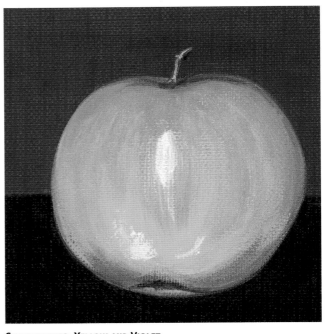

COMPLEMENTS: YELLOW AND VIOLET
A violet background intensifies the yellow of this apple, making it appear more pure and vibrant. Yellow mixed with violet makes a good shadow color for a yellow object. (Yellow mixed with black, on the other hand, makes green!)

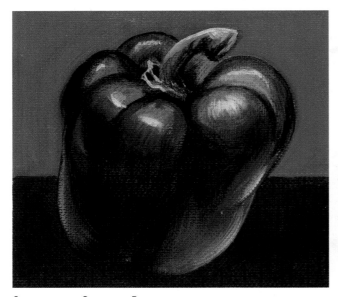

COMPLEMENTS: GREEN AND RED
A green pepper looks more vibrant on a red background. Mixing red and green produces a good color for the shadow areas.

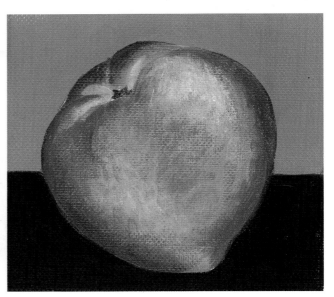

COMPLEMENTS: ORANGE AND BLUE
The orangey hue of this peach looks brighter when surrounded by blue. The shadow areas are a mixture of blue and orange.

Monochromatic

A painting created using variations of only one color is called monochromatic. This is how I often will introduce a new student to painting. A monochromatic painting can look very dramatic, like this painting of my son's dog, Kimber.

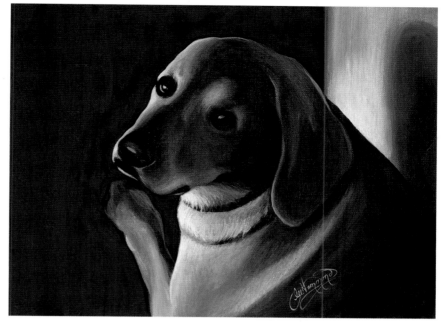

Kimber in the Moonlight
12" × 16" (30cm × 41cm)

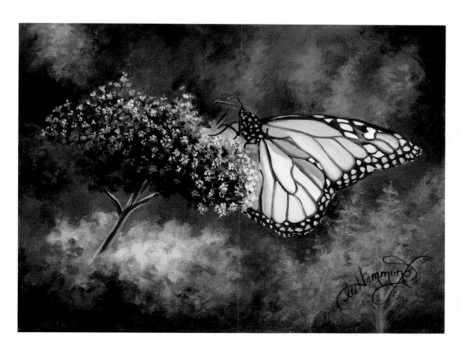

Triadic

A triadic color scheme uses three colors that are evenly spaced around the color wheel. This example, *Butterfly and Lilacs*, contains orange, purple and green. A triadic scheme always provides wonderful contrast, yet the colors are still harmonious.

Butterfly and Lilacs
12" × 16" (30cm × 41cm)

3

Basic Techniques

LEARNING SOMETHING NEW IS ALWAYS A BIT INTIMIDATING. AS WITH anything else, the best teacher is just plain experience—trial and error. This chapter will show you how to grab a brush, dip it in the paint and experiment. In no time you should feel comfortable enough to try the projects in this book. Acrylic paint is highly forgiving; if you don't like something, you can simply cover it up!

Try the exercises in this chapter to get a feel for flat, filbert, round and liner brushes and how they are used. Learn the five elements of shading and how to use them to create the illusion of form on a flat canvas. Finally, learn the grid method of drawing, which will enable you to draw any subject. You will then be ready to move ahead to the larger projects in this book.

Download free bonus material at Artistsnetwork.com/LeeHammondsBigBookOfAcrylicPainting.

Blending With a Flat Brush

Flat brushes are most commonly used for applying large areas of color and for creating blended backgrounds. I've done this blending exercise with Prussian Blue and Titanium White for a result that resembles a sky. Try it again with different colors. Cadmium Red and Titanium White will make a tropical scene. Have fun!

My Terminology

When mixing paint, I will often use the terms "a dab" and "a touch." A dab of paint is enough to cover the entire tip of the brush. A touch is a slight amount of paint that will cover only the corner of the bristles.

1 Take a blob of Titanium White about the size of a quarter and set it aside.

2 Add just a touch of Prussian Blue to the white. (When mixing paint, always add the darker color slowly into the lighter color; it doesn't take much to deepen a light color.)

3 Mix another blob of paint that is twice as dark as the first.

4 Dip your brush into the darker of the two blues you mixed in step 3. Hold the brush flat against the canvas and evenly distribute the paint with long sweeping strokes. Quickly go back and forth until the paint covers the canvas. You do not want to see any of the white canvas showing through the paint, so use enough to get good coverage.

5 When you have a wide stretch of dark blue, dip into the lighter blue and apply it to the canvas slightly below the first stripe, using the same stroke. Quickly blend the two blues together by stroking back and forth. Try to get the paint to blend as evenly as possible. Use a clean, dry flat brush to further blend and soften. This blending takes practice, so don't get frustrated. For more experience, create a horizon line and repeat the process in reverse to make a mirror image of the sky, which will then look like a water reflection.

Using a Filbert Brush

A filbert brush is similar to a flat, but the tip of it is rounded, much like the shape of a tongue. That's why this brush is sometimes called a "cat's tongue."

I like to use a filbert for almost any shape that requires filling in. I find the rounded edges comfortable when going along curved edges.

FILLING IN AND CURVES
A filbert brush is good for filling in areas and for going around curves. Try using your filbert to fill in a simple circle of color.

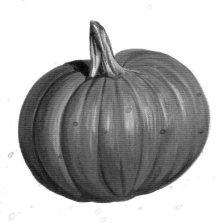

CURVES
The rounded tip of the filbert brush made it much easier to paint the curved features of these subjects.

Download free bonus material at Artistsnetwork.com/LeeHammondsBigBookOfAcrylicPainting.

Using Round and Liner Brushes

Pointed brushes such as rounds and liners are excellent for creating lines and details. They come in a variety of sizes and are essential for painting things like trees, grass, hair and fur. They are also good for making small dots for highlights and textures. Use rounds and liners on their tips. Don't place a lot of pressure on them because the bristles will bend over.

1 Paint a tree trunk with Burnt Umber and a no. 6 round. This size round brush will give you the width you need to create the trunk without repeated strokes.

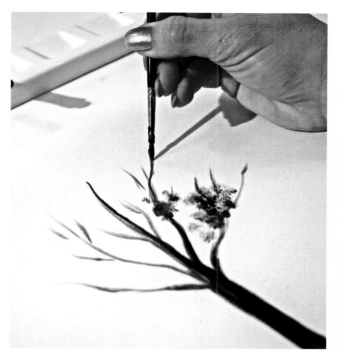

2 Switch to a no. 1 round or a liner brush to create the branches and small limbs. Add enough water to your paint to give it the consistency of thick ink. It needs to be fluid, but not transparent. After loading your brush with paint, gently pull the brush up in long strokes, lifting it slightly as you go. This will make the line taper at the end, and the limbs will get smaller and smaller, just as in nature.

3 Add many quick, short, overlapping strokes to create the illusion of layers of bark. Remember to keep your paint fluid by adding a few drops of water as you work.

Creating Texture

There are many ways to create texture with acrylic paint.

- **Drybrushing** creates a rough, textured appearance because the paint is used so sparingly that it doesn't fully cover the canvas.

- **Sponging** is great for creating textures such as distant foliage.

- **Dabbing with a liner brush** offers greater control over the placement of paint.

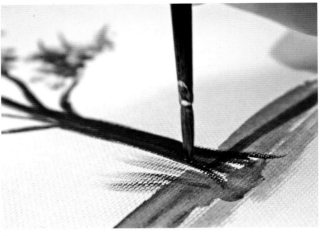

DRYBRUSHING

For this technique, use a stiff hog-bristle flat brush and unthinned paint. Dip just the ends of the bristles into full-strength paint. Wipe the brush back and forth on the palette to remove excess paint. Wipe a little more paint off with a rag. Then, scrub lightly with short strokes. Because there is barely any paint on the brush, the paint will be "hit and miss." This irregular application creates a textured appearance.

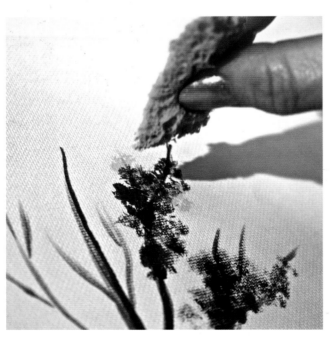

SPONGING

Tear off small pieces from a common cellulose kitchen sponge. Dip them into paint. Then apply the paint with a quick dabbing motion. Use many different layers of color, light, medium and dark, and you can make beautiful trees and landscapes.

Tearing off new pieces ensures that the edges are different every time, and you won't end up with repeat patterns. A dry sponge piece will create a more distinct edge; a damp one makes a softer impression. When the paint gets dry, the sponge becomes hardened; just throw the pieces away.

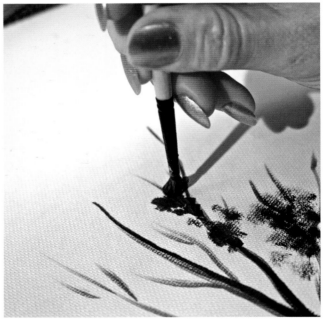

DABBING

Sometimes you need more control over the paint's application. Dabbing means making tiny spots of paint with a small liner brush. You could use this technique to create foliage, small flowers or patterns in lace.

Download free bonus material at ArtistsNetwork.com/LeeHammondsBigBookOfAcrylicPainting.

A Closer Look

Analyze this still life painting for the techniques and brushstrokes we have covered so far. Each area of the painting was created in a unique approach due to the subject's varied textures and surfaces. Some surfaces are smooth, while some are richly textured. These contrasts in textures make for very interesting paintings.

I used my entire color palette for this piece. Refer to the swatches in chapter two to see how I mixed the colors.

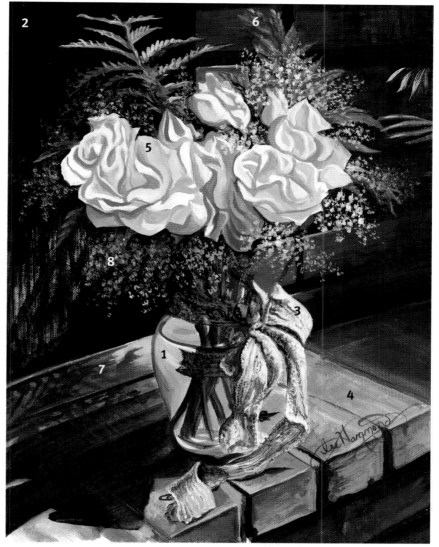

Texture Still Life
16" × 12" (41cm × 30cm)

IDENTIFYING BRUSHES AND STROKES

This painting has a lot of interesting qualities due to its range of colors and contrasting textures. Identify the type of brush used, and which type of stroke created each area.

1 Glass vase: Filbert brushes, smooth strokes

2 Fireplace screen: Flat bristle brushes, drybrushing

3 Lace ribbon: Round sable brushes, dabbing technique

4 Bricks: Filbert brushes, fill-in and dry-brush techniques

5 Flowers: Round sable brushes, smooth fill-in technique

6 Fern leaves: Round sable brushes, fill-in and dabbing techniques

7 Fireplace brass: Filbert brushes, fill-in and dry-brush techniques

8 Baby's breath: Sponging technique

The Five Elements of Shading

I firmly believe that the foundation for any realistic rendering, regardless of the medium, can be found in the five elements of shading on the sphere. I begin each and every book I write with this, and I start every new student with this valuable lesson. If you can create a believable and realistic depiction of a sphere (for example, a ball on a table), the ability to render everything else is right at your fingertips.

When rendering a sphere, each of the five elements will correspond with a shade on a value scale. The sphere on this page has been created using a monochromatic color scheme of Burnt Umber and Titanium White. The paint swatches beneath the sphere correspond with the five elements of shading. Use these different tones as a guide.

1 **Full Light:** This is the white area, where the light source is hitting the sphere at full strength.

2 **Reflected Light:** This is a light gray. Reflected light is always found along the edge of an object and separates the darkness of the shadow edge from the darkness of the cast shadow.

3 **Halftone:** This is a medium gray. It's the area of the sphere that's in neither direct light nor shadow.

4 **Shadow Edge:** This dark gray is not at the very edge of the object. It is opposite the light source where the sphere curves away from you.

5 **Cast Shadow:** This is the darkest tone on your drawing. It is always opposite the light source. In the case of the sphere, it is underneath, where the sphere meets the surface. This area is void of light because, as the sphere protrudes, it blocks light and casts a shadow.

Try the example below, and commit to memory the five elements of shading. These five elements are essential to realistic painting.

1 Full light

2 Reflected light

3 Halftone

4 Shadow edge

5 Cast shadow

Download free bonus material at Artistsnetwork.com/LeeHammondsBigBookOfAcrylicPainting.

Practice the Five Elements of Shading

Let's paint this sphere together using Ivory Black and Titanium White.

Identify where the five elements of shading will be and look at the value scale shown in step 1. Look and see how the value scale with the brown tones compares with the gray tones. It is important to make the depth of tone for each box the same for both. For example, the #3 brown tones should be the same value, or darkness, as the #3 in gray. If the brown scale were copied on a black-and-white photocopier, it would look the same as the scale on this page.

Materials List

PAINTS

Ivory Black, Titanium White

BRUSHES

no. 4 sable or synthetic round, no. 6 sable or synthetic filbert

OTHER

mechanical pencil, ruler

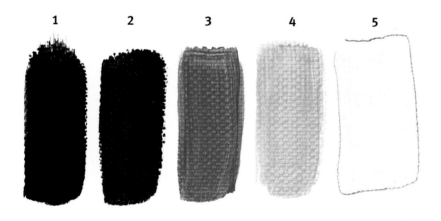

1 Mix Your Colors
Value #5 is pure Ivory Black. Mix a very small amount of Titanium White with Ivory Black until you match the #4 dark gray. When you are happy with your color, take some of the dark gray and mix a little more Titanium White into that to create the #3 halftone. Add some more white to that to create the #2 light gray. Value #1 is pure Titanium White.

2 Draw the Circle
With a mechanical pencil, trace a perfect circle onto your canvas paper. With a ruler, create a border box around the sphere. Then draw a horizontal line behind the sphere. This will represent a tabletop, and give the illusion of a background area.

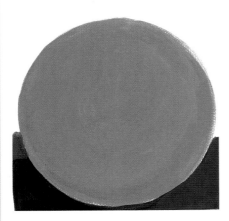

3 Paint the Base Colors

With a dark gray that matches the #4 on your value scale, base in the tabletop with a no. 4 round brush. This brush is pointy and can get into the corner and go around the curved surface easily. This deep gray will give us a foundation upon which to build the rest of the painting.

To paint the sphere, begin with the darkest area first. In this case, it is under the sphere in the cast shadow. Use the Ivory Black full strength (#5 on the value scale) to create the cast shadow over the dark gray. Use the same no. 4 round brush.

Switch to the no. 6 soft filbert brush and fill in the entire sphere with a medium gray mixture. This should match the #3 on the value scale. Be sure to completely fill in the sphere so that there is no canvas showing through.

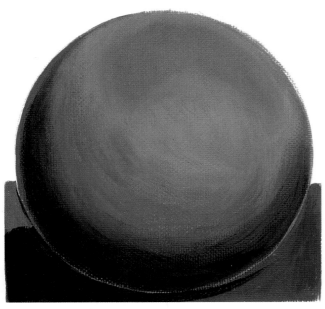

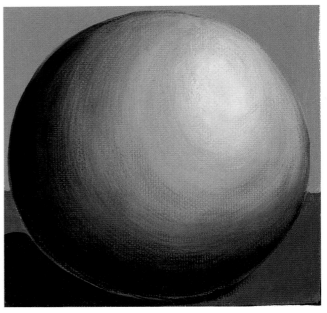

4 The Awkward Stage

With the #4 dark gray mixture, apply the shadow edge of the sphere with a no. 6 soft filbert brush while the medium gray paint is still wet. The filbert brush will blend the tones. Make sure the shadow is parallel to the edge of the sphere, allowing the two colors to blend. Allow the dark gray to show along the edge of the sphere, creating the reflected light.

While the paint is still wet, add some of the medium gray mixture above the dark gray and blend the two, using long rounded strokes that follow the contours of the sphere to create the halftone area. Blend until the tonal transitions are smooth.

5 Finish

With Titanium White, apply the full light area and blend it into the halftone using a no. 6 filbert. To make the light areas stand out, apply some of the medium gray mixture behind the sphere to create the background. The light edge of the sphere contrasts against it.

This is not as easy as it looks, so please do not get frustrated. Remember, you can go over things as many times as you want. I often will add some paint, and softly reblend into the paint that is already there. I can spend a lot of time trying to get it just right. This is all part of the challenge!

Create Spheres Using Complementary Colors

Practice painting the monochromatic sphere from the previous exercise. It really is the foundation for everything else you'll paint. When you feel you've got it, try painting spheres in color.

Remember the five values you created earlier in this chapter? For spheres in color, the main color of your sphere is a 3 on the value scale. Mix the lighter values (1 and 2) by adding Titanium White. Mix the darker values (4 and 5) by adding the complement of the main color. As you learned in chapter 2, complements produce a pleasing grayed-down color, perfect for painting shadows.

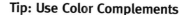

Tip: Use Color Complements

Complementary colors are colors opposite each other on the color wheel. Using complementary colors will help intensify the colors in your painting. For more on complements, see chapter two.

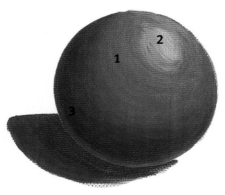

1 Cadmium Red Medium

2 Cadmium Red Medium mixed with Titanium White

3 Cadmium Red Medium mixed with green (Prussian Blue + Cadmium Yellow Medium)

1 Green (Prussian Blue + Cadmium Yellow Medium)

2 Green mixed with Titanium White

3 Green mixed with Cadmium Red Medium

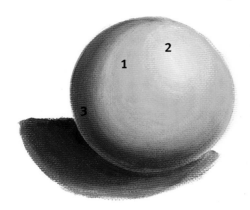

1 Cadmium Yellow Medium

2 Cadmium Yellow Medium mixed with Titanium White

3 Cadmium Yellow Medium mixed with violet (Alizarin Crimson + Prussian Blue)

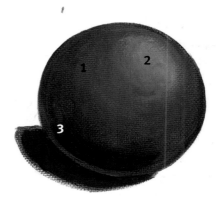

1 Prussian Blue

2 Prussian Blue mixed with Titanium White

3 Prussian Blue mixed with orange (Cadmium Yellow Medium + Cadmium Red Medium)

Paint Reflections

It is easy to see, when looking at these grapes, that the five elements of shading played an important part in creating them. While the grapes closely resemble a sphere, the reflections are much more extreme and will vary from one grape to another. This looks more complex but is much easier to paint than the overly controlled surface of the spheres. The highlights here do not blend out and disappear into the other tones. Here, they are stark and can be created with a swipe of the brush.

Materials List

PAINTS
Cadmium Red Medium, Cadmium Yellow Medium, Ivory Black, Prussian Blue, Titanium White

BRUSHES
no. 4 sable or synthetic round, no. 2/0 sable or synthetic liner

OTHER
mechanical pencil

1 Paint the Base Colors
Begin by lightly drawing three stacked circles with your mechanical pencil. Fill in each one with Cadmium Red Medium, using a no. 4 round brush.

2 The Awkward Stage
Mix a touch of Ivory Black into the Cadmium Red Medium paint to create a dark red mixture. Apply the shadow edge to each grape, using a small round brush. Be sure to leave reflected light around the edges. Blend and soften the tones by brushing the darker color into red. With the darker color, be sure to create a shadow where one grape overlaps another.

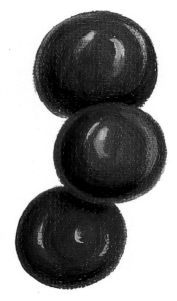

3 Finish Individual Grapes
Using a small pointed brush, such as a no. 2/0 liner, add the shiny look to the grapes with light highlights of Titanium White paint. Use brushstrokes that follow the round contours of the circle.

4 Create a Bunch!

Have even more fun by creating the whole bunch of grapes. Simply sketch in the circles, and repeat the previous process over and over.

To create the leaves, mix Prussian Blue and Cadmium Yellow Medium together to make green. With a round brush, fill in the leaves with this mixture. Feel free to make your leaves lighter than mine if you'd like. This is a time for you to experiment and have fun.

Mix some Ivory Black into the green mixture to create the veining. Use the no. 2/0 liner brush to create the delicate lines. For the highlight areas, add some white into the green mix.

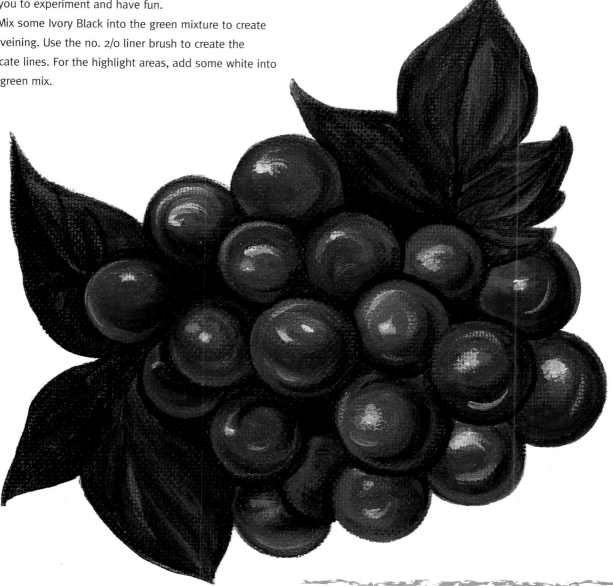

Tip: Use Contrast to Create Depth

I'm always amazed to see how much color and depth can be created with so few colors. Deep shadows and bright highlights make this possible. The extreme contrast between them creates an illusion of shine, which I find beautiful.

Paint Shadows and Highlights

The grapes on the previous page had very few colors in their creation. Although this apple is less complex in its shape when compared to the grapes (we are dealing with one continuous surface instead of many overlapping ones), the color is more complicated. Not only do we have variegated color, we also have the extreme lighting situation to replicate. All of the colors of the apple are affected by intense shadows and bright highlights.

Materials List

PAINTS
Alizarin Crimson, Cadmium Red Medium, Cadmium Yellow Medium. Ivory Black, Titanium White

BRUSHES
no. 2 sable round

OTHER
mechanical pencil, ruler

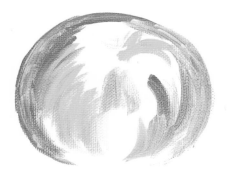

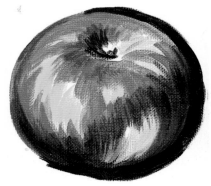

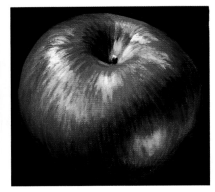

1 Draw, Then Paint the Base Colors

When I paint, I always create my paintings with layers. The first layer of paint is often very light and transparent. I use this first layer as a road map and color guide on which to build.

In the first stage of painting this apple, start with a light pencil outline. Then apply Cadmium Red Medium and Cadmium Yellow Medium with diluted, transparent layers using curved brushstrokes for form.

2 The Awkward Stage

Build up color with thicker applications of paint using curved strokes to maintain roundness. Add Alizarin Crimson into the red for more depth of color. Place some Ivory Black around the edges of the apple to begin the background. Streak the black into the surface of the apple to create a shadow edge. At this stage the colors will start to mix into one another.

3 Finish

To finish this piece, continue adding layers of paint with the curved strokes, allowing the colors to blend together somewhat. Look closely, and you can see where a brownish hue has been created in areas by the red, yellow and black mixing together. You can also see a touch of green where the yellow and black blended together.

Add some Titanium White highlights to the upper portion of the apple and tip of the apple stem. Draw a square around the apple with a ruler, and fill in the background with black.

Look at the painting of the fruit bowl in the introduction. You can see how I painted the apple in that piece the very same way.

Move Beyond the Sphere

This simple project in a brown monochromatic color scheme will give you some practice going outside the continuous circle of the sphere. You can see how adding the neck to the pot changes the shape and how this affects of the five elements of shading.

Materials List

PAINTS
Burnt Umber, Titanium White

BRUSHES
no. 4 sable round

OTHER
mechanical pencil

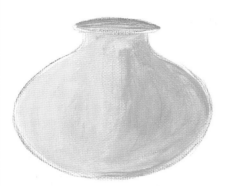

1 Draw the Pot
Lightly sketch the pot's outline with a mechanical pencil. Be sure it is symmetrical. Lightly fill in the area with a transparent mix of Burnt Umber and Titanium White plus a touch of water.

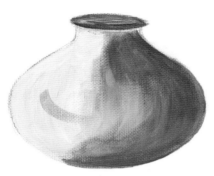

2 The Awkward Stage
Create the dark side of the pot with Burnt Umber. Follow the contours with curved brushstrokes. Fill the inner rim of the neck as well.

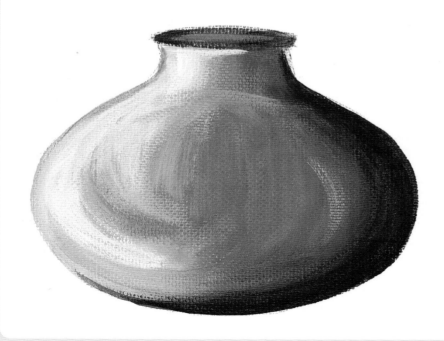

3 Finish
Add Titanium White to the Burnt Umber, and continue to develop the shape of the pot. You can see how I literally "draw" with paint. My brushstrokes create the form with their direction.

Basic Drawing

Why Drawing Is Important

To be a good painter, it is essential to learn some basic drawing skills. All paintings must have a firm foundation to build on, and the shapes of the objects you are painting must be accurate.

I take my own photo references to use in creating my artwork. To accurately depict what I want to paint, it is important to draw the shapes accurately in the beginning, before I start to paint.

How the Grid Method Works

When I teach drawing to my students, I introduce them to the grid method of capturing shapes. It is an excellent method for breaking down a complex subject into smaller, more manageable shapes.

1. **Place a grid of squares over a photo reference.** One-inch squares usually work well. If you have many small details to capture, you can place smaller squares over your photo. This will break the subject matter down into more manageable pieces.

2. **Draw an identical grid on your canvas.** The squares can be the same size, larger or smaller, but the grid on your canvas must have the same number of rows and columns as the one on the reference photo.

3. **Lightly draw what you see within each square.** This makes it easy to get the shapes right.

1	2	3	4	5	6	7	8	9	10	11	12	13
14	15	16	17	18	19	20	21	22	23	24	25	26
27	28	29	30	31	32	33	34	35	36	37	38	39
40	41	42	43	44	45	46	47	48	49	50	51	52
53	54	55	56	57	58	59	60	61	62	63	64	65
66	67	68	69	70	71	72	73	74	75	76	77	78
79	80	81	82	83	84	85	86	87	88	89	90	91
92	93	94	95	96	97	98	99	100	101	102	103	104
105	106	107	108	109	110	111	112	113	114	115	116	117
118	119	120	121	122	123	124	125	126	127	128	129	130
131	132	133	134	135	136	137	138	139	140	141	142	143
144	145	146	147	148	149	150	151	152	153	154	155	156
157	158	159	160	161	162	163	164	165	166	167	168	169
170	171	172	173	174	175	176	177	178	179	180	181	182
183	184	185	186	187	188	189	190	191	192	193	194	195
196	197	198	199	200	201	202	203	204	205	206	207	208
209	210	211	212	213	214	215	216	217	218	219	220	221
222	223	224	225	226	227	228	229	230	231	232	233	234
235	236	237	238	239	240							

THE GRID METHOD OF DRAWING

I have acetate overlays with the grid on them made at the copy shop. It is then easy to take whatever size grid you need and tape it over any photo you want to paint. You can even number the individual boxes to help you keep track as you draw.

Tip: Puzzle Pieces

When using this approach, remember this important key: Everything you draw or paint should be viewed as a puzzle. And all of the pieces of the puzzle are nothing more than patterns of interlocking shapes of light and dark.

Practice the Grid Method

Let's practice using the grid method. The shapes of these wine glasses are fairly simple to draw when using the grid method. You can use regular paper for this exercise.

The canvas paper I used for the projects in this book is wonderful for the grid method, because pencil lines lift up and are easy to erase with a kneaded eraser. It becomes more of a challenge on stretched canvas, because of the rougher surface. Stretched canvas, while still erasable in small doses, really holds the graphite and will smear. For stretched canvas, I would suggest using a projector (see the tip below) to get your outline, so you don't have to remove grid lines when you are ready to paint.

For more practice with the grid method, go through the book and practice creating the line drawings of the projects you would like to try. Use regular paper at first, just to get the hang of the method. When you are comfortable with your ability to draw and want to start painting, switch to canvas paper.

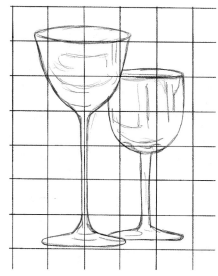

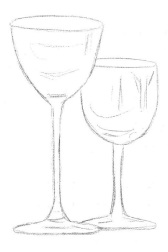

1 Study the graphed example. Really look hard and try to see everything as interlocking nonsense shapes within each square.

2 Lightly apply a grid of one-inch squares to your paper with a mechanical pencil. Using the grid as your guide, begin drawing the shapes of the wine glasses on the canvas paper, one box at a time. Go slowly, concentrate on one square at a time, and forget you are drawing a glass.

3 When you have accurately drawn the shape of the glasses, erase the grid with a kneaded eraser, and leave just the outline.

Tip: Using a Projector

If you don't want to erase grid lines, you can use an art projector to shine an image of a reference photo onto your canvas. Adjust the projector until the image fills the canvas the way you want it to, then trace the image lightly onto the canvas with a pencil. Art projectors are available wherever art and craft supplies are sold.

4

Still Life

IT'S TIME TO DO OUR FIRST FINISHED PAINTINGS! THIS CHAPTER STARTS OFF
with a simple subject: wine glasses. Don't let the fact that they are made of
glass scare you. It is actually no harder to paint shiny and transparent things
than it is to paint apples or grapes. Painting reflections is merely a matter of
viewing them as patterns of color. If you have the five elements of shading in
the back of your mind as you paint (see chapter 3) and an accurate line draw-
ing, your are well on your way to great painting.

As you continue through all the painting demonstrations in this chapter,
you'll learn how to use shading, backgrounds and color relationships to paint
any still life subject.

Paint Glass and Shine

I selected these wine glasses for this exercise because the five elements of shading—cast shadow, shadow edge, halftone, reflected light and full light—are easy to pick out.

materials list

PAINTS

Ivory Black, Prussian Blue, Titanium White

BRUSHES

no. 2/0 liner brush, no. 3 sable or synthetic filbert

OTHER

mechanical pencil, ruler, kneaded eraser

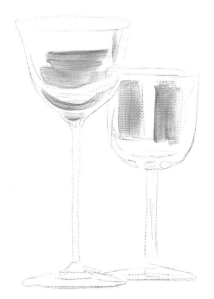

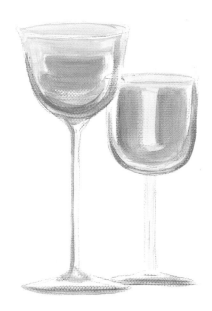

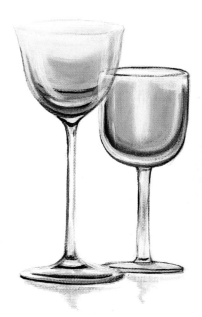

1 Sketch and Paint the First Strokes
Sketch the wine glasses on your canvas, using the grid method. With a diluted mixture of Prussian Blue and a small no. 3 sable or synthetic filbert brush, apply some streaks of paint where the shadow edge of the glass is. This begins the process of creating roundness.

2 The Awkward Stage
Use a no. 2/0 liner brush to paint the tall stems of the glasses, using the diluted Prussian Blue from step 1. Now mix a small amount of Titanium White into the Prussian Blue to make it more opaque. With the filbert brush, continue blocking in the colors. Can you see how it is covering the canvas more? At this stage you are creating patterns of dark and light.

3 Finish
To deepen the shadow areas, mix some Ivory Black into the Prussian Blue and white to create a dark blue-gray. With a liner brush, add the blue-gray mixture to the shadow edges. The roundness of the glasses really jumps out now.

To make the glasses look transparent and shiny, take pure white into the highlight areas. Paint right over the existing painting, which makes the white look as if it is reflecting off of the outer surface of the glass. You are painting blotches and patterns of color, which go together to create the illusion of glass.

Glass and Metal

The wine glasses were a simple project because of the simple color scheme and the white background. Now let's try something a bit more complicated. This project brings in two new elements: a dark background and the use of color.

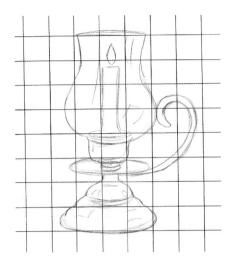

1 Do the Drawing
Use this grid to create an accurate line drawing of your own. Lightly draw a grid of one-inch squares on your canvas paper and then draw what you see one box at a time. When you are sure the drawing is accurate, remove the grid with a kneaded eraser, leaving just the outline of the candleholder.

2 Paint the Candle and Start the Background
Look at the candle. The five elements of shading are there. The stripes of light and dark create the look of a cylinder. The placement of the lights and darks makes it look rounded. To paint it, mix a touch of Cadmium Yellow Medium with Titanium White. Then add a touch of Burnt Umber. This makes a dark yellow ochre color. In addition, create a light and a medium version of this color by pulling aside portions of the mix and adding white.

Create the candle with vertical brushstrokes and a filbert brush. Start with the lightest color mixture first and then blend the darker colors into it. The patterns are important in creating the look of a cylinder. Save some of this yellow for step 3.

Start to fill in the background with Ivory Black. The dark background will create the light edges of the subject.

Tip: Let the Darks Create the Lights

Rather than outlining objects, let dark colors create the edges for light areas. In this painting, we can create the light outside edges of the candleholder by filling in the black background around it.

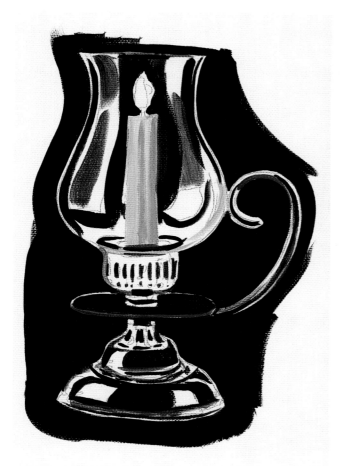

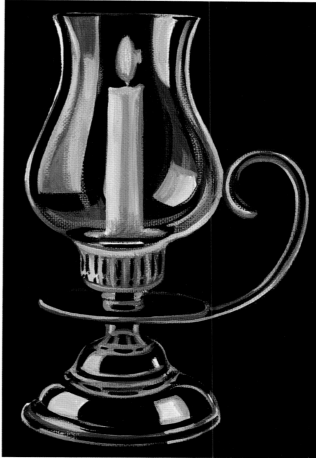

3 The Awkward Stage

Finish filling in the background to create all of the outside edges. Fill in some of the smaller black areas inside of the candleholder. Look at these areas objectively as small shapes, and assign each one a color. Any subject is easier to replicate if you think of it as puzzle pieces.

Mix a gray using black and white and apply it with a no. 2 round to the light areas of the glass. Add some of the yellow from step 2 into the lower right side of the glass. This is where the color of the candle is reflected in the glass.

Add a touch of Cadmium Red Medium to Burnt Umber. Look at the areas where I used this warm brown tone and apply to your painting accordingly with a small liner brush.

4 Finish

To finish the painting, continue filling in areas with patterns of color using a no. 2 round. Add Cadmium Yellow Medium to some areas to create the look of gold-colored metal.

To make the glass look real, mix some white and yellow together and drybrush it into the glass with curved brushstrokes to create reflections. Just as in the earlier wine glass, the highlights curve to create the roundness of the glass.

To make the candle flame, mix an orange out of Cadmium Yellow Medium and Cadmium Red Medium. It is the perfect finishing touch.

Candleholder
9" × 7" (23cm × 18cm)

Peaches and Teapot

I like to play colors off of each other. In this piece, the colors of the peaches enhance the color of the teapot. This is because red and green are opposites on the color wheel, and placing them side by side always creates a good color contrast. You can see another complementary color scheme in use here as well. The colors blue and orange are opposites, so the sky color helps illuminate the orange colors of the peaches and the orange colors reflected on the tabletop.

This is a good project for practicing your stroke work. This painting was mostly done with the no. 3 filbert brush and long fill-in strokes. When painting in long strokes, it is important to follow the contours of the object you are painting. In this example, curved strokes create the roundness of the teapot, straight strokes create the flat surface of the table and horizontal strokes give the illusion of a sky in the background.

Materials List

PAINTS
Burnt Umber, Cadmium Red Medium, Cadmium Yellow Medium, Ivory Black, Prussian Blue, Titanium White

BRUSHES
no. 3 sable or synthetic filbert, no. 2 sable or synthetic liner, no. 2 sable or synthetic round

CANVAS OR CANVAS PAPER
16" × 12" (41cm × 30cm)

OTHER
mechanical pencil, ruler, kneaded eraser

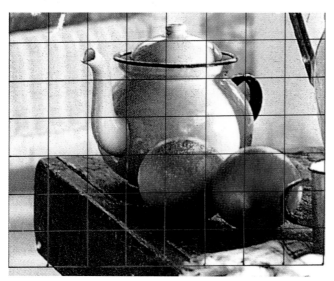

A GRAPHED PHOTO
The graph will help you draw this still life scene.

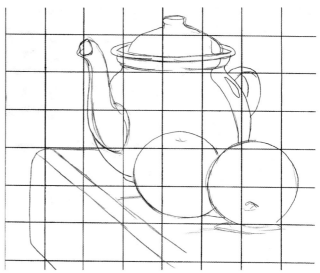

1 Draw the Still Life
Create an accurate line drawing on your canvas paper, using the grid method. When you are satisfied with your drawing, erase the grid lines.

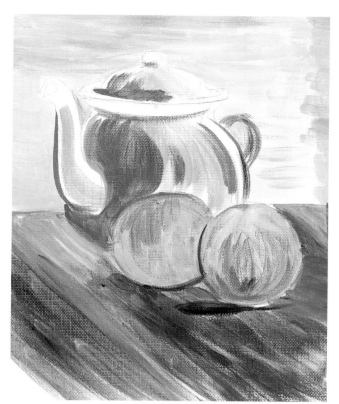

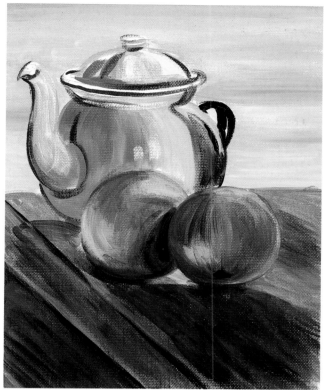

2 Block In the Colors

Block in the colors of the painting, using a no. 2 round for smaller areas, such as the teapot's spout and handle, and a no. 3 filbert for large, open areas. Pay attention to the direction of your brushstrokes: Let them follow the contours of the objects to begin creating their forms.

With the no. 3 filbert and a mixture of Prussian Blue and Titanium White, paint the sky with horizontal strokes. Save some of this color on your palette; it will be reflected into the teapot and the tabletop later on.

Paint the peaches with a mixture of Cadmium Red Medium and Cadmium Yellow Medium. Add a touch of Burnt Umber into the Cadmium Red Medium for the shadow areas.

Mix a jade green with Titanium White, Cadmium Yellow Medium, Prussian Blue and a touch of Ivory Black to gray it. Use this to paint the teapot. Save this color on your palette.

Paint the brown table with a mix of Burnt Umber, Cadmium Red Medium and Cadmium Yellow Medium.

3 The Awkward Stage

For this step, use the same colors, but apply them more heavily for greater coverage. Again, the brushstrokes in this piece are very important for creating the forms, especially those of the teapot and the peaches. To create the fine lines seen on the edge of the teapot and its lid, use a no. 2 liner brush for more precision. Use Ivory Black for contrast, especially in the handle.

Tip: Create Form With Your Brushstrokes

Make sure your brushstrokes always follow the contours of the surface you are painting.

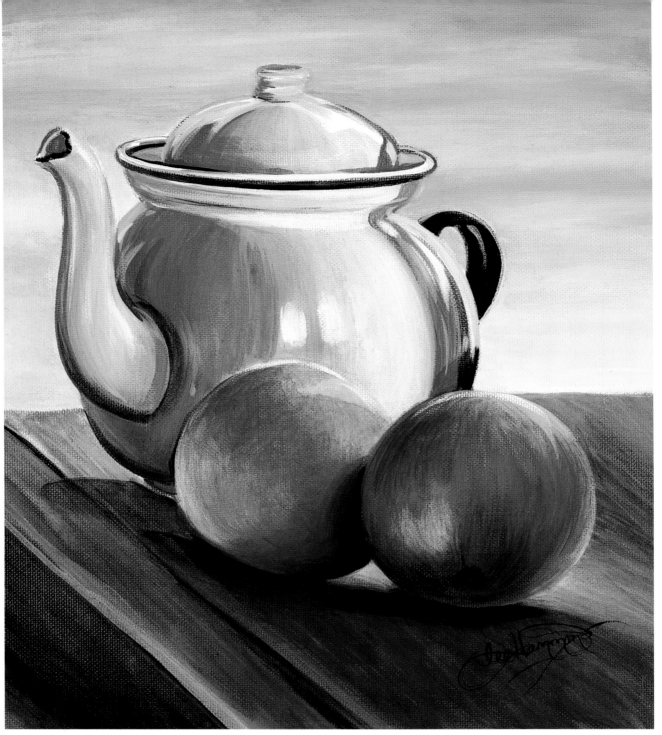

Peaches and Teapot
16" × 12" (41cm × 30cm)

4 Finish

Using the no. 2 liner brush and the same colors as in the previous step, smooth out the textures and clean up the edges. Make sure the paint completely covers the canvas. Use some Titanium White to add a few highlights on the rim and belly of the pot.

Tip: For a Finished Look, Completely Cover the Canvas

Compare the final painting to step 3, and you can really see the difference it makes when you take the time to completely cover the canvas and smooth out the shading and edges. This extra care is what takes a painting from the awkward stage to a finished work of art!

Download free bonus material at Artistsnetwork.com/LeeHammondsBigBookOfAcrylicPainting.

Petals in Color

You can create layers of flower petals by letting the dark values establish the light values. Here we'll try it in color with a lily. The tonal variations on the lily petals are subtle, but this painting also makes dramatic use of the dark values in the background to create the flower's shape.

DEMONSTRATION

Materials List

PAINTS
Cadmium Red Medium, Cadmium Yellow Medium, Ivory Black, Prussian Blue, Titanium White

BRUSHES
¾-inch (19mm) sable or synthetic filbert, no. 2 sable or synthetic round, no. 2/0 sable or synthetic round

CANVAS OR CANVAS PAPER
11" × 14" (28cm × 36cm)

OTHER
mechanical pencil, ruler, kneaded eraser

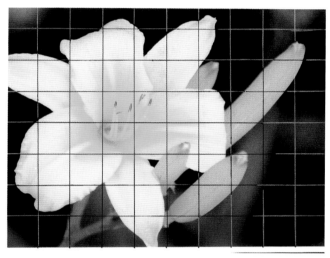

A GRAPHED PHOTO
Use the grid lines on this photo to obtain an accurate drawing. Remember, you can make your painting as large as you want by enlarging the squares you place on your canvas.

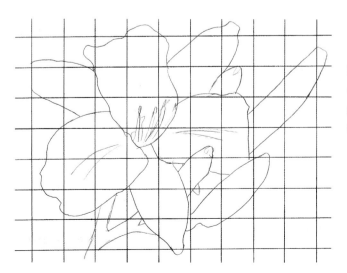

1 Draw the Lily
This is what your drawing should look like after drawing the details of each box one at a time. Gently erase the grid lines from your canvas when you are sure of your accuracy.

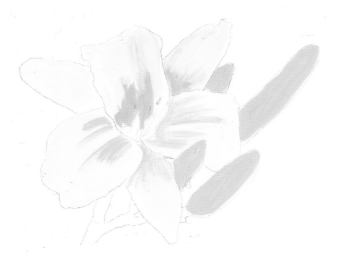

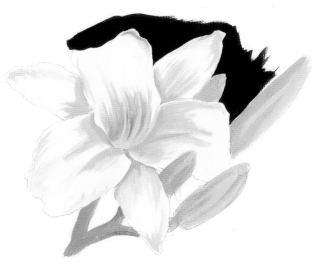

2 Basecoat the Petals

Paint the flower petals with Titanium White that has just a hint of Cadmium Yellow Medium added to it, using a no. 2 round brush. To establish the pods and the darkest areas of the flower, use pure Cadmium Yellow Medium. This helps define the overlapping petals and begin the process of creating form.

3 The Awkward Stage

Create an orange color for the center of the lily by mixing Cadmium Yellow Medium with a touch of Cadmium Red Medium. Paint the center of the lily with this color and a no. 2 round. This will help the center of the lily appear recessed. Leave areas of the lighter color exposed for the stamens.

Switch to a no. 2/0 round for the details. Use the orange mix you created for the lily's center to detail the shadow areas in the flower and on the pods. Paint the stem with a green created by mixing a touch of Prussian Blue into Cadmium Yellow Medium. Also streak some of this green into the pods to make them look real. Paint the shadow on the stem with a brown made by mixing some Cadmium Red Medium into the green mix.

Mix Prussian Blue and Ivory Black and start painting the background with this mix and a ¾-inch (19mm) filbert. This defines the outside edges of the petals.

Tip: Use Contrast for More Impact

Don't be afraid to use lots of contrast in your paintings. Compare the areas of the flower near the background color to the areas where the background hasn't been painted yet. Isn't it amazing how much the added contrast changes the look?

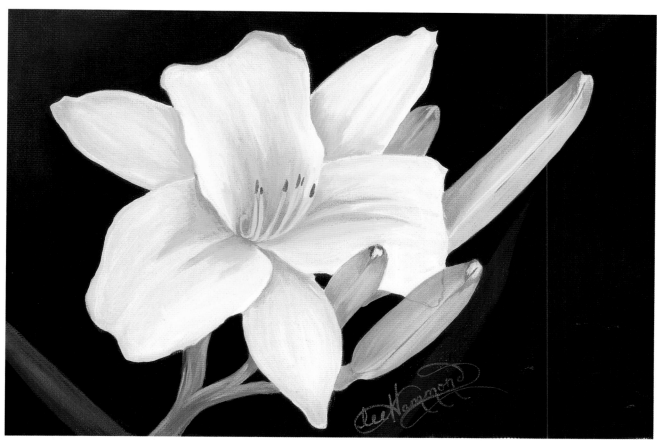

4 Finish

Continue filling in the background with the dark mixture from step 3. To make it look more interesting, blend in touches of other colors in some areas. Add some light blue and a hint of lavender in the upper left corner. This lavender color acts as a complement to the yellow of the lily. You can add more violet in the background to help create contrast against the yellow. Refer to chapter 2 for a refresher on how complementary colors work in a painting.

Add two subtle leaves to balance the composition. I encourage you to change this in any way you want and make it truly your own piece. Just have fun!

A Backdrop of Color

I love this photo for the way the colors play off each other. Even though the background is out of focus, it plays just as important a role in the painting as the main subject. This is a color copy of a digital print, and some of the colors are more bluish than the original, so I adjusted the color in the painting.

Materials List

PAINTS
Alizarin Crimson, Cadmium Red Medium, Cadmium Yellow Medium, Prussian Blue, Titanium White

BRUSHES
¾-inch (19mm) sable or synthetic flat, ¾-inch (19mm) sable or synthetic filbert, no. 2 sable or synthetic round, no. 2/0 sable or synthetic round

CANVAS OR CANVAS PAPER
8" × 10" (20cm × 25cm)

OTHER
mechanical pencil, ruler, kneaded eraser

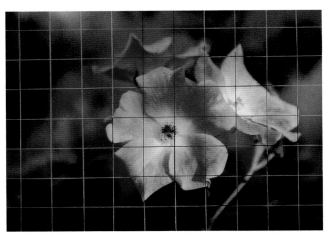

A GRAPHED PHOTO

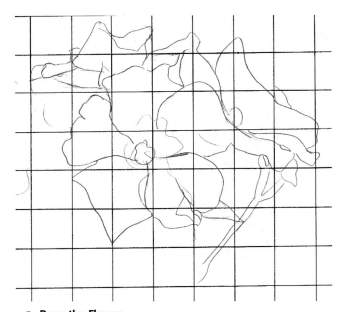

1 Draw the Flower
Using the graphed photo as your guide, draw the flower on your canvas. Make the painting as large as you like by altering the size of the grid squares. When you are sure of your accuracy, gently remove the grid lines from your canvas with a kneaded eraser.

2 Paint the Background
Mix Prussian Blue and Titanium White to create a sky-blue color. Cover the entire background with this color and a ¾-inch (19mm) filbert; the blue will be a foundation for the other colors. Let the background color create the edges of the flowers.

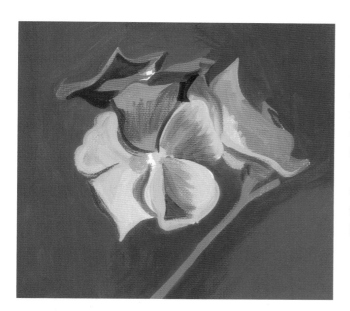

3 The Awkward Stage

Fill in the petals with a no. 2 round and a light pink made of Alizarin Crimson and Titanium White. Add more Alizarin Crimson to the mix to make a darker pink. Use this and a no. 2/0 round to paint the separations between the petals. Some of the shadows require a deeper tone, so add a touch of Prussian Blue to the mix for these.

Add Titanium White to some of the background color to make a light blue and use this to paint the center of the main flower. Mix a mint green using Prussian Blue, Cadmium Yellow Medium and Titanium White; use this to paint the stem.

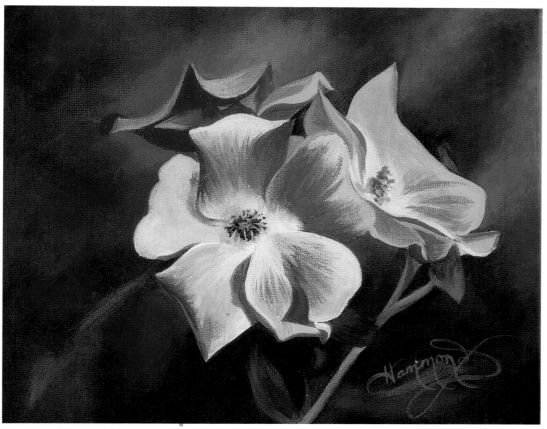

4 Finish

Add various blues, greens and purples into the background by scrubbing the paint in with a ¾-inch flat brush. This allows the colors to overlap one another with subtle edges, similar to a photographer's background. Detail the flowers by drybrushing on various shades of pink and white. Dot on brown and pink with a no. 2/0 round brush in the center of the main flower. Add light green details to both flower centers. Add some subtle leaves with medium and dark greens.

Landscape

LANDSCAPES ARE ONE OF THE MOST POPULAR SUBJECTS FOR ARTISTS. Not only do they provide beautiful colors to capture, but the many elements of landscape allow you to explore different techniques. In this chapter you'll first learn some compositional principles and then practice painting several different landscapes elements: skies, foliage, trees, grasses, flowers, rocks, mountains, hills, water and atmosphere effects. Finally, you'll put these compositional principles and elements together to create several complete landscape paintings.

Colors Used: Alizarin Crimson, Cadmium Red Light, Cadmium Yellow Medium, Dioxazine Purple, Ivory Black, Prussian Blue and Titanium White

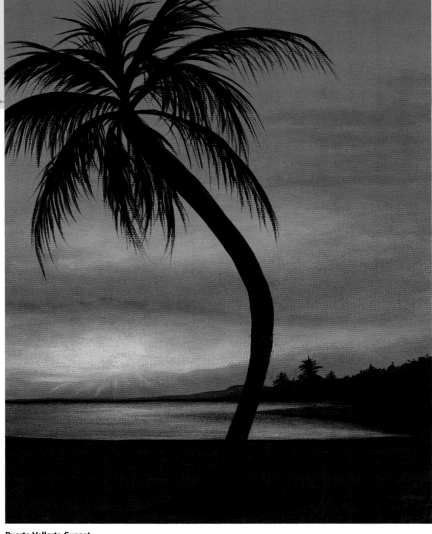

Puerto Vallarta Sunset
12" × 9" (30cm × 23cm)

Horizon Line

Since we will always be starting from the back, it is important to know where the background ends and the foreground begins. Drawing a simple horizon line can help you get your perspective on the composition.

In the beach scene at the beginning of this chapter, the horizon line is toward the bottom, which allows room for the beauty of the sky. The composition should never be divided right in half. That would ultimately end up destroying the balance of the painting, because the focal point would be divided equally, thereby placing the focus on nothing. A horizon line high on the page places the focus of the painting in the foreground. The amount of sky is reduced.

1 Horizon line

2 Sky area

3 Ground or water area

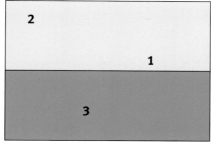

An awkward composition

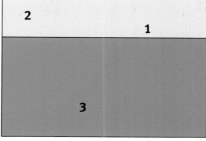

Better

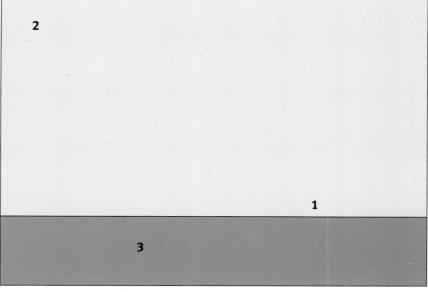

HORIZON LINE PLACEMENT
Outdoor scenes start with a simple horizon line (1). This is where the sky (2) and the ground or water (3) meet. As a general rule for any landscape, be careful not to cut your composition exactly in half with the horizon line. If you do, the viewer's eye won't know what to focus on first. Place the horizon line either above the middle of your canvas (to emphasize the ground or water area) or below it (to emphasize the sky area).

Composition Examples

When we talk about composition, we're simply talking about how the elements of your painting are arranged on the surface. Since composition can vary, let's study some examples.

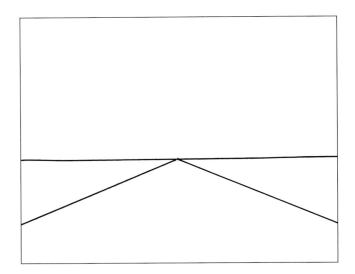

CONVERGING LINES

One of my personal favorites is the converging-lines composition, in which a road or path gets smaller as it nears the horizon line. This type of composition creates an extreme illusion of depth and distance, making the eye and the imagination search for even more.

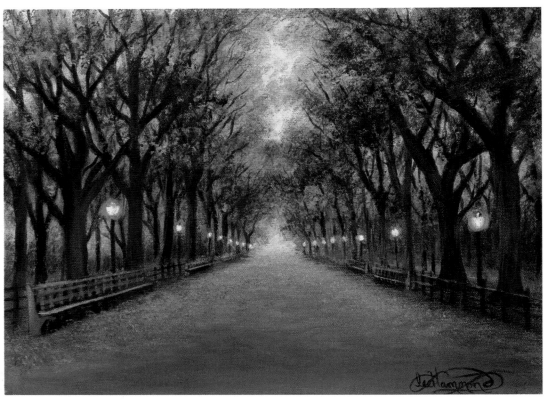

Central Park
9" × 12" (23cm × 30cm)

Colors Used: Alizarin Crimson, Burnt Umber, Cadmium Red Light, Cadmium Yellow Medium, Dioxazine Purple, Ivory Black, Prussian Blue and Titanium White

CONVERGING LINES IN ACTION

One-point perspective creates a converging-lines composition. This example is one of those pieces. Simple lines make up the composition. The walkway creates an extreme upside-down V shape. These lines come together and meet at a common point along the horizon line. The converging composition pulls you into the picture, making you imagine what is there beyond the horizon line.

OFF-CENTER CONVERGING COMPOSITION

A converging composition does not have to be perfectly centered. Sometimes the lines of convergence can be off center to create a different vantage point. Look at this diagram and you can see where the perspective lines meet at the horizon line.

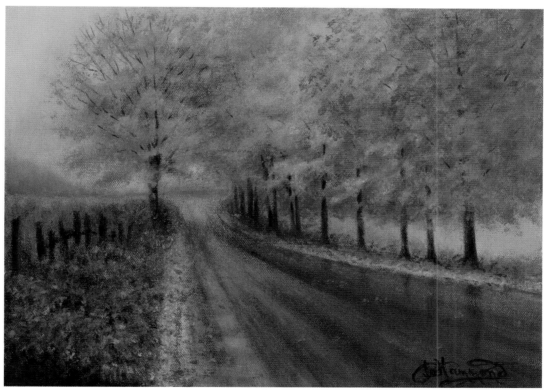

Misty Morning Walk
9" × 12" (23cm × 30cm)

Colors Used: Burnt Umber, Cadmium Red Light, Cadmium Yellow Medium, Dioxazine Purple, Ivory Black, Prussian Blue and Titanium White

OFF-CENTER CONVERGING IN ACTION

The off-centered road makes room for the row of trees on the right, but the hill and the tree on the left balance the weight of the composition. Weight, which is made up of the size and tone of an object, is extremely important to composition. If certain masses are too large and not offset by another large mass in another area, the entire painting can look lopsided or confusing. Look at all the areas in a painting, not just the subjects. A sky area has just as much weight as a mountain when it comes to composition!

S-Curve

This is my ultimate favorite of the compositions. It does the same thing as the examples before, in which the lines of composition diminish to a common point on the horizon line. But with an S-curve, the lines are curved and often interrupted, going in and out of the landscape, sometimes disappearing behind something altogether.

This type of composition actually pulls your eye around the painting.

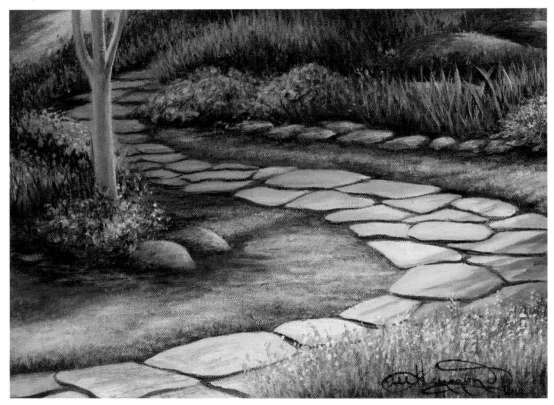

Garden Walkway
9" × 12" (23cm × 30cm)

Colors Used: Alizarin Crimson, Burnt Umber, Cadmium Red Light, Cadmium Yellow Medium, Dioxazine Purple, Ivory Black, Prussian Blue and Titanium White

S-Curve in Action

The curve of the walkway divides the painting into equal parts, giving each part of the painting a feeling of importance. In this piece, the focal point is first the walkway, then the flowers—all of them. You start with the ones in the foreground and then visually follow the path around the garden to see the rest. This type of painting makes you work a bit as you view it. It becomes a guided tour of the painting, leading the eye around the picture plane.

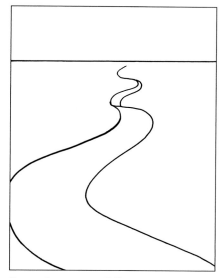

HEAVILY INTERRUPTED S-CURVE

You can see how the lines of this composition resemble the look of a ribbon winding up to the horizon line, going in and out of the scenery. This type of gentle curve makes for an interesting painting. The interrupted line gives an illusion of hidden space and unseen areas. It makes your imagination take over to fill in the blanks.

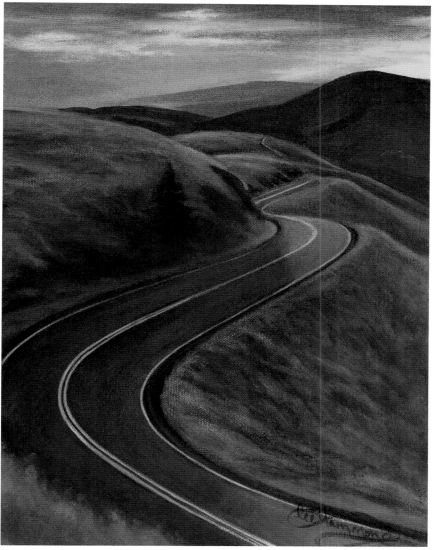

HEAVILY INTERRUPTED S-CURVE IN ACTION

The winding highway gently leads you through the hills to the warm sun setting on the horizon. Compare this composition to the one of the garden walkway. The way the S-curve goes in and out of this painting gives it much more of an illusion of distance, with the pavement getting smaller and smaller as it gradually disappears. The garden path remains large, meaning it is closer to us. The highway, on the other hand, becomes so small it actually disappears into the hills. It creates the look of miles, not yards.

Winding Sunset Highway
12" × 9" (30cm × 23cm)

Colors Used: Alizarin Crimson, Burnt Umber, Cadmium Red Light, Cadmium Yellow Medium, Dioxazine Purple, Ivory Black, Prussian Blue and Titanium White

MIRROR IMAGE

When water is involved in a landscape painting, often the composition is altered, due to reflections that are created. The water acts like a mirror, reflecting the images upside. The dual images balance the weight of the composition. This type of landscape is very common.

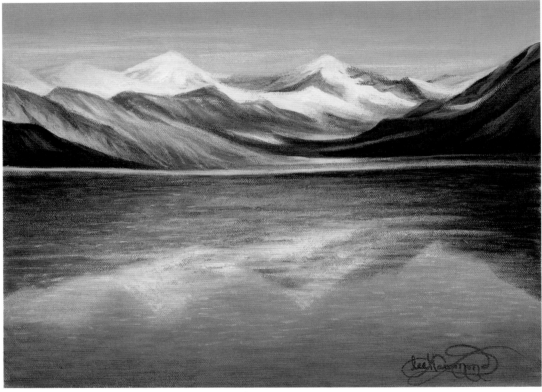

Icy Mountain Reflection
9" × 12" (23cm × 30cm)

Colors Used: Alizarin Crimson, Dioxazine Purple, Ivory Black, Prussian Blue and Titanium White

MIRROR IMAGE IN ACTION

The top and the bottom of this painting look similar. To make discernible what is up and what is down, the image reflected in the water is not as sharp, appearing a bit out of focus. The shapes in the reflection are also interrupted by the movement of the water's surface, making them appear broken up. You can see how the ice in the water breaks up the reflections. With any reflections, you must not confuse them with shadows. Shadows will move according to the light source. Sometimes they stretch out or go off to the side, depending on the strength of the light. Reflections, however, are always directly below the subject being reflected no matter what the light is doing. In this painting, you can see each mountain peak reflecting directly below in the water. It is always a direct vertical. With a mirror-image composition it is important to take the horizon line out of the middle. In this piece, I moved it above center to allow a bit more room below in the water area. If the sky had been more dramatic, I could have moved it below center to put more focus there.

Tip: Composition Checklist

Look through the pages of this chapter and see how each piece is handled. The most important thing to remember about composition is balance.

Think about the following as you lay out your paintings:

- **Balance:** Be sure the weight and size of the shapes and elements are evenly distributed and not all on one side. Offset your horizon line so it doesn't appear too top or bottom heavy.

- **Color and Value:** Be sure the colors and tones are evenly distributed. Too much light or dark in an area can throw off a composition. Colors should repeat around the page.

- **Pathway:** I like all the elements in my paintings to come together to lead the eye around the painting, and then back to center.

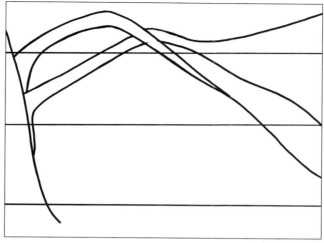

BALANCE

This line drawing is an example of good compositional balance.

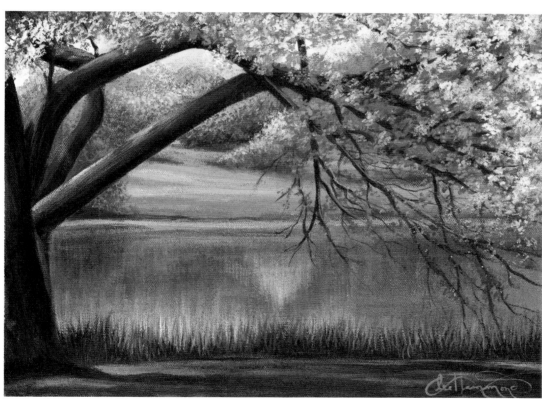

Springtime Reflections
9" × 12" (23cm × 30cm)

Colors Used: Alizarin Crimson, Burnt Umber, Cadmium Red Light, Cadmium Yellow Medium, Dioxazine Purple, Ivory Black, Prussian Blue and Titanium White

BALANCE IN ACTION

The horizon line is above center (at the top of the hill, not at the water's edge), with a mirror image of the colors of the trees reflecting below. The shapes of the large tree in the foreground act as a natural framework, leading the eye around the canvas. Look at how the weight of the tree trunk and branches on the left side are offset by the mass of flowers in the corner on the right side. It is a good distribution of compositional weight.

Using Thumbnail Sketches

We've seen how a good composition can look; now let's look at ones that aren't so good. Being able to see the problems in the early stages is very important, for once you start to paint, problems may be difficult to remedy. One way of creating a good composition is to create some thumbnail sketches first, before you begin to paint. Sketch out the elements of your painting on a piece of paper and experiment with their placement. I have selected three compositional items most often seen in landscape painting: the sky, some trees and a mountain. With only three items, it may seem as if it would be easy to balance and distribute them around the canvas, right? Not so fast! Here are some line drawings to show you what can go wrong.

TOO CENTERED AND CROWDED
This composition is balanced when it comes to the weight of the objects, but it still doesn't work. Everything seems to be too centered and it looks crowded. By placing the mountain so close to the top, there isn't much room for any sky effects either.

LOPSIDED
This time I turned the mountain into more of a hill to give myself some more room in the sky. To offset it, I moved the trees over to the right, but this doesn't work either. Now it looks lopsided!

OFF-BALANCE
This one is a lot better, but it doesn't work either! I like the placement of the mountain and the slight hill in the foreground, but the placement of the trees bothers me. The one in the middle throws the balance off!

MY FAVORITE

I moved the trees a little and completely removed the one in the middle. Now it looks roomy, and the weight of the layout is evenly distributed. This is definitely something that I can work with.

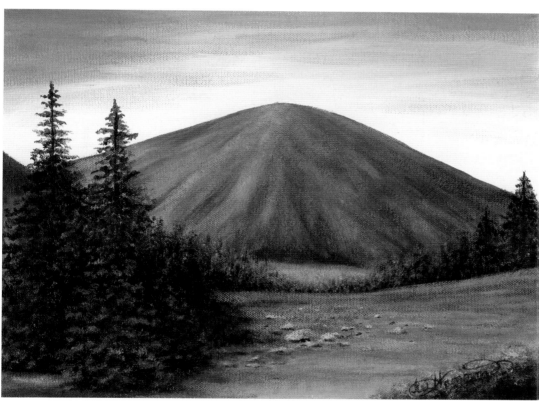

Mountain Meadow
9" × 12" (23cm × 30cm)

Colors Used: Alizarin Crimson, Cadmium Yellow Medium, Dioxazine Purple, Ivory Black, Prussian Blue and Titanium White

BALANCED PAINTING

The darkness of the trees on the left is balanced by the trees on the right, and the small bush in the lower right corner. Even though the mountain is centered, the horizon line is below center in the grass. The deep violet color of the sky in each corner helps offset the weight of the mountain.

There is some color balance going on here as well. The light side of the mountain (on the left) makes the darkness of the trees stand out. The dark side of the mountain (on the right) makes the light stand out in the grassy area. Look for these things when choosing how to arrange your next painting.

Atmospheric Perspective

Landscapes are made up of layers that create depth and the illusion of distance. When painting them, it is important to start with the background first and work forward from there. Everything is built from back to front. Things can then overlap, creating layers and the look of distance.

Atmosphere is an incredibly important element when taking on the job of painting landscapes. Atmosphere is not just the way the sky looks, but the way the surroundings appear.

The sky is the vehicle for weather, and the weather affects everything it touches. These two examples show you how atmosphere can alter the way we look at things. When looking into the distance, things farther away will appear to become lighter in value. This is because layers of the atmosphere are placed between you and the horizon. The farther away something is, the more it will take on the sky color.

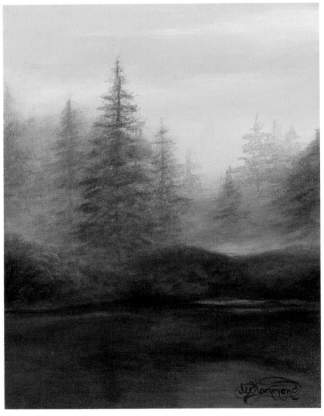

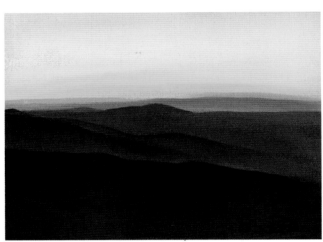

MORE SKY COLOR = DISTANCE
Here, the illusion of distance is created by the color of the hills. Notice how much lighter they get as they go back. In this complementary color scheme, the distant layers take on more of the yellow tones from the sky, making them fade into the sunset. The colors go from a rich, deep violet in the foreground to a shade of orange in the background, all due to the color of the sky and the distance between each hill.

Arizona Hills
9" × 12" (23cm × 30cm)

Colors Used: Alizarin Crimson, Burnt Umber, Cadmium Red Light, Cadmium Yellow Medium, Dioxazine Purple, Ivory Black, Prussian Blue and Titanium White

FEWER DETAILS = DISTANCE
The farther away the pine trees are, the more of the sky color they take on. Each one becomes a bit lighter as they go back. With distance and atmosphere, you also lose details. The farther away something is, the fewer details you will see.

Misty Pines
12" × 9" (30cm × 23cm)

Colors Used: Burnt Umber, Cadmium Yellow Medium, Dioxazine Purple, Ivory Black, Prussian Blue and Titanium White

Skies: Cirrus

Let's practice painting some cloud formations, starting with the easiest first—the cirrus clouds. As with any sky, the background color should be done first. It is important that this be done well, with the right consistency of paint. You don't want it to be so thin that it looks like watercolor. You also do not want it to be too thick because the speckles of the canvas will show through.

Materials List

PAINTS
Prussian Blue, Titanium White

BRUSHES
1-inch (25mm) flat, no. 2 liner

CANVAS OR CANVAS PAPER
Any size

Tip: Easy on Prussian Blue

Prussian Blue is highly potent, so it requires very little to create sky blue. Just a slight touch of it will colorize a large puddle of white paint. Proceed with caution, or you will end up with way more paint than you need, having to add more and more white to tone it down.

1 Basetones
With a 1-inch (25mm) flat, apply an even sky color with smooth horizontal strokes; use Titanium White with a tiny dab of Prussian Blue. Apply the paint smoothly and evenly. This stage must be complete before applying the clouds. Once the paint has dried, apply very thin wisps of pure white paint with a no. 2 liner. Use quick, light, horizontal strokes to keep them very thin and hairlike.

2 The Awkward Stage
Air masses move horizontally, and the look of your clouds must follow that direction. With the same no. 2 liner, apply more strokes of the wispy clouds with quick horizontal strokes to build up the cloud layers.

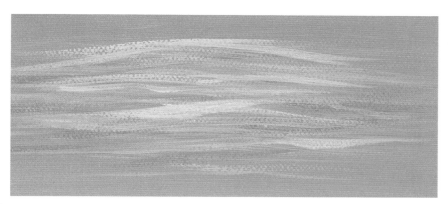

3 Finish
Add more layers to the clouds, using the same types of strokes, layering them all together. Your strokes should vary in size to keep them from looking like stripes. Try this exercise once more using different colors.

Skies: Stratus

Painting stratus clouds is similar to the previous exercise. Cirrus clouds have the same characteristics, but stratus clouds are a bit heavier and more filled in. Follow along to create these pretty stratus formations.

Materials List

PAINTS
Cadmium Yellow Medium, Cadmium Red Light, Dioxazine Purple, Titanium White

BRUSHES
1-inch (25mm) flat , no. 2 round sable or synthetic

CANVAS OR CANVAS PAPER
Any size

1 Basetones
Mix a pretty pale yellow using Cadmium Yellow Medium and Titanium White. Apply this to the entire sky area with a 1-inch (25mm) flat, using horizontal strokes and a smooth and even application.

When that layer is dry, begin the cloud formations using a no. 2 round sable or synthetic, quick horizontal strokes and a Dioxazine Purple and Titanium White mixture. Because yellow and violet are opposite colors, the violet appears grayed down.

2 The Awkward Stage
Apply streaks of alternating colors.

With the same no. 2 round begin streaking horizontal strokes of a salmon color (Cadmium Red Light with a touch of white) into the lavender strokes already there. Add more lavender as needed for more volume.

3 Finish
Build up layers of horizontal strokes for volume. Continue layering these colors with the same no. 2 round sable or synthetic, alternating the colors as you go to build up the look of layers.

Skies: Cumulus

Cumulus clouds are very full and fluffy. Usually their tops are very white, and their underbellies are a shade of gray. They can hang in the sky alone or be seen in large groups. You will see them in every size and shape. Higher-level clouds appear to the eye to be still, while cumulus clouds can be watched as they move silently across the horizon.

Materials List

PAINTS
Ivory Black, Prussian Blue , Titanium White

BRUSHES
1-inch (25mm) flat, no. 4 filbert or flat

CANVAS OR CANVAS PAPER
Any size

1 Basetones
With a 1-inch (25mm) flat, paint the entire sky light blue (white and a very small amount of Prussian Blue). Remember, Prussian Blue is extremely potent. Apply a smooth, even coverage of paint using horizontal strokes. Once this layer is completely dry, begin creating the fluffy shapes of the cumulus cloud with a no. 4 filbert, Titanium White and curved brushstrokes.

2 The Awkward Stage
With a no. 4 filbert and using the same curved stroke, build up the density of the paint to make the cloud even whiter and fluffier. Allow some sky blue to still peek through to make the cloud look airy and not too filled in.

3 Finish
Mix a blue-gray by mixing a small touch of Ivory Black into Titanium White, then adding a tiny touch of Prussian Blue. Using a no. 4 filbert, add the dark shadow underbelly of the cloud. Vary the color, making some areas a bit lighter than others to keep it airy.

Silhouettes: Tree Basics

Silhouettes are often seen in nature due to backlighting. This lighting illuminates everything in the distance while making everything in the foreground appear colorless and dark. Here are some quick exercises to give you the basics for painting trees in silhouette form. It is all in the brushstrokes and observing the shapes. All trees start with a vertical line that represents the trunk. Everything builds off of that. Depending on the size and scale of your painting (larger paintings require larger brushes) paint in the trunk with a pulling motion and a round (thicker trunks) or liner (thinner trunks) brush. Add a bit of water to your paint to create an inklike consistency. It is important that when pulling the brush that the paint moves fluidly.

Materials List

PAINTS

Ivory Black

BRUSHES

no. 2 liner, no. 2 round, no. 4 filbert

CANVAS OR CANVAS PAPER

Any size

Pine Tree

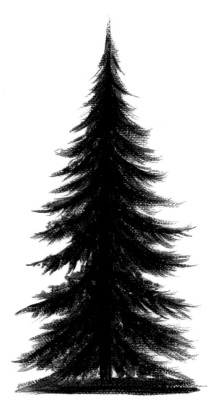

1 Start at the base with the no. 2 liner and pull upward so the line tapers, getting smaller as it goes up. Once you have painted in the vertical guideline that represents the trunk, observe the direction of the branches. Add the limbs in curved, downward-tapered strokes. This tree's branches tilt downward first, then flip up at the ends. Using the same brush, add the foundation for the branches.

2 Still using the liner and quick brushstrokes, slowly fill in the shapes of the branches. Remember that this is a silhouette; you will not see the details. Make the ends of the branches look wispy, not solid. It should look like there are pine needles sticking out

Fir Tree

1 This tree is similar in shape to the pine, but it is not as filled in. Start with an upward pull to create a tapered vertical line. Once the trunk is created, add the limbs with curved, upward strokes.

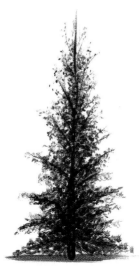

2 Use stippling (dabbing with a brush or sponge (see Ceating Texture in chapter three) to fill in. In some areas, the paint becomes worn off and goes on lighter, as in drybrushing. This keeps it looking natural. In these areas you can add some extra tiny lines to make the illusion of little limbs. If you get carried away, as I sometimes do, just mix some of the background color and stipple back into the black, making it look open again.

Leafy Tree

1 Pull upward with a vertical stroke and a no. 4 filbert for the trunk. Separate the trunk into two large limbs. Use a round or liner to add branches off these with upward strokes. Allow the strokes to taper at the ends, getting smaller as they go up.

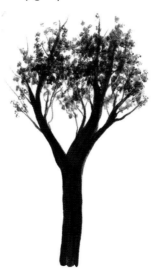

2 Fill in the foliage by dabbing with a no. 2 round. This is much like the stippling on the fir tree. The light and dark patterns of the clumps of leaves can make or break the look of the tree. Allow the light to come through in areas. If you do fill in too much, just mix more of the color behind the tree and carefully dot that color back in to open up the tree.

Palm Tree

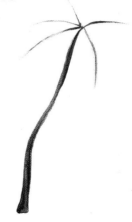

1 Tropical trees, such as the palm, have their leaves coming out the top of the trunk. Apply the trunk with the same upward stroke as before and a liner. With the liner or round brush and tapered strokes, create the thin center vein of the palm leaf.

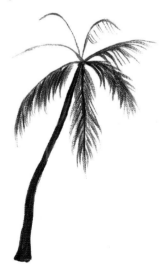

2 Add the thin lines coming off the main vein of the palm leaves. The leaf of the palm is made up of many thin lines all coming off of the main vein. Depending on the direction the leaf is facing, these small lines may seem parallel to one another or they may overlap. When they overlap, they seem to fill in.

Trees and Plants: Foliage

Deciduous trees look very different from season to season. Through winter, they may have only branches. In the spring the leaves come back and stay full throughout the summer. The foliage fills in, hiding many of the small branches. You've had some practice creating tree branches. Let's practice filling them in a bit.

Materials List

PAINTS

Cadmium Yellow Medium, Ivory Black, Prussian Blue, Titanium White

BRUSHES

no. 2 liner, no. 2 round

CANVAS OR CANVAS PAPER

4" × 9" (10cm × 23cm)

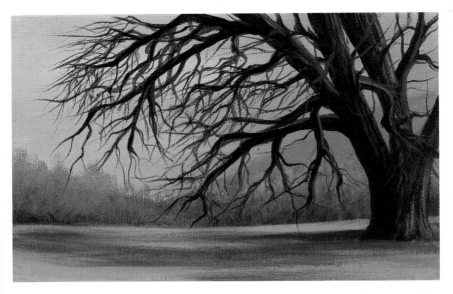

The grass had turned green, but the leaves hadn't formed yet. A deciduous tree loses its leaves every year. In the fall and winter, the branches are bare like this. The tiny branches and limbs are apparent.

Early Spring
4" × 9" (10cm × 23cm)

Tip: Look for Light

It is really light effects that make a painting great. When selecting your photo references, look for lighting situations that will create interest. Don't settle for ordinary when lighting can provide you with spectacular!

BRANCHES: DON'T!
These lines are too thick and too much the same everywhere. It looks thick and contrived. These were painted with a no. 2 round, which is too large for delicate lines.

BRANCHES: DO!
These tree limbs look much better. They were created with the no. 2 liner, which makes the lines taper at the ends. The varying sizes of the limbs makes this look much more realistic.

1 Medium Colors

Foliage is made up of light, medium and dark colors. Start with the medium colors first, using a dabbing motion.

2 Darker Colors

Dab the darker color for the look of shadow effects and volume.

3 Lighter Colors

Dab on the lighter color for the look of reflected light. Repeat the colors until you like the look. Sometimes it takes many layers to get it right!

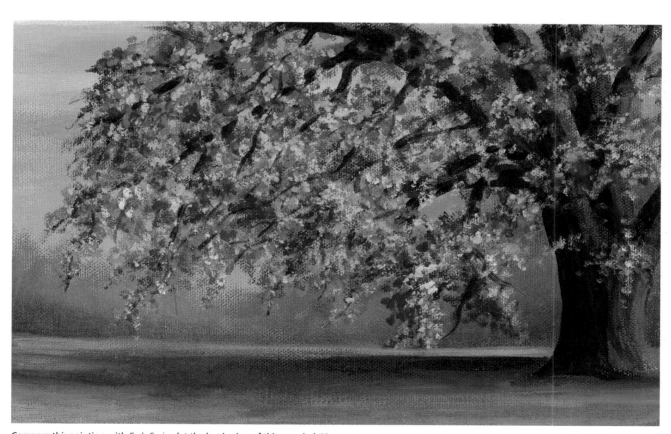

Compare this painting with *Early Spring* (at the beginning of this exercise). You can see that they are basically the same scene but at different times of year.

Late Spring
4" × 9" (10cm × 23cm)

Trees and Plants: Bark

Now let's try an easy approach to painting tree bark with this lesson. This basic method can be used for many types of trees.

Materials List

PAINTS
Burnt Umber, Cadmium Red Light, Ivory Black, Titanium White

BRUSHES
no. 2 liner, no. 2 round bristle

CANVAS OR CANVAS PAPER
Any size

1 Medium Colors

Mix a small amount of white into Burnt Umber to create a medium brown. Apply it in the shape of a cylinder, using a no. 2 round bristle brush. Tree trunks and branches are made up of the long cylinder shape.

2 Dark Colors

Using a no. 2 round, mix a small amount of black into the Burnt Umber to make a very dark brown. Apply this with a drybrush application to create the shadow side of the trunk and to add the rough texture of the tree bark.

3 Light Colors

Add a small dab of Cadmium Red Light into the medium-brown base color, and add a bit of white to that to lighten it. Add this color with a dry brush on the highlight side. Add more of the white to intensify the light source and to build up the look of texture.

Trees and Plants: Birch Tree

I love the look of the birch trees standing out against the darker colors of a wooded area. It doesn't matter what the season, they seem to stand out against everything else. They are really just long cylinders or tubes. The secret to creating believable birch trees is all in the bark.

Materials List

PAINTS
Burnt Umber, Cadmium Red Light, Cadmium Yellow Medium, Ivory Black, Titanium White

BRUSHES
no. 2 liner, no. 2 round bristle, no. 4 flat

CANVAS OR CANVAS PAPER
Any size

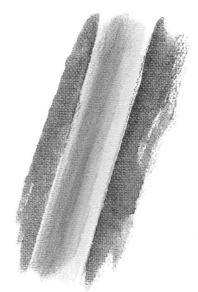

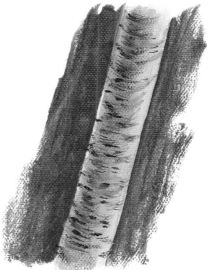

1 Basecoat
With a no. 2 round bristle, base in the tree trunk with white.

2 Earth Tones
Since the tree trunks are light, you must have some color around them. Scrub in some earth tones, as shown here, with a no. 4 flat brush. Use Burnt Umber, Cadmium Red Light and Cadmium Yellow Medium.

3 Finish
Create a warm gray mixture with white, black and a touch of Cadmium Red Light. Create the shadow edge as shown. Add the black surface details with a small liner brush.

Trees and Plants: Spruce

Let's try a quick study of a spruce tree before moving on. This tree is simple in both its shape and color.

Materials List

PAINTS
Cadmium Yellow Medium, Ivory Black, Prussian Blue, Titanium White

BRUSHES
no. 2 liner, no. 2 round bristle

CANVAS OR CANVAS PAPER
Any size

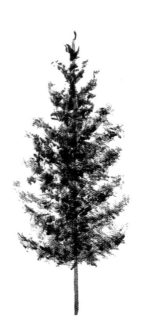

1 Trunks and Limbs
With a no. 2 liner and Ivory Black that has been thinned down with a little water, pull up the strokes for the trunk and limbs, as shown.

2 Foliage
With a no. 2 round bristle, lightly dab the black into the tree to start the look of foliage. Use thicker paint for this application.

3 Hint of Color and Shadow Below
Mix a blue-green for the tree's hint of color. Begin by adding a small amount of Prussian Blue into some white. Then add a small amount of Cadmium Yellow Medium into that. Add more white, if necessary, to create the pastel tint. Using the same no. 2 round bristle, lightly dab this color on top of the black already applied. If it gets too heavy, simply add some more black mixture into it to open it up. Create a very light tint of the blue-green color by adding more white, and apply a small amount on the tips of the branches for a soft look. Add the shadow underneath for a realistic look.

Trees and Plants: Flowers

In landscape painting, adding flowers is about creating the illusion of flowers rather than painting single flowers in great detail. Stay loose while you paint. If you get too caught up in the details, trying to put in more than you need, you may end up with a very cartoonlike outcome.

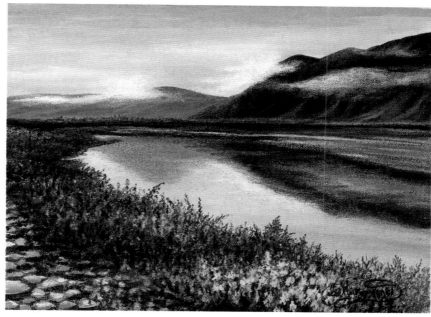

FLOWERS IN A LANDSCAPE

Flowers in a landscape are generally seen at a distance, meaning you won't need to paint them in great detail. This painting suggests a lot of flowers along the lake. They were created using the dabbing technique with many layers of colors.

Floral Shores
9" × 12" (23cm × 30cm)

Colors Used: Alizarin Crimson, Burnt Umber, Cadmium Red Light, Cadmium Yellow Medium, Dioxazine Purple, Ivory Black, Prussian Blue and Titanium White

1 Once the main color of the bush has been scrubbed in using the dark shades of green, mix a deep pink with Alizarin Crimson and Titanium White. With a no. 2 round sable or synthetic, dab small controlled dots of color over the green. Use a light touch to make more distinct shapes.

2 Continue to dot in flowers using different shades of pink with many layers and varying shades. Alternate from pure Alizarin Crimson to pale pink made by adding a lot of white. With a liner and black, create the small limbs going in and out of the flowers. Use a stippling or dabbing approach to create the flowers.

Tip: Flowers in a Bush

Allow the flowers to look like separate clumps and separate branches. You don't want a big pink blob. If you fill in too much, let the area dry and then re-apply some of the greens to open it back up.

Rocks and Mountains: Peaks

Mountain scenes are a favorite subject in landscape painting. This simple exercise will give you confidence in painting snowy peaks.

Materials List

PAINTS
Dioxazine Purple, Ivory Black, Prussian Blue, Titanium White

BRUSHES
1-inch (25mm) flat, no. 2 round bristle, no. 2 round sable or synthetic

CANVAS OR CANVAS PAPER
Any size, but 9" × 12" (23cm × 30cm) was used for this piece

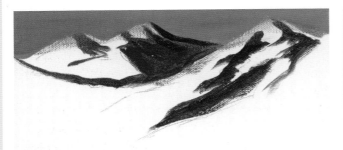

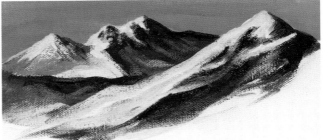

1 Begin with the sky color. Create the shapes of the mountain peaks with black. Fill in the shadows on the right. Paint the sky area with the standard sky blue color, created with Titanium White and Prussian Blue. Use the 1-inch (25mm) flat for this. With a no. 2 round sable or synthetic, carefully paint in the shapes of the peaks with pure black. Notice how the light is coming strongly from the left and all of the cast shadows are on the right. Create a blue-gray color by taking white and adding a small amount of Prussian Blue and a dab of black. Using the no. 2 round, add the shadow to the right side of the mountain peak on the left.

2 Add the snow to the peaks and then drybrush the pastel colors for realism. Use the no. 2 round sable or synthetic and add pure white to the light areas of the mountains. Allow the edges of the white to become a dry-brush effect as it meets the black. Add a tiny bit of Prussian Blue to the white and drybrush this over the white in some areas. Be sure the white is completely dry first. Use a no. 2 round bristle for this. Add a touch of Dioxazine Purple to the light blue mixture, and add the lavender to the peaks on the left. Again, allow this to be somewhat drybrushed on.

Rocks and Mountains: Rocks

Before we can attempt to paint a rocky scene, we must first have some practice painting rocks in general. This small exercise will show you what to look for and how to create a realistic-looking rock or stone.

Materials List

PAINTS
Burnt Umber, Cadmium Red Light, Ivory Black, Titanium White

BRUSHES
no. 2 flat, no. 2 round sable or synthetic

CANVAS OR CANVAS PAPER
Any size

1 Basecoat
Using a no. 2 round, lightly sketch in the basic shapes. Mix a small amount of Burnt Umber into some Titanium White. Then add a touch of Cadmium Red Light for a light brown and paint around the shapes. Add a touch of Cadmium Red Light to some white for a peachy color and base in the rocks. Add a small amount of Ivory Black to the light brown color, and add this under and around the rocks for contrast.

2 The Awkward Stage
The rocks resemble the sphere in chapter three under Five Elements of Shading. With a no. 2 round sable or synthetic, paint in the shadows behind and beneath the rocks with pure Burnt Umber. Drybrush some of this color onto the right side of the rocks, too. Leave a light edge along the bottom to represent the reflected light.

Mix a tiny bit of Burnt Umber into Titanium White for a warm light gray. Use the no. 2 round to apply this on the left side of the rocks where the light is hitting them. Add a few smaller stray rocks around the large ones. Then add some Ivory Black to the Burnt Umber and deepen the cast shadows under the rock.

3 Finish
Use a no. 2 flat to drybrush darker values into the shadow sides, using Burnt Umber. Drybrush Titanium White into the full light areas for highlight. Deepen the color of the ground by drybrushing it with Burnt Umber. Make the little rocks stand out more by adding Titanium White to them.

Water

Water is a constant in nature. There are just a few simple rules to making water look realistic.

- Remember that water is highly reflective. Any colors above or around it show up in the water. Water is not always blue. It is only blue if the sky is blue and reflecting down into it.

- Water is a moving surface. The surface can range from smooth to rough. The surface moves horizontally much like the atmosphere.

- You can create water with light, medium and dark tones, like anything else.

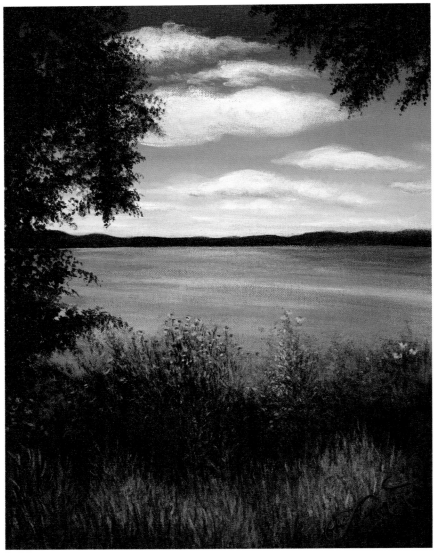

Wildflowers on the Lake
16" × 12" (41cm × 30cm)

Colors Used: Alizarin Crimson, Cadmium Red Light, Cadmium Yellow Medium, Ivory Black, Prussian Blue and Titanium White
From a photo by Pat Thomson

Water: Light and Dark

The look of water depends largely on what the light is doing in the scene, as is shown in the following two exercises.

Materials List

PAINTS
Ivory Black, Prussian Blue, Titanium White

BRUSHES
1-inch (25mm) flat, no. 2 linerm no. 2 round sable or synthetic

CANVAS OR CANVAS PAPER
Any size

Water in Bright Light

1 Basecoat
With a 1-inch (25mm) flat, base in an area with light blue (Titanium White with a touch of Prussian Blue). Apply this loosely with horizontal strokes. You can see the streaks, and this is fine.

2 The Awkward Stage
With a deeper shade of the same blue, continue adding streaks horizontally, going from the top downward. Use the same flat. You can see how the look of the water is now being developed.

3 Finish
Complete this exercise with a bit more control. Using a no. 2 liner, carefully add the tiny horizontal streaks over the other layers. Use pure Prussian Blue at the top and work down toward the center. When you get to the halfway point, switch to Titanium White and continue the process. Go back and forth with the dark blue and white until your painting looks like mine. Add the white streaks for reflections.

Darker Water

This second exercise is done the same way, but has a very different look. This water is much darker, with less light reflecting off of the surface. The movement of the water is more evident, suggesting a body of water with waves.

1 Basecoat
With a 1-inch (25mm) flat, loosely base in an area with light blue (Titanium White with a touch of Prussian Blue), using horizontal strokes. Create a darker version of the blue and apply it with sweeping horizontal strokes.

2 The Awkward Stage
Continue streaking the darker blue color with loose sweeping strokes. Add a small amount of Ivory Black to the Prussian Blue and add it to the top area of the water. Continue adding wavy streaks to create movement.

3 Finish
Switch to a no. 2 round sable or synthetic and continue adding the streaks with the dark blue mixture. Use wavy lines to represent the wave movement. Create a lighter blue by adding some Titanium White to the dark blue mixture, and add the lighter waves with the same wavy lines. Deepen the tones with dark blue and add the lighter waves.

Water: Reflections

I mentioned previously that the water is highly reflective, and it can create mirror images. This small project will give you practice creating a mirror image. After you complete this, try painting the mirror-image mountain earlier in this chapter under Composition Examples. Everything you need to complete it is in this exercise.

Materials List

PAINTS
Dioxazine Purple, Ivory Black, Prussian Blue, Titanium White

BRUSHES
1-inch (25mm) flat, no. 2 round sable or synthetic

CANVAS OR CANVAS PAPER
Any size

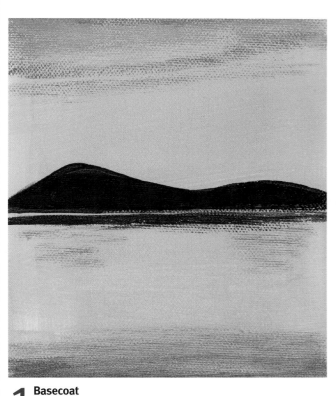

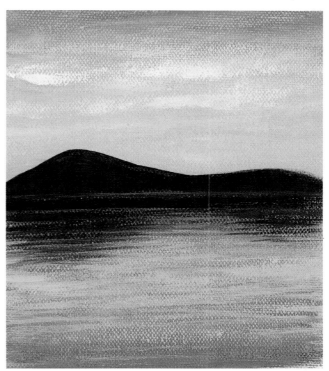

1 Basecoat
Base in the entire canvas with a layer of the sky blue mixture (Prussian Blue and Titanium White), using a 1-inch (25mm) flat. With Ivory Black and a no. 2 round sable or synthetic, fill in the mountain range. Move down to the water and start the mirror image of the mountain. Allow a small line of blue to separate the mountain from the water. Create a violet-blue color by adding some Dioxazine Purple to the sky blue mix. Apply it with the same brush to the upper part of the sky. Repeat this color along the bottom of the water. Also apply a small amount of this below the mountains as a guide to the reflections in the next step.

2 Finish
Streak some lavender (Titanium White and a small amount of Dioxazine Purple) clouds into the sky with horizontal strokes. Add some pure white clouds over the lavender ones. Keep it simple. Use the no. 2 round to add the clouds, allowing them to fade as they near the horizon line. Move down to the water and streak some of the lavender into the water with horizontal strokes. Use the same round for this. Create the reflection of the mountain with Ivory Black and horizontal strokes. Streak the lighter colors over it to make the reflections.

Silhouettes: Cloudy Sky

Now you're ready to put several elements together to create a complete scene. This is a brilliant silhouette, yet it is fairly simple to paint. The warm colors are a combination of yellow, orange and red. Because of the vivid colors, the silhouetted trees almost seem to glow in the foreground. Follow along to create this wonderful scene. Refer to the earlier part of this chapter for the basics of painting tree shapes.

Materials List

PAINTS
Alizarin Crimson, Cadmium Red Light, Cadmium Yellow Medium, Ivory Black, Titanium White

BRUSHES
1-inch (25mm) flat, nos. 1 and 2 liner, no. 2 flat bristle, no. 2 round sable or synthetic

CANVAS OR CANVAS PAPER
12" × 16" (30cm × 41cm)

OTHER
mechanical pencil

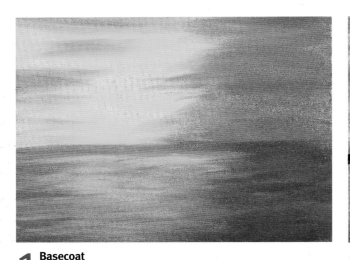

1 Basecoat
With a pencil, draw the horizon line slightly below the center point of the canvas. This divides the background from the foreground. With a 1-inch (25mm) flat and with wide and sweeping horizontal strokes, apply a layer of Cadmium Yellow Medium across the sky and water areas. Add a small amount of Cadmium Red Light to the yellow to create a nice orange color. Using the same brush, add the orange mixture with the same type of brushstrokes. This will create the look of cirrus and stratus clouds and water texture. This must be done before adding the trees. Add a small amount of Alizarin Crimson to the Cadmium Red Light to make a vivid red color. Add this to the water area on the right side.

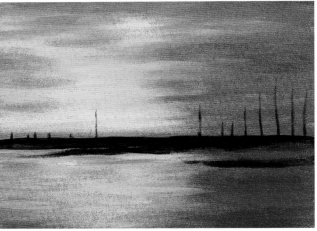

2 The Awkward Stage
With Ivory Black, add the ground in the horizon. With a no. 2 liner, add the vertical strokes that represent the tree trunks. As you can see, the reflections in the water have not yet been addressed. This is because they must be mirror images of the trees. We don't know what they will look like yet, so the trees must be done first. The trees and reflections in your painting may not look like mine, so adjust accordingly.

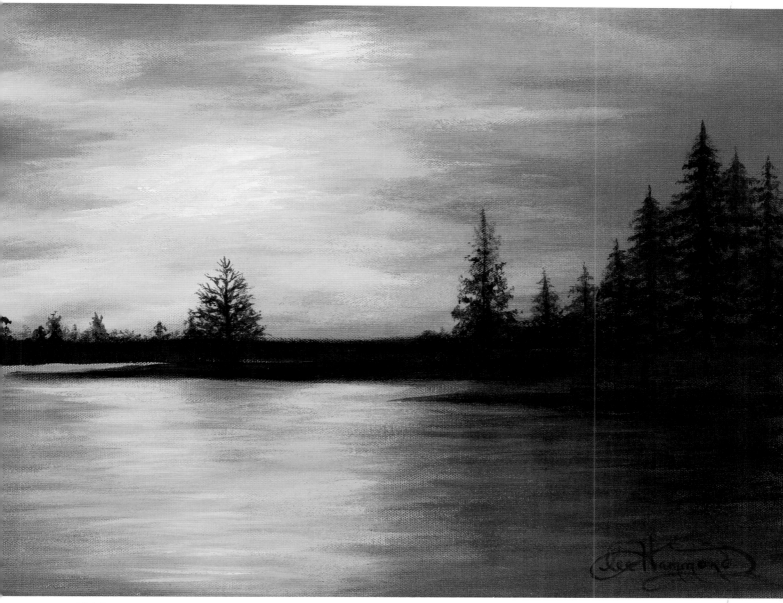

3 Finish

For the trees, we are merely creating an illusion with not much detail. Dab in the shapes of the trees with a no. 2 round, looking at them as abstract shapes. Do not get caught up in what you know the details would look like. Shut off your thinking and proceed with artistic freedom. Dilute the black paint a bit to keep it from building up and appearing too heavy and to allow the colors of the sky to peek through. The tree just to the left of center is made up of small lines that represent limbs. Do this with a no. 1 liner. Use a very light touch and quick flicks of the wrist, allowing the lines to taper at the ends for a wispy look. Do a small amount of dabbing with the liner brush towards the bottom to make it look full. With a no. 2 flat bristle, create the reflections of the trees on the right side. Just a representation is fine. Use horizontal strokes, once again keeping the paint a bit thin so it looks more transparent. Mix some white into the Cadmium Yellow Medium and add a few lighter cloud streaks to the sky. Add some of them to the water as well for sparkle.

Silhouettes: Blended Colors

This is a fun project that will give you practice blending colors. Follow along to create this study of primary colors (red, blue and yellow).

The previous project had a streaky, cloudy sky. This project is an example of a graduated color scheme, where the colors are very smooth and blended together. Working with blended colors can be more difficult because of the tendency for acrylic paint to dry so quickly. To create an even blend of color, mix larger amounts of paint, keeping it very fluid and moist as you work. Strive for a fine balance of paint and water because you do not want it to look transparent and streaky. Practice creating the blends before you begin. And if you're not confident painting the tree shapes yet, take the time to practice on a separate sheet of canvas paper.

Materials List

PAINTS

Alizarin Crimson, Cadmium Red Light, Cadmium Yellow Medium, Ivory Black, Prussian Blue, Titanium White

BRUSHES

1-inch (25mm) flat, no. 2 flat bristle, no. 2 liner, no. 2 round sable or synthetic

CANVAS OR CANVAS PAPER

16" × 20" (41cm × 51cm)

OTHER

rag (optional)

1 Basecoat

Keep the paint moist and fluid throughout this step. Use a flat brush and sweeping horizontal strokes to blend the colors. Use a flat big enough to cover your canvas with relatively few strokes. For a smaller painting, a 1-inch (25mm) flat will do. For larger paintings, you may want to use a 1½-inch (38mm) or a 2-inch (51mm) flat.

Mix a dab of Prussian Blue into a sizable blob of white to create a medium blue. Apply the paint from side to side, making sure it is smooth and even. With the paint still wet, add a small amount of white into the blue mixture and work downward. Blend back and forth until the colors fade into one another for a gradual blend.

While the blue is drying, mix some white into a puddle of Cadmium Yellow Medium. Overlap the blue mixture. If your paint is still wet, it will create a green look as seen here. Ignore that for now and continue to work down.

Add some Cadmium Red Light into the yellow mixture and continue to blend this into the sky, allowing the orange and the yellows to merge.

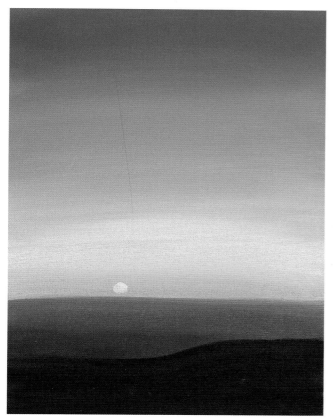

2 The Awkward Stage

Continue to blend the colors until they are smooth and gradual. Add Cadmium Red Light below the yellow. Once the paint has dried, use the Cadmium Yellow Medium and white mixture from Step 1 to drybrush over the greenish area we made between the blue and the yellow. This will to soften it.

With Cadmium Red Light, paint in the area below the orange. These colors remain distinct and not blended. Add a small amount of Alizarin Crimson to this, allowing the red to become darker toward the bottom. With Ivory Black, fill in the foreground, creating a slight hill shape against the red. With a small amount of pure white, add the little circle into the orange area to create the setting sun.

3 Finish

Paint vertical strokes for the trunks with a no. 2 round sable or synthetic. Each tree is at a different distance, with the one on the left being closest to you. As they recede, they become smaller and shorter. Make sure that the trunks are different heights and thicknesses.

Use the Silhouettes: Tree Basics exercise earlier in this chapter as a guide to create two tree types, using black to paint them in. The tiny ones on the far right are like fir trees. The ones in the middle are leafy trees. Use the no. 2 liner to create the small tapered lines of the delicate tree limbs.

Next, drybrush in the sun rays using a no. 2 flat and a small amount of Cadmium Red Light. Wipe off some of the paint onto your palette or a rag before you begin if you need to. With strokes that radiate outward like spokes on a wheel, drag the color down and over the darker colors below and across the trunks of the main trees.

A Study of Primary Colors
20" × 16" (51cm × 41cm)

Trees and Plants: Red Autumn

Now we can practice painting a tree with lots of beautiful foliage. But before we can get to that, we must create everything around it first. To paint a tree such as this, you must have the entire background done first, so you are not painting *around* the tree later.

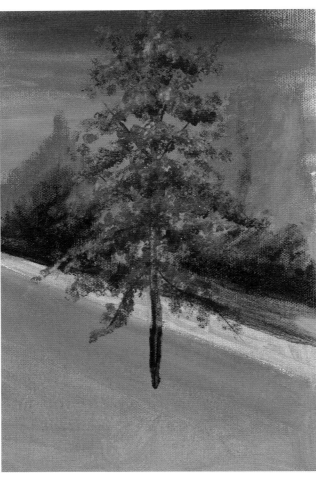

Materials List

PAINTS
Alizarin Crimson, Burnt Umber, Cadmium Red Light, Cadmium Yellow Medium, Ivory Black, Prussian Blue, Titanium White

BRUSHES
1-inch (25mm) flat, no. 2 flat bristle, no. 2 liner, no. 2 round bristle

CANVAS OR CANVAS PAPER
12" × 16" (30cm × 41cm)

OTHER
mechanical pencil, small piece of cellulose kitchen sponge (optional)

1 Basecoat
THE SKY

Draw in the horizon line slightly below the center mark. Mix a small amount of Prussian Blue into white, and apply it with a 1-inch (25mm) flat, using horizontal sweeping strokes. For subtle clouds, add a bit of white and let it become streaky.

THE FOREGROUND

Add Cadmium Yellow Medium to the sky mixture to create chartreuse-green. With the 1-inch (25mm) flat, apply this to the foreground. Create the sidewalk with white and a touch of black.

THE BACKGROUND TREES

Scrub in the illusion of background trees, using this same chartreuse green mixture and a no. 2 flat bristle. Vary the colors by adding more yellow for the lighter ones and a touch of Burnt Umber for the darker one on the left. With Burnt Umber, add the darker color in front of the background trees and along the sidewalk.

THE MAIN TREE

Apply the trunk of the tree with a no. 2 liner. Slightly dilute Burnt Umber and Alizarin Crimson, and pull the stroke upward from the base. Apply small strokes to create the branches. With a no. 2 round bristle, dab in the look of foliage. Start with Burnt Umber for the darker colors underneath. Add a small amount of Cadmium Yellow Medium to the Burnt Umber for the lighter brown. Add that on top with the same dabbing method. Lighten the color once more by adding a small amount of Cadmium Red Light for an orangey hue and dab this on. Add some pure Cadmium Yellow Medium to the mix for some highlights.

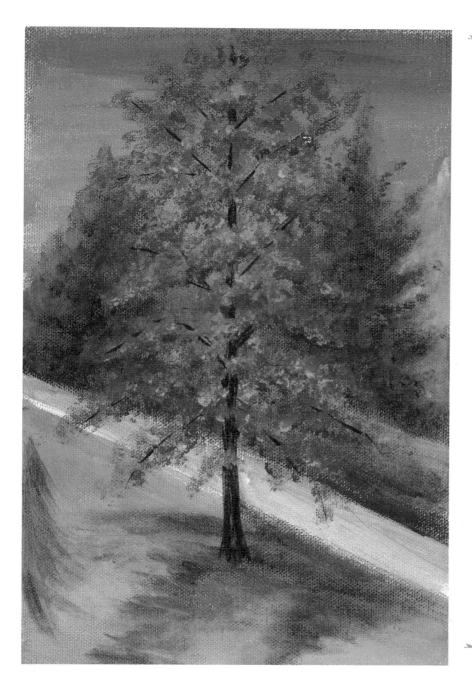

Tip: Cast Shadow Reminder

The cast shadow is always on the opposite side from the light source. How little or how much of a cast shadow a tree produces is governed by the light source and the direction it is coming from.

Tip: Dabbing Leafy Trees

Dabbing is the primary technique used for painting this type of leafy tree. Try a small piece of sponge to dab on the color. Tearing the sponge, rather than cutting it, produces a ragged edge that creates irregular shapes. Vary the shapes. Leaves appear in clumps. They fill in and overlap one another, creating groups and layers with areas of sky that show through, and you can see the branches of the tree going in and out of the leaves. If you fill in things too much, mix more of the sky color and dab it back in to open it up a bit. I usually start with the darker colors first—the colors that are seen in the darker, recessed areas—then dab the medium and light colors on top of that to create the layers. Layer the colors back and forth, adding dark and light colors until you like the way it looks.

2 The Awkward Stage
THE BACKGROUND TREES

Build up the background trees a little more using a no. 2 flat bristle. Create darker shades of green by mixing some black into the light green color you used first. Use the scrubbing technique for adding more color. Because the trees are in the distance, they lose the small details.

THE MAIN TREE

Once the background trees are complete, add more layers to the main tree using a no. 2 round bristle. Use the same colors as before, alternating dark and light. Use a kitchen sponge for a more textured look.

THE SHADOWS

Add the shadow below the tree with a dark green mixture (Cadmium Yellow Medium with a touch of Prussian Blue and a bit of black), using a no. 2 flat bristle. Also use this to suggest the pine tree peeking in on the left. Add a touch of the reddish colors below the tree on the ground next to the shadow. Use the same colors as you did for the foliage.

3 Finish

Finishing a painting is all about adding layers.

THE BACKGROUND TREES

Add a bit more highlighting and texture. Don't overdo it, for the trees must look farther away. Add a small amount of Cadmium Yellow Medium to the trees on the right.

THE MAIN TREE

Once the background trees are complete, continue filling in the main tree, allowing it to overlap the trees in the background and steal the show. Add a bit of highlighting to the tree trunk to make it look textured using a bit of the light green used for the ground. Add some pure Cadmium Red Light for more color.

THE GROUND

To detail the ground to make it look realistic, use a no. 2 flat bristle and scrub in various colors using a dry-brush application for a speckled appearance. Start with the lighter colors first (lighter green and yellow tones). Apply them over the chartreuse color already there. Return to the shadow area and scrub in some darker colors (black mixed into Burnt Umber) on top of the dark green already there. Don't let this fill in too much. As with foliage, you must be able to see the colors underneath peeking through. Reflect some red tones (Cadmium Red Light and Cadmium Yellow Medium) into the ground also.

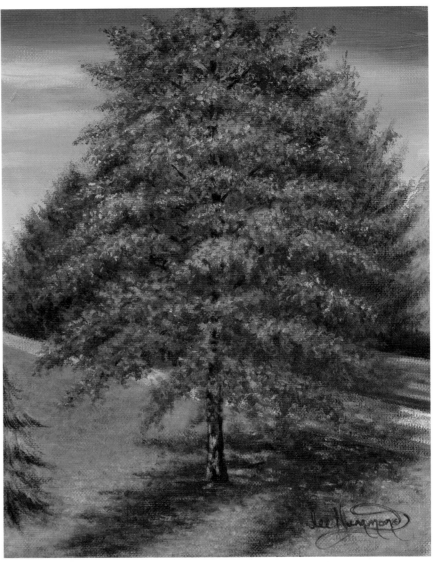

Red Autumn Tree
16" × 12" (41cm × 30cm)

Trees and Plants: Snowy Pines

A painting does not have to be complicated to be pretty. Sometimes simple can look elegant and soothing to the eye. I like this piece for its tranquility. It appears calm and peaceful due to its simple composition and pale hues. Follow along to create this simple snow scene. The bulk of this painting was created with the blending technique.

Materials List

PAINTS

Alizarin Crimson, Burnt Umber, Dioxazine Purple, Ivory Black, Prussian Blue, Titanium White

BRUSHES

1-inch (25mm) flat, no. 2 liner, no. 2 round bristle, no. 2 round sable or synthetic

CANVAS OR CANVAS PAPER

11" × 14" (28cm × 36cm)

OTHER

mechanical pencil

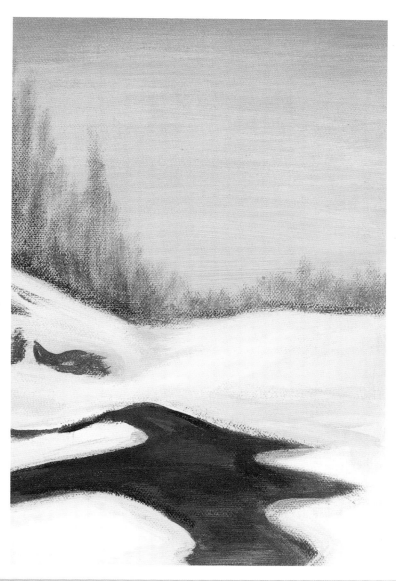

1 Basecoat

THE SKY

Draw the horizon line slightly above the center mark. Paint the sky with long strokes, using a smooth application of paint and a 1-inch (25mm) flat.

The sky is darker at the top, gently fading in color as it approaches the horizon line. Begin with the basic Prussian Blue and white sky mixture. At the top where it is darker, add a tiny bit of Dioxazine Purple. As you move down, keep adding more white until it fades into the horizon line.

THE BACKGROUND TREES

Mix a deep blue-gray color by adding black into the darker sky color used before. Drybrush in the illusion of background trees along the horizon line, using a no. 2 round bristle.

THE FOREGROUND

Using the same color you used for the trees, fill in the shape of the pond and the rocks, using a no. 2 round sable or synthetic. Fill in the entire snow area with white. Add a small amount of the lighter sky-blue color, and create the look of subtle shadows.

2 The Awkward Stage
THE BACKGROUND TREES

Use the scrubbing/dry-brush technique to make the distant trees look farther away and a bit out of focus. For more depth and distance, apply a small amount of brownish pink in the back of them using white, a touch of Alizarin Crimson and a very small touch of Burnt Umber. With a no. 2 round bristle, scrub in this light pink color over the darker color you already applied. With black and Burnt Umber mixed together, create the illusion of trees in the background. Scrub in the ones on the left. Use a no. 2 liner on the right for more detail. Dilute the paint a little. Create a light gray color by mixing black and white. Add some water to make the mixture fluid. Using the no. 2 liner, pull up the tree trunks of the trees on the left. Add a bit of this color to the rocks below them.

THE SNOW

Drybrush a bit more of the blue tones, as well as some of the pinkish color from the background. Only the highlight areas appear to be bright white.

THE POND

Using the no. 2 round sable or synthetic, take a small bit of black that has been thinned with some water and add it to the water area along the shoreline.

Tip: Understanding Black and White

Black isn't black, and white isn't white. Both of them are neutrals and are very reflective. You will never see pure black or pure white in nature. They will be reflecting all of the surrounding light, shadows and colors. This painting is a perfect example. Your brain tells you that snow is white. We all know that. But, if you observe it in nature, it will rarely appear to be pure white. In this case, the snow is really made up of pastel shades of blue and pink. It may be subtle, but it's true.

3 Details to Finish
THE BACKGROUND TREES

Drybrush the distant trees to keep them looking out of focus. Add snow using a no. 2 flat bristle and scrubbing a small amount of white into them. Add some tiny tree trunks with the liner and some gray. Make them interrupted lines that seem to go in and out of the foliage. For the closer trees, use a no. 2 round sable or synthetic and not much paint to randomly dab in snow so it looks different from tree to tree.

THE LARGER TREES ON THE LEFT

With a light gray (black and white) add a few limbs with the no. 2 liner. Thin down some black and add a shadow along the right side of the trunk for dimension. With a medium gray (black and white), dab some foliage onto the limbs with a no. 2 round bristle. When it's dry, add white on top for the look of snow using the no. 2 round sable. Be random! Add ice and snow to the rocks below.

THE POND

Since water is reflective, drybrush all the colors from the surroundings (light blue, grays and a touch of pink) into the water, using the no. 2 round bristle. Make horizontal strokes across the water, creating the illusion of reflection along the shorelines. The white of the ground reflects along the water's edge. The ground and the water are separated by a subtle gray shadow. Add some bright white in the highlight areas directly above the pond, on top of the rocks and along the top of the little island in the water.

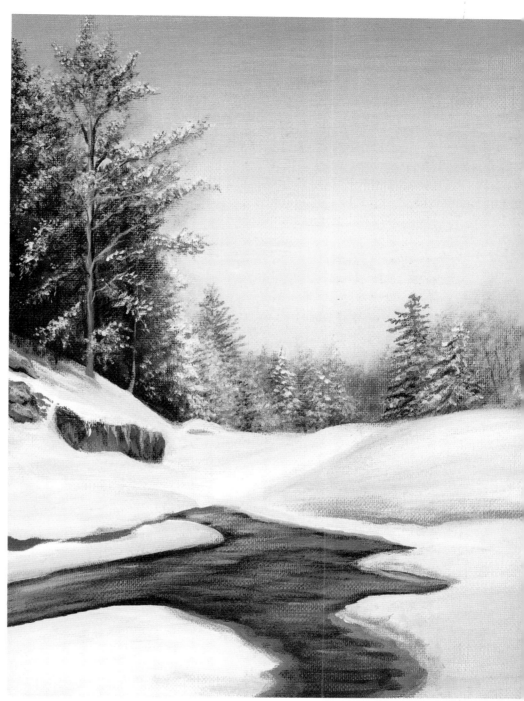

Simple Snow Scene
14" × 11" (36cm × 28cm)

Grass: Prairie

Grass is an important detail in landscape painting. It plays an important part in telling the story. Like foliage, grass is painted in many layers to create its volume and depth. It is done with a small round or liner brush. using quick tapered strokes.

Materials List

PAINTS
Burnt Umber, Cadmium Red Light, Cadmium Yellow Medium, Ivory Black, Prussian Blue, Titanium White

BRUSHES
1-inch (25mm) flat, no. 2 flat bristle, no. 2 liner, no. 2 round bristle

CANVAS OR CANVAS PAPER
8" × 10" (20cm × 25cm)

1 Basecoat
As with everything else, the background must be put in first. Apply the sky color with a mixture of white and Prussian Blue and the 1-inch (25mm) flat. Allow the sky to become lighter by adding more white as it approaches the horizon line.

Separate the sky from the ground with a thin line of Burnt Umber painted with the no. 2 liner. Create a cream color by mixing a small amount of Cadmium Yellow Medium into some white and apply this directly below the horizon line using a 1-inch (25mm) flat. Add some Burnt Umber to deepen the color and keep on moving down. Keep adding Burnt Umber until it becomes darker and darker. At the bottom, add some black for the deepest tone of all.

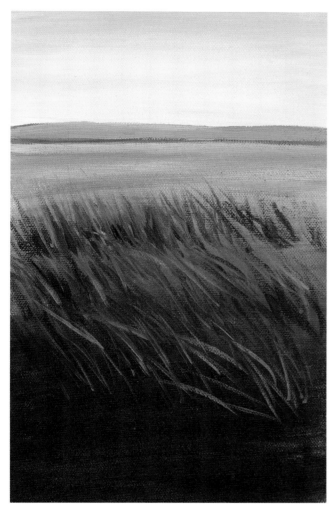

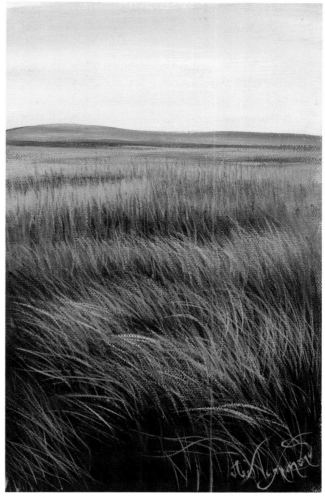

2 The Awkward Stage

Reflect some of the sky color onto the ground. Mix a warm brown with white, Burnt Umber and a touch of Cadmium Red Light. Apply this along the horizon line using a no. 2 flat. Streak some of the sky-blue color across the ground directly below the horizon line.

Move to the middle ground and begin layering dark grass strokes with Burnt Umber, using a no. 2 liner. Make the strokes quick with tapered ends. Bend them off to the left side to make it appear that the wind is blowing, and keep in mind that the grass appears taller in the foreground and shorter as it goes back because of distance and perspective.

Once you have a good start with the dark strokes, add medium ones on top of those, using a no. 2 liner (add a bit of white and a touch of Cadmium Yellow Medium to the Burnt Umber). After that add a bit more white to the mix and layer on the lighter strokes.

3 Finish

Continue the quick strokes with a no. 2 liner until they build up like mine. Allow the strokes to overlap and fill in. The final layers should be with extremely thin lines, especially those in the very front. Build up the many layers of grass until it looks real. Do not stop too soon. The more layers, the more realistic the grass will appear!

Prairie grass
10" × 8" (25cm × 20cm)

Rocks and Mountains: Ultimate Mountain Scene

This is another mountain scene that would look lovely on a larger scale. Feel free to make this one huge to show off its beauty. If you have followed the exercises and projects in the book so far, you should have all of the experience you need to complete this painting. It may look complicated, but it really isn't. Follow along for the ultimate mountain challenge!

Materials List

PAINTS
Alizarin Crimson, Burnt Umber, Cadmium Red Light, Cadmium Yellow Medium, Dioxazine Purple, Ivory Black, Prussian Blue, Titanium White

BRUSHES
½-inch (13mm) flat, 1-inch (25mm) flat, no. 2 round sable or synthetic, no. 2 liner

CANVAS OR CANVAS PAPER
9" × 12" (23cm × 30cm)

OTHER
Mechanical pencil

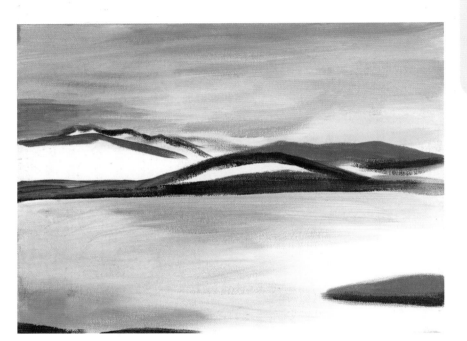

1 Basecoat
THE HORIZON LINE

Draw in a horizon line that is a little below center. With Burnt Umber, Ivory Black and a no. 2 round sable or synthetic, paint across the horizon line and create the shapes of the mountains and hills to separate the sky from the water. Create the shape of the small rock formations in the water below.

THE SKY

Using the 1-inch (25mm) flat, streak in the sky with a light blue (Titanium White and a touch of Prussian Blue), light yellow (Titanium White and a touch of Cadmium Yellow Medium) and a pink (small amount of Alizarin Crimson into some Titanium White).

THE WATER

Use the same brush and same paint mixtures to streak color into the water area.

THE DISTANT MOUNTAIN

Using the no. 2 round sable or synthetic, fill in the small mountain range on the far right and the small rock formation in the right foreground with a blue-gray (add a small amount of Ivory Black into the sky color).

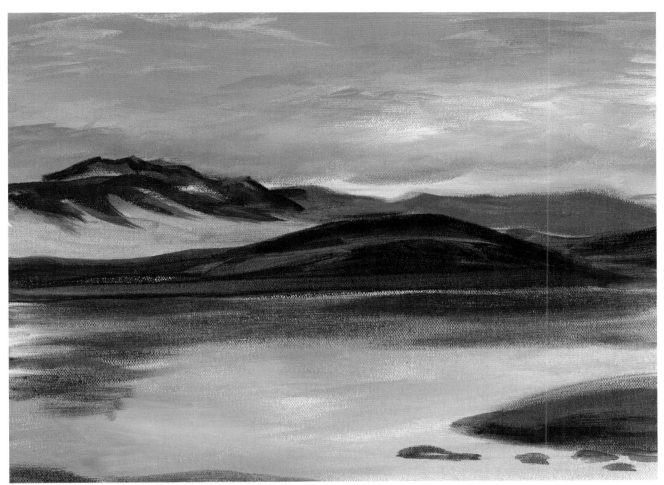

2 The Awkward Stage
THE SKY

Create the beautiful cloud formations and finish the sky
before moving on to the mountains (see the Cloud exercise
earlier in this chapter). Start with the largest cumulus cloud on
the right, and base it in with a light yellow (Cadmium Yellow
Medium and Titanium White). Add a bit of Cadmium Red Light
to this mixture and scrub in the orangey colors so it looks airy.
Add violet (mix Dioxazine Purple with some Titanium White) to
the clouds as well. Layer all of these back and forth until you
like the look of your clouds. Take the same colors and reflect
them into the water directly below in a mirror image. Use the
1-inch (25mm) flat and horizontal strokes. Allow the images to
remain drybrushed and streaky.

Move to the left side and use the same technique to create
the smaller cloud formations, remembering that two clouds
are never alike.

THE MOUNTAINS

Using a ½-inch (13mm) flat, fill in the colors of the mountains
as shown. The darker ones are combinations of Burnt Umber
and Ivory Black. The lighter one on the left has Burnt Umber
on top and orange below (Cadmium Yellow Medium mixed
with a small amount of Cadmium Red Light).

THE WATER

Streak the brown tones from the Burnt Umber and Ivory
Black mixture of the mountain into the water, using a ½-inch
(13mm) flat. Add a few more rocks with a no. 2 round sable or
synthetic and the same brown tones of the mountains. This
stage is not polished so the paint can be a bit thin here.

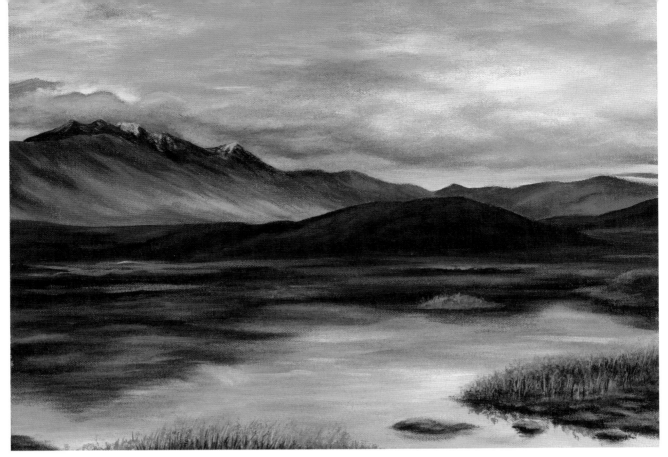

3 Finish

Study this finished example carefully, and you can see where the additional work has been applied. Add the details to your painting in this order:

THE SKY

Continue until it is realistic and colorful. If you have filled in too much, mix more sky blue (see Step 1) and streak it back in. Add pastel colors to the cloud formations until they look real.

THE MOUNTAINS

Add details with dry-brush applications. There are some pinky pastel snowy peaks on the left. Add these to the mountain peaks with a no. 2 round sable or synthetic and Cadmium Red Light and white. Drybrush this color to the smooth area of the mountain in the middle. Drybrush a cooler pink (Alizarin Crimson and Titanium White) to the gray mountain on the right with a no. 2 round bristle. Add this color to the dark brown mountains in the front, too. For the orangey color of the mountain on the left, streak in the pink Alizarin Crimson

mixture again with a no. 2 round sable or synthetic, using diagonal strokes. Then highlight that with a light yellow (Cadmium Yellow Medium and Titanium White).

THE WATER

Using horizontal strokes applied with a no. 2 round sable or synthetic, streak various colors from the painting above into the water area. It is a mirror image, so pay attention to the shapes. Alternate the colors until it looks similar to mine. Like the sky, if it fills in too much, just streak back in with the sky blue.

THE PLANTS

Create a light olive green by mixing Cadmium Yellow Medium with a touch of Ivory Black. Add a bit of Titanium White to the mixture to lighten the tones. Use quick strokes with a no. 2 liner to create the grass on the rock formations. Alternate the brown and orangey colors seen in the mountains, too, using light, medium and dark tones to bring the grass to life.

Mountain Scene
9" × 12" (23cm × 30cm)

Rocks and Mountains: Garden Walkway

This project will teach you how to create more decorative rocks. This walkway does not have the natural appearance of beach rocks. It has more of a planned look, so each stone must be addressed individually. Follow along to create this garden path.

Materials List

PAINTS
Alizarin Crimson, Burnt Umber, Cadmium Red Light, Cadmium Yellow Medium, Dioxazine Purple, Ivory Black, Prussian Blue, Titanium White

BRUSHES
no. 2 flat bristle, no. 2 liner, no. 2 round bristle, no. 2 round sable or synthetic

CANVAS OR CANVAS PAPER
9" × 12" (23cm × 30cm)

OTHER
mechanical pencil

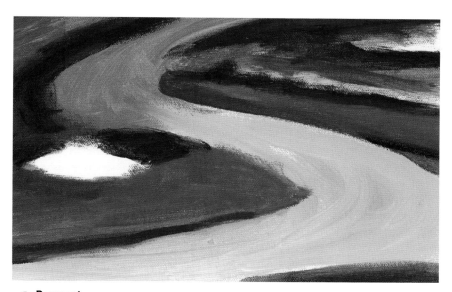

1 Basecoat
Because of this unusual composition, we do not see the sky at all. All the focus is on the ground.

THE WALKWAY
Pencil in the S-shape that represents the walkway. Mix a touch of Ivory Black into Titanium White. Then add a touch of Burnt Umber to create a warm gray to fill the walkway in, using a no. 2 flat bristle. Toward the back the color gets darker, so add some more Ivory Black to this area.

THE GRASS
Mix a nice green with Cadmium Yellow Medium and Prussian Blue. Make a light version of it with more Cadmium Yellow Medium and a darker version with a dab of Ivory Black added. Use the no. 2 flat bristle to apply the green tones, as seen in my example.

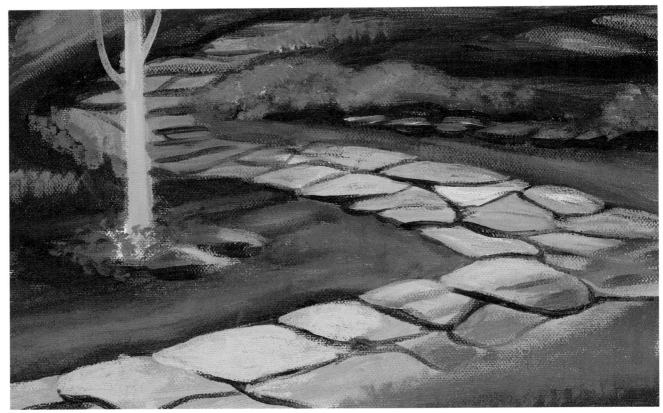

2 The Awkward Stage

THE WALKWAY

Thin some Ivory Black to an inklike consistency. With a no. 2 liner, carefully outline the shapes of the stepping stones. You can draw them with a pencil first to get the shapes right. They do not have to be exactly like mine. The most important thing is that they are larger up close and smaller farther away. Then add some different colors to the stones. The ones in back have the darker gray that we first applied still showing. The ones to the right of the tree have a lavender (Titanium White and Dioxazine Purple). With the no. 2 round sable or synthetic, dab some lavender for flowers on the upper left of the walkway and along the top. Use this to streak across the walkway and on the stones in the lower right corner. For a warm gray with a reddish tint, mix a small amount of Burnt Umber into Titanium White, add a touch of Cadmium Red Light into that, and highlight the stones in the middle right region of the walkway. Add some to the stones on the lower left as well.

THE TREE

Using the same gray used for the walkway, add the tree trunk using a no. 2 round sable or synthetic. Add a couple of large rocks to the right. Deepen the gray with Ivory Black and Burnt Umber and scrub in the darkness around the tree and on the shadows of the rocks. Use Ivory Black to create a deep shadow underneath them. Add some rocks to the right of the walkway in the grassy area. Use the same colors and techniques described above for creating them.

THE FOLIAGE

Add a little yellow to the green mixture you used for the grassy areas to brighten it up, and use this and a no. 2 flat bristle to scrub some light into the grass in the upper left corner and some foliage into the lower right corner. Create the look of small bushes to the right of the walkway, too. Loosely apply this color to the left of the tree and in the upper right corner.

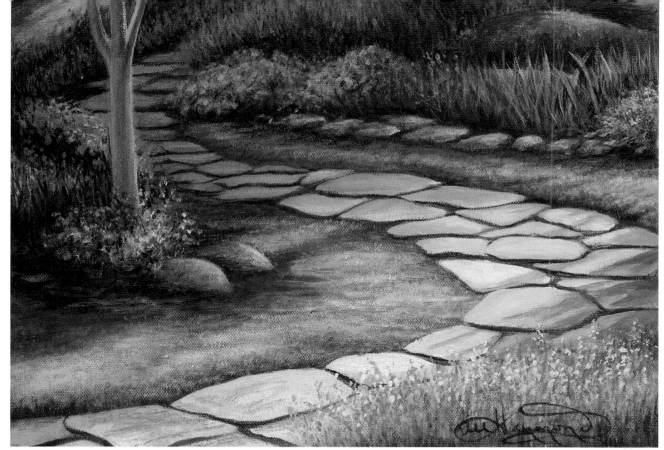

3 Finish
THE TREE

With medium gray (Titanium White with Ivory Black), drybrush the shadow edges of the tree down the center of the trunk and both limbs with a no. 2 round bristle. With a liner, apply the light edges to the trunk and limbs. Use pure white on the right. Add a hint of Prussian Blue on the left.

THE ROCKS AND STONES

Use a no. 2 round to apply the light blue to the stones to the right of the tree. Make the rocks next to the tree larger and rounder, reflecting subtle blue tones. Complete the large rocks in the upper right-hand corner using the same process. Add white to the grass color to show light reflected from the tops of the rocks.

THE WALKWAY

Add touches of color and highlights here and there to each stone. Use lots of light green and white in the middle stones. With a bit more control, use a no. 2 round sable or synthetic to paint the shadows of the stones in the lower righ in blue and gray tones.

THE FLOWERS AND PLANTS

Add as many plants and flowers as you like. Start with the area behind the tree in back of the walkway. Work on top of the dark green. Mix more dark green and scrub it in with a no. 2 round bristle to look like stems. Add some stems with a liner along with a few dots here and there. With the same liner, lightly dot in flowers over the dark green using a variety of colors, from deep Alizarin Crimson to pure Cadmium Red Light and lavender and pink. Create lavender flowers on either side of the walkway with the liner and quick vertical strokes. Add some grass with a variety of green tones as you work along the back. Go across the canvas and behind the large rocks. Dab and dot greens in front of the purple flowers. With the liner, dot in the other lavender flowers on the left side of the walk. With a variety of greens, dab in the bushes right behind the row of rocks on the right with a no. 2 round bristle. As you move to the right, switch to the liner and create a grassy impression. Again, use a variety of greens. Add a hint of flowers in this areas with the liner, using red, white and lavender. Move over to the left again and create the look of grass and flowers here, too. Dab for texture and pull upward strokes for grassy looks. Create an entire flower bed in the lower right. The sunlight is really strong, so use a lot of white to make it look bright.

Finish by enhancing the sunlight on the lawn with drybrushing, adding bright greens with a lot of yellow and white mixed in.

Garden Walkway
9" × 12" (23cm × 30cm)

Water: Rocky Stream

I love the feeling of depth created in this piece. It is due to the extreme contrasts of tones and colors, and how the horizon line quietly fades away into the background. This painting incorporates all of the things we have previously discussed, so you should have fun with it. To start the painting, block in all of the shapes and colors in what looks like a color map.

Materials List

PAINTS

Burnt Umber, Cadmium Red Light, Cadmium Yellow Medium, Ivory Black, Prussian Blue and Titanium White

BRUSHES

no. 2 liner, no. 2 flat bristle, no. 2 round bristle, no. 2 round sable or synthetic

CANVAS OR CANVAS PAPER

9" × 12" (23cm × 30cm)

OTHER

mechanical pencil, small piece of cellulose kitchen sponge

1 Basecoat

Sketch in the horizon line above the center.

THE BACKGROUND

Apply green tones to the upper part of the painting with a mixture of Cadmium Yellow Medium and a touch of Prussian Blue, using a no. 2 flat bristle and a circular scrubbing motion. Add a bit more yellow to the mixture and add the lighter green to the background for the light and dark bushes. Place this yellow-green into the water directly below the lighter bush. Scrub in black directly below the bushes for a shoreline. Take it clear across to the left side, leaving open the light areas that will become rock formations.

THE WATER

Loosely block in the rocks in a variety of shapes and sizes with light tan (a little Burnt Umber and white) and a no. 2 round sable or synthetic. (Draw them first, if needed.) Add light blue (white and Prussian Blue) to the rocks, too. Scrub a touch of black under some of the rocks. Use light tan and the no. 2 round sable or synthetic for the tree trunk leaning toward the water.

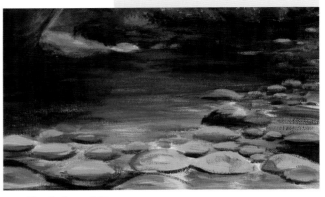

2 The Awkward Stage

THE WATER

Streak horizontal strokes of black into the water. Add more greens into the water, using the same colors as the foliage. Streak it along with the black for a reflective look. Drybrush a little Burnt Umber into the shoreline. Add Burnt Umber to the left side of the tree trunk, too.

THE ROCKS

Add a red (Titanium White with a touch of Cadmium Red Light and Cadmium Yellow Medium) to enhance the rocks. Loosely dot in more rocks to the upper right water area with the no. 2 round sable or synthetic and the same blue and tan you used before. Drybrush Burnt Umber underneath these. With black and the no. 2 round, outline under the edges of the larger rocks in the foreground.

THE FOLIAGE

Using the green tones from Step 1, dab foliage hanging over the water with a no. 2 round bristle.

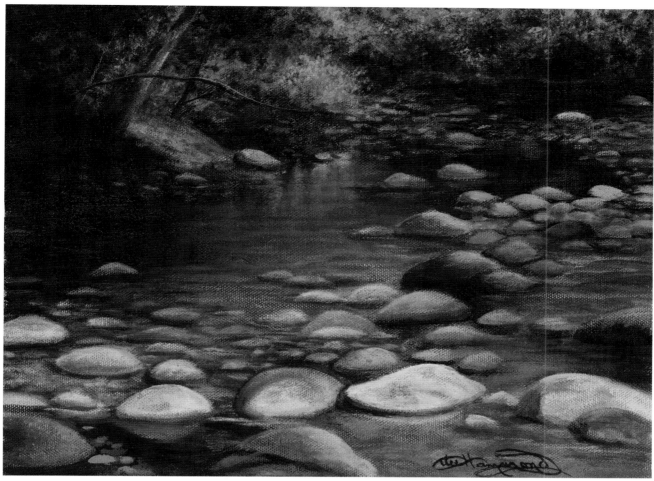

3 Finish
THE BACKGROUND FOLIAGE

The foliage in the background is highly affected by the light sneaking through the trees above. It is created with dabbing and the no. 2 round bristle. You could also use a piece of sponge. Alternate greens, ranging from deep green with a lot of black mixed in to bright greem made with lots of yellow. Dab lightly with a minimum amount of paint to keep the texture subtle and airy. Look for the shadows and create the shapes that they create. The light is bouncing off of the tree bark on the right side of the small tree leaning over the water and the ground next to it, so drybrush this texture with the no. 2 round bristle, using a very light olive color mixed with Cadmium Yellow Medium, Ivory Black and Titanium White. Paint the small thin limb in front of the small tree, using a thin, tapered line with thinned Ivory Black and the no. 2 liner. Add a small highlight down the top of it with Titanium White. Add all the small limbs you see in the painting using the liner. Look carefully, some of them are vague and difficult to see. Some are black, and some are white.

THE ROCKS

Apply the five elements of shading to the rocks (see chapter three). The ones that are larger and closer have more information. The smaller ones are vague. Use the same colors as before. Go one rock at a time and replicate what you see. Use the no. 2 round sable or synthetic for details. Drybrush in any color that is reflecting off the tops of the rocks with the no. 2 round bristle.

THE WATER

Use a no. 2 flat bristle to apply the horizontal streaks of color. Study my example to see the colors. Mix as you go. Your colors don't have to look just like mine. Look carefully under each rock, and you will see a reflection of its color below it.

Rocky Stream in British Columbia
9" × 12" (23cm × 30cm)

Water: Lavender Waves

Sometimes it is nice to simplify the composition and eliminate a lot of the business that we have learned to master so far. While trees and flowers are great, wide open spaces and the serenity of water are, too. This little beach scene is still fun to paint.

Materials List

PAINTS
Alizarin Crimson, Burnt Umber, Dioxazine Purple, Ivory Black, Prussian Blue and Titanium White

BRUSHES
1-inch (25mm) flat, no. 2 flat bristle, no. 2 round sable or synthetic

CANVAS OR CANVAS PAPER
9" × 12" (23cm × 30cm)

OTHER
mechanical pencil

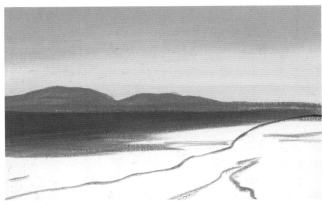

1 Basecoat
Draw a horizon line a little bit above the center.

THE SKY
Mix a pale blue-violet by adding a small amount of Prussian Blue and Dioxazine Purple to Titanium White, and apply it to the sky with horizontal sweeping strokes and the 1-inch (25mm) flat. At the midway point, add more Titanium White. As you near the horizon line, add some Alizarin Crimson for a pale pink.

THE BEACH
Create a light brown by mixing Burnt Umber with Titanium White, and add a touch of Dioxazine Purple. Using the 1-inch (25mm) flat, apply this directly below the horizon line and take it across the canvas, allowing it to become thinner on the right.

THE MOUNTAINS
Mix Titanium White, a touch of Alizarin Crimson and a small touch of Prussian Blue. Apply it to the small mountain range with a no. 2 round sable or synthetic. Add a little more Prussian Blue as it meets the brown at the horizon line. Place a little of this below the brown area on the beach. With the round and this color, sketch in the lines that represent the water movement.

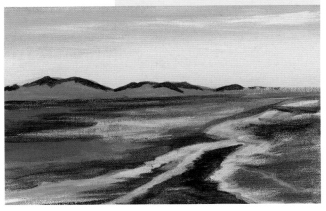

2 The Awkward Stage
THE SKY
With the no. 2 round sable or synthetic, streak in some white and pink clouds. This is an area where you can do whatever you like. Just keep them soft and allow them to contrast against the darker color underneath.

THE MOUNTAINS
Add some Ivory Black to the mountaintops with the no. 2 round brush. Streak some black along the bottom of the mountains, too.

THE WATER
Use the no. 2 round sable or synthetic. Apply the same blue you mixed for the sky to the left side of the beach area. Mix a purple with the Dioxazine Purple and white, and apply it below the blue and in the dark area of the water. With Titanium White, add the froth of the waves, following the curvy patterns that they produce. Add some of the pink from the sky into the beach in the center of the painting. Remember that colors always reflect, especially on wet surfaces.

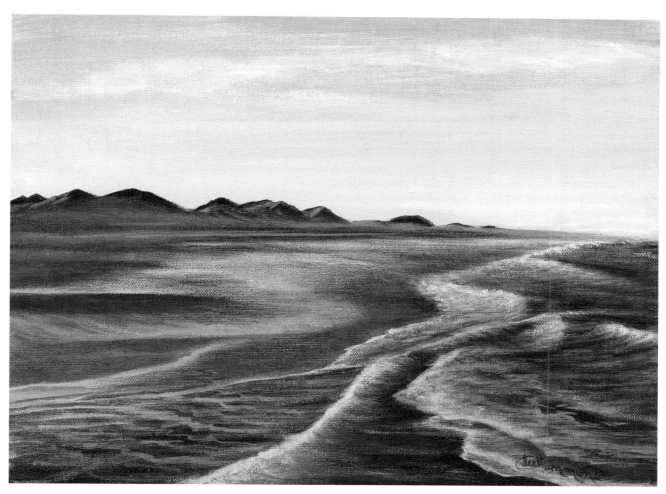

3 Finish

The painting is completed with layers of drybrushing and pastel colors of pink, blue and lavender. Finishing the painting requires a lot of drybrushing to soften and refine all of the colors.

THE SKY

Add more streaks of pastel pink and white using a no. 2 round sable or synthetic.

THE MOUNTAINS

Detail the mountains by creating the look of light reflecting off of them. Apply a warm, light brown (Burnt Umber, Titanium White and a touch of Alizarin Crimson) with the no. 2 round sable or synthetic. You can see the light on the left side of the peaks. Streak the warm, light brown across the horizon line on the right side for the look of sunlight. Apply violet (Titanium White, Dioxazine Purple and a touch of black) to the base of the mountains and let it streak upwards. Pull more Ivory Black down into this violet, allowing the colors to blend.

THE BEACH

With a no. 2 flat bristle, drybrush Titanium White across the top of the beach colors, using horizontal strokes to soften. Add some pink and light blue as well (the same colors you used in the sky). Keep the paint very dry; you do not want it to cover up the colors completely. Add some of the purple on top.

THE WATER

The water and waves are also created with drybrushing. Look at how the patterns of the water are created with more horizontal strokes. Use the no. 2 flat bristle and streak the colors out and away from the white edges of the waves. With back-and-forth strokes and drybrushing, streak the water until it looks like mine. Alternate all the colors you used in the sky and the beach. Add Titanium White to the edges of the waves.

Lavender Waves
9" × 12" (23cm × 30cm)

Putting It All Together: Country Afternoon

We have seen how important the use of color and lighting is to creating beautiful art. Nature is the great provider of color and light, and this painting captures it wonderfully. The finished painting may seem a bit daunting at first, but it really is no harder than the previous demonstrations. It takes everything we have learned so far and wraps it up in one big project. This is another painting that would look great on a large scale. Make it as large as you like. Just adjust the sizes of your brushes accordingly and mix a lot more paint for each step.

Materials List

PAINTS
Alizarin Crimson, Burnt Umber, Cadmium Red Light, Cadmium Yellow Medium, Dioxazine Purple, Ivory Black, Prussian Blue and Titanium White

BRUSHES
1-inch (25mm) flat, no. 2 flat bristle, no. 2 round sable or synthetic, no. 2 liner, no. 2 round bristle

CANVAS OR CANVAS PAPER
12" × 16" (30cm × 41cm)

OTHER
mechanical pencil

1 Basecoat
THE SKY

Draw in the horizon line a little bit below center. Apply sky blue (Titanium White and a bit of Prussian Blue) with horizontal strokes and the 1-inch (25mm) flat to the top and upper right corner of the canvas. Move down to the horizon line and apply pure Cadmium Yellow Medium to the left side, moving up to the halfway mark. Add a small amount of Alizarin Crimson to the yellow and continue up, using horizontal strokes and allowing the color to make streaks. Add a small amount of Titanium White and a touch of Dioxazine Purple to the mix, and carry it up, using the horizontal strokes, until it meets and overlaps the sky blue. With the Alizarin Crimson mixture, switch to a no. 2 round sable or synthetic and paint in the line across the horizon line.

THE FOREGROUND

Mix a light blue-violet with Titanium White, a touch of Prussian Blue and a touch of Dioxazine Purple. With the 1-inch (25mm) flat, apply this from the horizon line down to the bottom of the canvas.

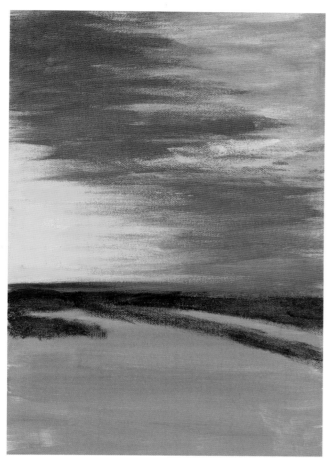

2 Basecoat, continued

Start the look of clouds and create the dark tones in the background.

THE SKY

Mix a light yellow by adding a small amount of Titanium White to Cadmium Yellow Medium. Use a no. 2 flat bristle and horizontal strokes to drybrush the light clouds in the upper right. Carry the strokes down into the reddish colors. Using a no. 2 flat bristle and the sky colors from Step 1, continue streaking the sky. Notice how the colors are blending together.

Remember that your sky can look different from mine. Skies are ever changing with no two alike. If you like more red or pink, put more in.

THE FOREGROUND

With Ivory Black, apply the darkness below the horizon line, using the no. 2 flat bristle.

3 The Awkward Stage

THE SKY

Continue with the previous colors and the no. 2 flat bristle, streaking to create the look of a sunset. Add more yellow tones to the horizon area. Continue working and reworking until it seems just right to your eye.

THE FOREGROUND

Switch to the no. 2 round sable or synthetic and the Alizarin Crimson/yellow mixture to define the horizon line and create the look of a background hill in the distance. Add a small amount of it below the tree row in the middle, too. Switch to the no. 2 flat bristle and build up the look of trees in the right background area using the scrubbing technique with Ivory Black. Scrub some Burnt Umber into the tops of the tree masses. Using the same brush and Ivory Black, create the dark streaks in the foreground.

THE TREES

Add a touch of Ivory Black to some Burnt Umber and paint the larger tree trunks with the no. 2 round sable or synthetic. Switch to the no. 2 liner and add the smaller trunks on the right.

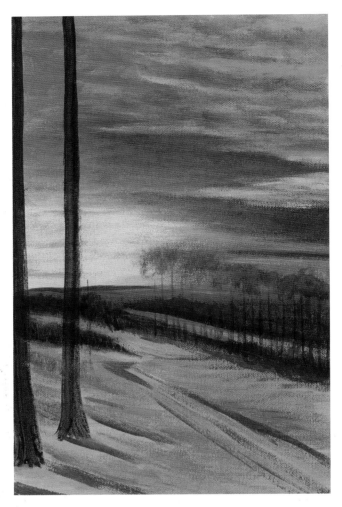

4 Deepen and Warm

Deepen the colors of the sky and continue building the look of trees. Add the warm sky color to the foreground.

THE SKY

Using the no. 2 flat bristle, continue adding colors with horizontal streaking strokes. Add more reds with Alizarin Crimson and a small amount of Titanium White and Cadmium Yellow Medium to deepen the sky and give it more of a late-afternoon look. You can see how the sky-blue color is starting to get covered up now. Don't cover it completely. It must show through in areas. Move down to the sky on the right directly above the horizon line. Brighten this with some Cadmium Red Light.

THE SMALL TREES

With thinned Ivory Black, scrub in the look of tree foliage with circular strokes and the no. 2 round bristle. Add a few more trunks with the liner.

THE FOREGROUND

Start developing the sunlit appearance on the snowy ground. The cool light blue-violet color already there will peek through the warmer colors on top. Reflect the reddish color from the sky down onto the ground, using the no. 2 flat bristle along the right side of the shadow patterns. Notice how they are creating the look of a gentle slope and a sunlit path.

Tip: Make Changes

Acrylic is the most forgiving medium you can use. If you are unhappy with any area, simply rework it. If areas of your painting get too dark, simply add some lighter colors. If too light, add some darker ones. You are in charge and you have the ability to make as many changes as necessary. Don't give up. You can do it!

5 Finish

This will be a process of building and layering colors with the dry-brush application. I find this stage much like drawing with a brush.

THE SKY

Use the no. 2 flat bristle to drybrush more cloud layers. Use the Alizarin Crimson mixture from previous steps and the light yellow/white mixture to create the layered stratus clouds. Use white to add the sun in the middle. Streak the yellow/white mixture out from it to make it look soft and hazy, with the look of sun rays. Keep this subtle. Add more Cadmium Red Light glow behind the trees on the right.

THE TREES

Add more trunks to the trees on the right with the liner. Continue to build up the tree foliage, scrubbing with the no. 2 round bristle and a combination of Burnt Umber and Ivory Black. Scrub some Cadmium Red Light into them, too, to make it look like the sun glow is passing through them. For the shorter, small trees in the distance, scrub in some Burnt Umber with a bit of Cadmium Red Light to make them look fuller. Switch to the no. 2 liner, and use thinned paint to pull thin tapered lines for small limbs and branches coming from the large trees on the left. Deepen the color of the trunks with Ivory Black/Burnt Umber. Drybrush a small amount of pure Burnt Umber into the right side of the trunks to highlight them.

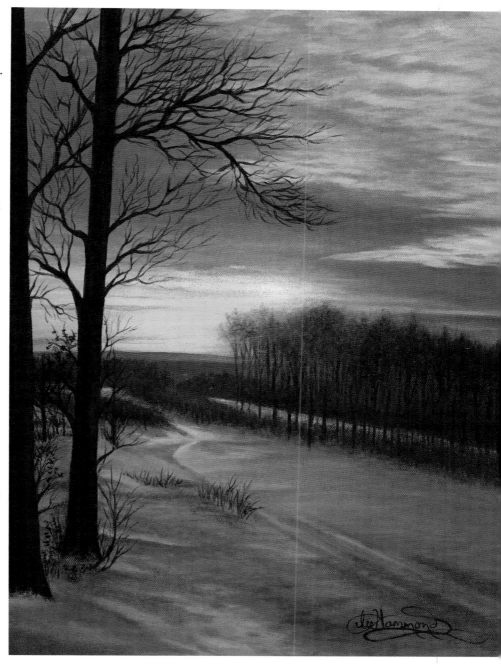

THE FOREGROUND

This is the part that will take the most time, but it is the most important. It is all about drybrushing a combination of the warm and cool colors and making them work together to create the soft illumination of the snow.

Using scrubbing, horizontal strokes that keep consistent with the patterns of sunlight, the no. 2 flat bristle and the blue-violet from the foreground in step 1 with a bit of Ivory Black added to make it grayer, create subtle shadows in the dark areas. Add a small amount of white to the blue-violet for the lighter shadow areas where they appear bluer.

Drybrush light warm colors of the sky next to and on top of the cool shadow colors to illuminate the light areas on the ground. It may take a while to get the same look as mine. When you have completed the foreground colors, add the small grasses and twigs with Ivory Black and the liner.

Snowy Country Afternoon
16" × 12" (41cm × 30cm)

6

Animals

THERE ARE MANY CONCEPTS TO REMEMBER WHEN PAINTING ANIMALS. I try to keep the process as simple and uncomplicated as possible so that it is fun for my students. While I could analyze the unique anatomical features of every animal, I think it is more important to focus on the traits they have in common.

I encourage you to look for the following three traits in each animal you observe: shape, color and texture. If you can describe these three traits, you will greatly simplify your subjects. It will make no difference whether you are creating a horse or a goldfish.

FOCUS ON ATTENTION-GRABBING FEATURES
This close-up of a kitty is a good example of how the features of an animal can capture your attention. Cropping a painting to focus on the features makes a good composition with a lot of eye appeal.

Kitty
7½" × 11"
(19cm × 28cm)

Hair and Fur

Hair varies greatly from one animal to the next. In the animal world, you will find both long and short hair, both straight and curly. I find fur color and markings intriguing, and I love capturing them in my artwork.

Painting fur requires a lot of patience. It takes many, many layers to make the fur look real. The key is to keep trying. Work through the awkward stage and take time to build up the layers of paint.

The paint swatches on this page give you formulas for creating some of the most common hair tones.

HAIR COLOR: BLACK TONES

Black is never pure black. These two swatches show cool and warm variations of black. The first one shows Ivory Black mixed with Prussian Blue and green (made from Prussian Blue and Cadmium Yellow Medium). This deep teal hue is a cool color, and it is often seen reflecting off black animals' fur. The second shows a warm black created by adding Alizarin Crimson and Cadmium Red Medium.

HAIR COLOR: WHITE TONES

White fur is never pure white. It is a combination of white and hints of other colors. These swatches show both cool and warm variations. The first is made with a hint of Ivory Black to create gray tones. The second is made with a hint of Burnt Umber for a tan tint.

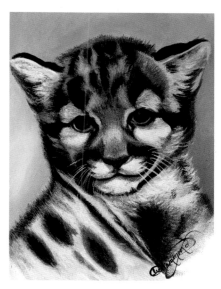

GUINEA PIG FUR

This little guy has very long fur. Use long brushstrokes to replicate the length and texture of the silky hair.

HAIR COLOR: BROWN TONES

This light color forms the beginning of all the brown tones. Create it with Titanium White and Burnt Umber. The value scale shows the range of tones that can be created with this simple color mixture.

HAIR COLOR: RED TONES

Add a touch of Cadmium Red Medium to the brown mixture to create this reddish hue. Look at the wide variety of tones in the value scale. Add more Titanium White to make it paler or more Burnt Umber to make it deeper. The Cadmium Red Medium makes it much warmer.

CHEETAH CUB FUR

This little cheetah cub has short, spotted fur. Use short, quick brushstrokes to make the fur look textured. Brushstrokes must follow the direction in which the hairs grow. Quick strokes will make the lines taper and look more realistic.

HAIR COLOR: YELLOW TONES

This color is similar to the original brown mixture, but it has a hint of Cadmium Yellow Medium. Black and yellow make olive green, so the touch of Cadmium Yellow Medium gives the color a bronze hue. This value scale gives you a wide range of tones. The greenish color is easy to see.

Facial Features

Each species has uniquely shaped features. Study the animal you're painting closely.

Eyes

I think one of the biggest obstacles in creating animal eyes is the tendency to humanize them by showing white around the irises. Rarely will you see white in an animal's eye, although there are a few exceptions.

Eyes are shiny and reflective and have a very smooth surface. You'll often see bright catchlights and glare reflecting off their glassy surfaces. These elements can be challenging to paint, but the result is more than worth the effort.

Mouth and Nose

Look at the way the shape of the nose connects to the mouth. It's important to work on those two features together as you paint.

Ears

Animal ears vary greatly in shape and size. Remember the three common traits (shape, color and texture) that you should look for in every animal.

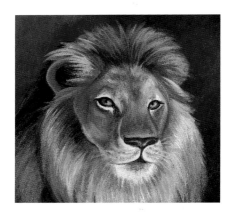
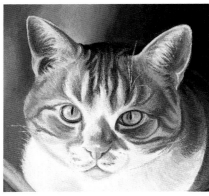
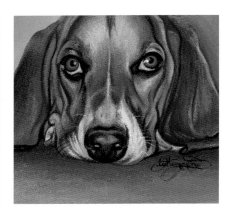
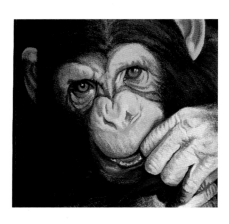
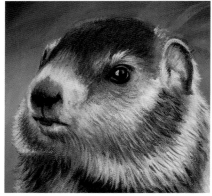
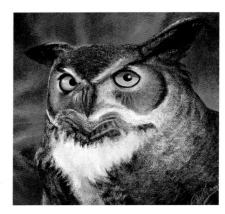

Set of Eyes

It's important to learn how to put two eyes together. As you can see in the finished exercise, the eyes of this cat look very different from one another. This is due to the location of the light source. The eye on the right is more shadowed, which makes the color of the eye appear much deeper.

Materials List

PAINTS
Burnt Umber, Cadmium Red Medium, Cadmium Yellow Medium, Ivory Black, Prussian Blue, Titanium White

BRUSHES
no. 4 filbert, no. 2 round

SURFACE
canvas or canvas paper

OTHER
mechanical pencil

1 Begin With the Outline
Lightly draw the shapes of the eyes on your canvas paper. Apply diluted Cadmium Yellow Medium to the iris areas with a no. 2 round.

2 The Awkward Stage
Use the no. 2 round and diluted paint to add more color to the irises. Add a touch of Cadmium Red Medium to Cadmium Yellow Medium and apply the mixture to the outside edge of the irises. Mix a touch of Burnt Umber with some Cadmium Yellow Medium and apply it around the pupil, allowing a small edge of pure yellow to remain. The eye on the right is much darker. Add a touch of Ivory Black to some Cadmium Yellow Medium to create a nice olive green. Apply this mixture to the right eye as shown. Use a no. 4 filbert to apply diluted Ivory Black to the area around and between the eye.

3 Finish
Finish the eye by going over the same areas with a thicker application of paint. For the highlights on the black fur, add a touch of Titanium White and Prussian Blue to Ivory Black to create a blue-gray. Apply this mixture on top of the black.

Front, Three-Quarter and Side Views

Here you can see how different the features of an animal appear when viewed from various angles. I am focusing on dogs and cats since they are so commonly portrayed in art.

Dogs

Although every dog nose is different, the basic anatomy remains the same. Look at how the edge of the nostril wraps around. You will see this characteristic in all dog noses.

You can also see from these examples how the mouth and the nose are interconnected. It is important to work them together as you paint. The division line in the center of the nose always connects to the separation of the mouth and upper lip area.

Cats

Like the dog's nose, the cat's nose is divided down the center and connects to the division in the mouth. Cat features also change dramatically when viewed from different angles and poses. Notice how different the nose looks from the side.

DOG: FRONT VIEW
Look at the way the nose and mouth fit together. The center line of the nose connects to the center crease of the mouth.

DOG: THREE-QUARTER VIEW
The side of the mouth is now more visible.

DOG: SIDE VIEW
The edge of the nose and the way the nostril area wraps around is much more visible in this view.

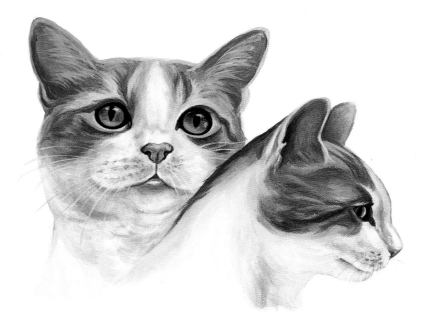

CAT: FRONT AND SIDE VIEWS
The front view of this kitty shows the features in their entirety. The side view shows the features from a different perspective. It is important to study the shapes carefully. As you can see, a side view of an eye looks completely different from a front view. Careful observation is critical for good artwork. Always paint what you see, not what you remember.

Monochromatic Cat

Sometimes, when encouraging my students to try something new, I find that they have an easier time if they start with a monochromatic color scheme. By painting in monotones, you can concentrate on the shapes, tones and contrasts without having to worry about color.

Materials List

PAINTS
Ivory Black, Titanium White

BRUSHES
no. 3 filbert, no. 3/0 round, no. 2 round

SURFACE
canvas or canvas paper

OTHER
mechanical pencil, ruler, kneaded eraser

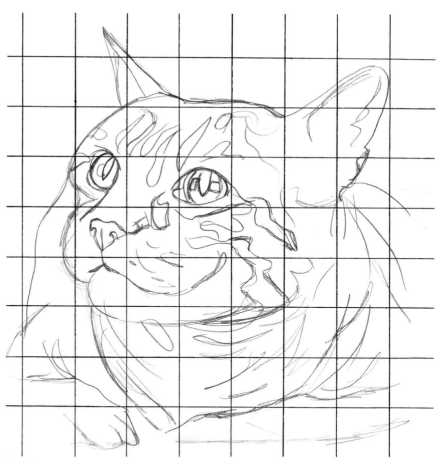

REFERENCE PHOTO
Carefully study the shapes of the photograph, and draw what you see. Notice that the eyes are not circular like those of the cat on the previous page. Circles seen in perspective become ellipses.

Tip: Paint What You See

There is a lot of psychology in the drawing process. When we are trying to represent our subject from an angle rather than straight-on, we may subconsciously try to make the image too symmetrical. The reference photo for this project is a three-quarter view and the drawing needs to be made accordingly. The slight turn makes more of the nose visible on the right side of the center line than on the left.

LINE DRAWING
Use the grid method to create an accurate line drawing on your canvas paper. When you have the shapes drawn, remove the grid lines with your eraser, leaving the image behind.

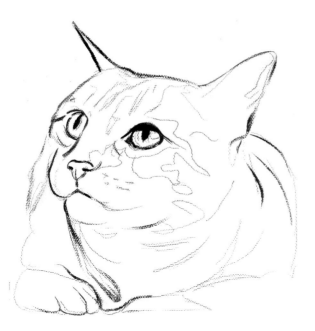

1 Begin With the Outlines
Use the no. 2 round and diluted Ivory Black to carefully outline the features such as the eyes, nose and ears. This captures the pencil drawing so that the shapes will not get lost while you paint.

2 Continue Adding Features
Further dilute the paint and continue adding the features of the cat with the no. 2 round. Capture the markings and stripes of the face and lightly wash in the tone above and inside the nose.

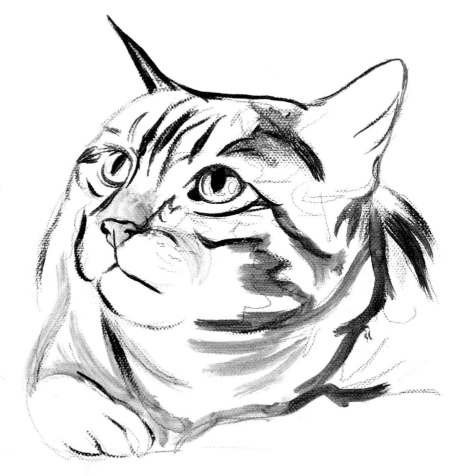

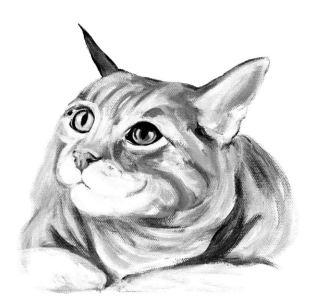

3 The Awkward Stage

Mix a light gray tone with Ivory Black and Titanium White. Use a no. 3 filbert to fill in most of the cat. Also use this color to fill in the iris. Continue adding details to the eye with various shades of gray and a no. 3/0 round. The eye on the right is deeper in color, with more patterns, so study it closely. Use Titanium White for the catchlights.

Add more Ivory Black to the paint mixture to create a medium-gray tone. Use this color and a no. 2 round to block in the patterns of the fur markings.

4 Finish

Finish the kitty by building up the fur with quick strokes. Make sure your strokes follow the direction of the fur growth, and alternate dark and light values so they overlap one another. This stage can take a long time, so don't stop too soon. The more patient you are, the better your painting will be.

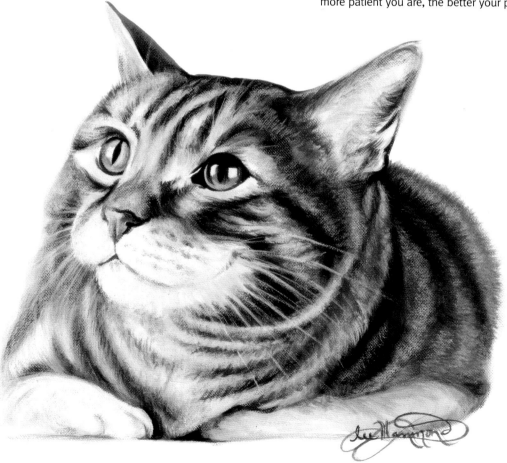

Blue-Eyed Kitten

Few things are as cute as a kitten. They make adorable artwork. This kitten study is a fun project, and it's not difficult to do. This time we will include the entire body, longer fur and additional colors.

Materials List

PAINTS

Burnt Umber, Ivory Black, Prussian Blue, Titanium White

BRUSHES

no. 3 filbert, no. 6 filbert, no. 3/0 round, no. 2 round

SURFACE

canvas or canvas paper

OTHER

mechanical pencil, ruler, kneaded eraser

REFERENCE PHOTO
A kitten's proportions are slightly different from those of a full-grown cat. The grid method will help you accurately capture those differences on your canvas paper.

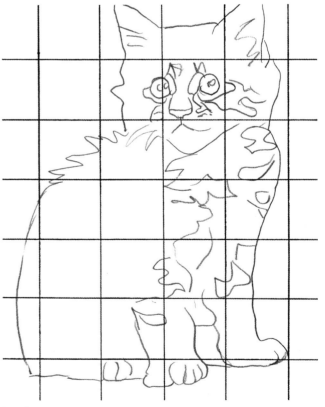

LINE DRAWING
When you have the shapes drawn accurately, your line drawing should look like this. Remove the grid lines with your eraser, leaving the image behind.

1 Begin With the Outlines

Use a no. 2 round and diluted Ivory Black to capture the shape of the kitten. Outline the edges of the eyes and nose. Create a blue-gray by mixing Titanium White with a touch of Ivory Black and a tiny bit of Prussian Blue. Be careful, because Prussian Blue is extremely potent; a tiny little bit will go a very long way. Use the no. 3/0 round to fill in the color of the eyes with this mixture. Allow a small white area to remain for the catchlight. Fill in the little nose with a diluted mixture of Ivory Black and Burnt Umber, using the no. 3/0 round.

2 The Awkward Stage

Block in the fur of the kitten with diluted Ivory Black and a no. 3 filbert. Your brushstrokes should follow the fur's direction and natural patterns. Even at this stage, the texture and depth of the fur is being created. Use diluted Prussian Blue and a no. 3 filbert to wash in the background color surrounding the kitten. Create a line across the page to represent a horizon line. This line separates the background from the foreground and creates the illusion of a floor. Fill in this area with a diluted mixture of Ivory Black and Prussian Blue. With diluted Burnt Umber and a no. 2 round, fill in the inside of the ears.

3 Finish

Apply thicker layers of paint to finish. Rather than sticking to just Ivory Black and Titanium White, which would result in a kitten in shades of gray, I added a touch of Burnt Umber to the color mixtures. This addition offers a subtle, warm brown coloration to the fur.

Fill in the darker areas of the body first, using a no. 3 filbert and a mixture of Ivory Black and Burnt Umber. Add small amounts of Titanium White to this mixture to create several light and medium shades of gray. Use these colors and the no. 3 filbert to paint the lighter patterns in the fur. Overlap the light colors on the dark colors to create the illusion of long fur. Switch to the no. 2 round and continue building the fur layers, overlapping light and dark strokes for a more realistic effect. Look at the chest area to see how I developed the fur layers. Make sure to capture all of the patterns in the face, particularly around the eyes.

Use the no. 2 round to paint the feet. View them as patterns of light and dark shapes. Add the hair inside the ears. Make sure to use very quick strokes so that they taper at the ends and look like hair. With the no. 3/0 round and diluted Titanium White, add the whiskers. They'll stand out against the darker fur.

To finish the background, apply a thicker layer of Prussian Blue and Titanium White. Use the no. 6 filbert and apply the paint in a circular, swirling motion. Make the color deeper near the kitten. Add more Titanium White to the mixture and make the background color lighter as it moves farther outward, away from the kitten.

Finish the foreground with a thicker application of gray, using the no. 6 filbert. The subtle blue tones from the original wash should still show through on the right. Use Ivory Black to create the shadows under the kitty. As you work away from the kitten, add some Burnt Umber to the black to give the edge of the shadow a warm glow. For the shadows on the left side of the kitten, add some Ivory Black and Prussian Blue to the mixture and use circular brushstrokes for a hint of texture. This method allows you to gradually lighten the tones as they get farther away from the kitten.

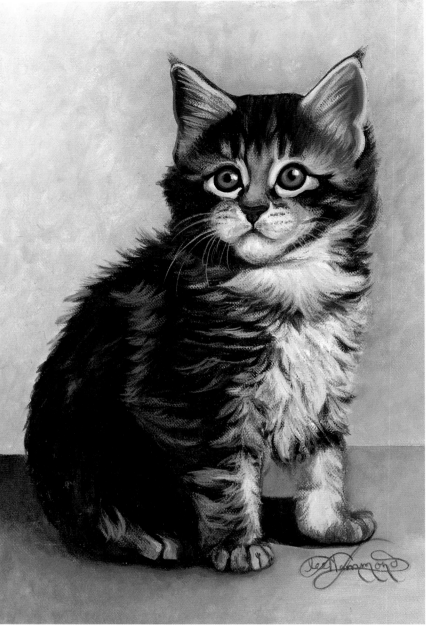

Monochromatic Dog

Once again, I believe it is important to start slowly and use a monochromatic color scheme for your first dog portrait. This demo will give you practice capturing the features, seeing them as shapes and tones, without fixating on the colors. Follow the step-by-step instructions to create this cute spaniel.

DEMONSTRATION

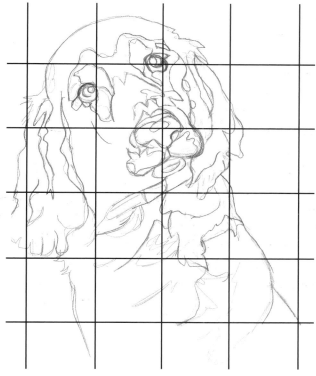

REFERENCE PHOTO
This spaniel's fur is long and curly. Use the grid method to accurately capture the shapes on your canvas paper.

LINE DRAWING
When your drawing is complete, erase the grid lines

1 Begin With the Outlines

With a no. 1 round, outline the eyes of the dog with Ivory Black. Fill in the pupil, leaving a small area for the catchlight. A catchlight appears in the iris as well as in the pupil. Switch to a no. 2 round and start filling in the darkest areas of the dog: along the top of the head and in the neck area. Leave the shape of the collar alone.

With a no. 1 round, add strokes to the ears. These brushstrokes should follow the direction the fur is growing, curving with the waves of the fur. Fill in the nose with the no. 1 round. Leave the highlight areas of the eyes uncovered.

2 The Awkward Stage

Continue building the tones of the dog by adding more Ivory Black with a no. 2 round. The brushstrokes should always follow the direction the fur, even if the area fills in solidly. Should brushstrokes show, they must be consistent with the fur's direction. Straight strokes would make the dog's form look flat.

Create a medium gray by mixing Ivory Black and Titanium White. Use this color to fill in the iris of the eyes, the area above and below the eyes, and the area of the muzzle around the nose. Use the same color to fill in the collar and add some waves to the areas of the ears.

3 Finish

This step is about creating volume and dimension in the fur. In the previous step, I deliberately left some of the canvas uncovered in the highlight areas. Now you will layer medium gray and Titanium White into these highlight areas to make the fur look full. Using the no. 1 round, add the medium gray in quick, curved strokes to replicate the shape of the waves. To make the waves look shiny, add some white highlights on top of the gray using the same quick strokes. Can you see how this layering technique makes the fur look thick and full?

Puppy Close-Up

This little puppy face will give you practice applying subtle color. In the previous project, the many layers of curls on the black dog were much more defined. The patterns of light and dark were separated and relatively easy to create. Although it may look easier, this project is more challenging. The smoother texture of the fur and the even distribution of light in this painting are more difficult to replicate.

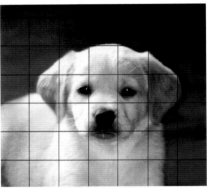

REFERENCE PHOTO
The smooth fur of this Labrador retriever puppy shows very little texture, and the light distribution is more even. This makes the tones very subtle; they blend and fade into one another very gradually. The blue tones of the background reflect on the light-colored fur.

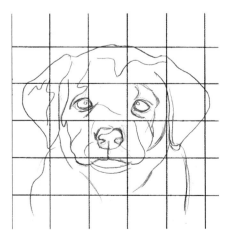

LINE DRAWING
When you are sure of the accuracy of your drawing, carefully remove the grid lines with your kneaded eraser.

1 Begin With the Outlines
Start by outlining the eyes and nose with Ivory Black, using a no. 2 round. Place the pupil in the eye. Remember to leave a small dot of white on the border of the pupil and iris for the catchlight.

Mix some Titanium White into Ivory Black to make a dark gray; use a no. 2 round to fill in the nose, leaving the upper part white. Mix Burnt Umber with a touch of Ivory Black and then dilute it. Use this diluted mixture to outline the edges of the face with the no. 2 round, and add some around the eyes and in the lower lip area.

2 The Awkward Stage

Take the dark gray color you used for the nose and fill in the irises. These are small areas, so use the no. 3/0 round. Don't fill in the catchlights.

Take the diluted Burnt Umber and Ivory Black mixture from step 1, and lay a wash of this color into the ears, mouth area and neck.

Mix Ivory Black and a tiny bit of Prussian Blue. Apply a diluted solution of this mixture in swirling strokes to the background with a no. 3 filbert.

Further dilute the blue mixture and apply it to the face with a no. 2 round. You can see this bluish color in the middle of the forehead and on the right side of the muzzle, mouth and neck.

3 Finish

Apply thicker layers of paint to finish. Add Titanium White to the color mixtures during this layering stage to make the colors more opaque.

With a no. 2 round, apply Titanium White to the areas we had previously left blank. Allow the white to gently soften into the colors you have already applied. Mix Burnt Umber and a tiny bit of Ivory Black into some Titanium White and apply it to the ears. Add some more Burnt Umber and apply it to the area below the nose.

To create the reddish brown edges around the eyes, ears, face, chin and neck, mix Titanium White with Burnt Umber and Cadmium Red Medium. Apply this color with a no. 2 round. Can you see the five elements of shading on the right side of the face? These elements create the contours of the face. There's an edge of reflected light along the right side of the face, under the ear. These effects are subtle, but they're important for achieving realism.

To finish the puppy, scrub in the highlights of Titanium White on top of the darker colors, using a no. 2 flat and the dry-brush method. Deepen the background color with a thicker application of the same dark mixture used in step 2.

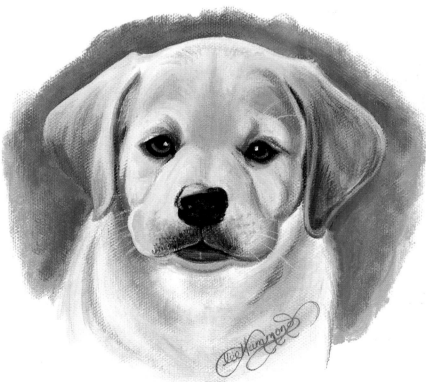

Use a no. 3 filbert to scrub in a circular motion. Reflect the background color on the forehead; lighten it with Titanium White and scrub it in with a no. 2 flat. Mix Ivory Black and Titanium White to create a light gray and then add some small dots to the muzzle with a no. 3/0 round. Add the whiskers with the same brush and Titanium White. Use quick strokes, lifting at the end of each stroke so the whiskers taper.

Horse

One of the great things about painting horses is that they give you the opportunity to capture the great outdoors as well. This painting is a good example. The colors of the grass and background help make the light color of the horse stand out.

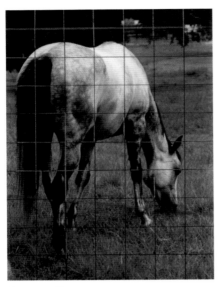

REFERENCE PHOTO
Use this photo with a grid to begin your painting.

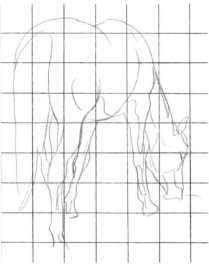

LINE DRAWING
Use the grid method to create the drawing on your painting surface. When your line drawing looks like mine, carefully remove the grid with a kneaded eraser.

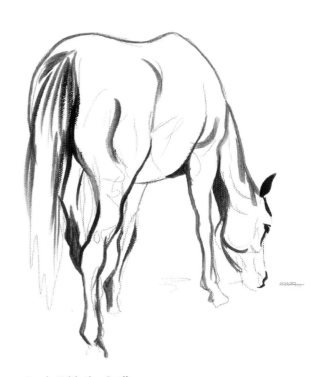

1 Begin With the Outlines
Carefully outline the shapes of the horse with Ivory Black and a no. 2 round.

2 Start Filling In the Color

Use the no. 2 round and diluted Ivory Black to wash in the contours of the horse. This step begins to define the form, giving it the look of roundness. Fill in the tail and the darker shadow areas of the horse with a less diluted solution of Ivory Black.

Create a light green by mixing Cadmium Yellow Medium with a hint of Prussian Blue. Dilute the mixture and use a no. 2 round to apply it with horizontal strokes under and around the horse. This color starts to suggest grass.

3 The Awkward Stage

Continue building the colors of the horse and background using diluted applications of paint. Use a no. 4 filbert for this entire stage of the painting. Although the sky is not included in the composition, you can see its blue color reflecting off the white areas of the horse. Use Prussian Blue for the sky's reflection.

The brushstrokes will be visible throughout the painting. They curve where the body of the horse is round and are straight in the background area, where they represent the flat ground, blades of grass and trees.

The shadow underneath the horse gives the painting depth and realism. Create the shadow by applying transparent Ivory Black over the green tones. Use the black to create the row of trees in the background as well.

4 Finish

Apply thicker layers of color to finish. With a no. 4 flat, drybrush using a circular motion to give the dappled gray coat a mottled look, alternating light and dark colors. Create the darkest areas with Burnt Umber and Ivory Black, the lighter areas with Titanium White and Prussian Blue. Use pure Titanium White in the brightest areas. The light blue should be used in all highlight areas of the horse. This gives the appearance of the sky's reflections on the horse's coat.

Streak some highlights into the tail using a mixture of Burnt Umber and Ivory Black with a touch of Titanium White. With the no. 3/0 round, make quick, long strokes to replicate the length and texture of the hair.

Use the no. 2 round and quick vertical strokes to create the appearance of grass. Make various shades of green by mixing Prussian Blue with Cadmium Yellow Medium, and Ivory Black with Cadmium Yellow Medium. Look for the shadow areas, and make them darker. Add more Cadmium Yellow Medium and Titanium White to the green mixtures for the highlight area. The grass in the front has more detail. The grass in the background appears smoother, with the highlights streaking across horizontally. Streak Ivory Black and some of the green mixture (Prussian Blue and Cadmium Yellow Medium) into the wet paint to create the illusion of the trees in the background. Make some vertical strokes in the upper right to suggest tree trunks. The lack of detail will make them appear far in the distance.

Rabbit

This little bunny is very textured. Each hair is distinct, and its length shows clearly. I created each tiny hair with a fine brush and quick, tapered strokes. You will use dry-brushing to create this texture. This project will require more patience. Tiny strokes and more layers take more time.

Materials List

PAINTS
Alizarin Crimson, Burnt Umber, Cadmium Red Medium, Cadmium Yellow Medium, Ivory Black, Prussian Blue, Titanium White

BRUSHES
no. 4 filbert, no. 3/0 round, no. 2 round

SURFACE
canvas or canvas paper

OTHER
mechanical pencil, ruler, kneaded eraser

REFERENCE PHOTO
Use the grid lines on this photo to obtain an accurate drawing.

Photo by Mel Theisen

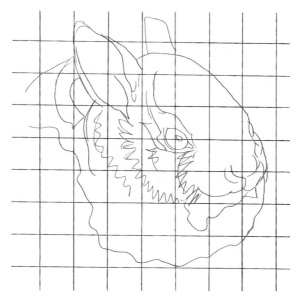

LINE DRAWING
When your line drawing looks like mine, carefully remove the grid with a kneaded eraser.

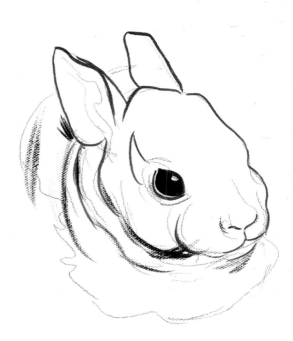

1 Begin With the Outlines
With the no. 2 round and Ivory Black, carefully outline the shapes of the rabbit. Fill in the eye, leaving a small dot of white for the catchlight.

2 The Awkward Stage

With the no. 4 filbert, block in the colors of the painting with an application of diluted paint. Use Cadmium Yellow Medium for the head and face. With Burnt Umber, wash in the nose area, the right ear, the neck and the body.

Combine a bit of Alizarin Crimson with Burnt Umber. Then add this color to the inside of the ear on the left. Create a green with Cadmium Yellow Medium and Prussian Blue and apply it to the background.

Switch to a no. 3/0 round and create the facial hairs with tiny, quick strokes of Ivory Black. Follow the direction of the hair growth.

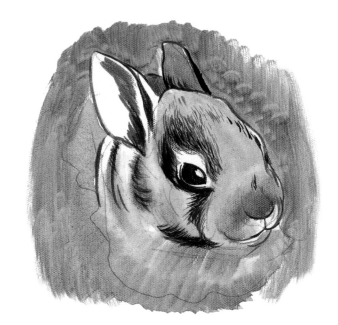

3 Finish

Add a tiny bit of Prussian Blue and Titanium White to the catchlight of the eye. Create an orangey color by mixing Cadmium Red Medium with Cadmium Yellow Medium. Apply a small edge of this color around the eye with the no. 3/0 round.

With the same brush and Ivory Black, develop the dark patterns of the fur. These patterns look like stripes around the neck. Use tiny strokes to replicate the fur.

Apply the orangey color to the area around the nose and mouth and to the ear on the right with the no. 2 round. Make quick strokes. Layer some black strokes on top to make these areas look furry.

Apply a cream color made with Titanium White and a touch of Cadmium Yellow Medium to the light areas of the rabbit with a no. 2 round. Overlap this color in the dark areas and over the orangey color of the nose and chest.

To make the fur look realistic, it is important to overlap the three colors in many layers. Study the finished painting closely; notice how many layers I applied to build up the thickness of the fur. The black, cream and orange overlap everywhere. Sometimes the dark colors overlap the light colors and vice versa.

Complete the painting by deepening the colors of the background. Use the no. 4 filbert and circular, swirling strokes to blend the colors. Apply a thicker layer of the green used in step 2. Deepen it in the upper-left corner with more Prussian Blue and a touch of Ivory Black. Use this color along the right side of the bunny to create a hint of shadow.

Swan

You do not often find a perfect example of a swan. This swan at our local zoo was actually posing for me. I laughed because its perfect shape reminded me of a soap dish! The photo turned out to be an awesome reference for artwork, with the gorgeous blue reflection of the water on the white feathers. The dark colors of the background make the swan's colors stand out even more.

Materials List

PAINTS
Burnt Umber, Cadmium Red Medium, Cadmium Yellow Medium, Ivory Black, Prussian Blue, Titanium White

BRUSHES
no. 4 filbert, no. 3/0 round, no. 2 round

SURFACE
canvas or canvas paper

OTHER
mechanical pencil, ruler, kneaded eraser

REFERENCE PHOTO
Use the grid method to draw the swan on your canvas paper.

LINE DRAWING
When you are satisfied with your drawing, erase the grid lines with a kneaded eraser.

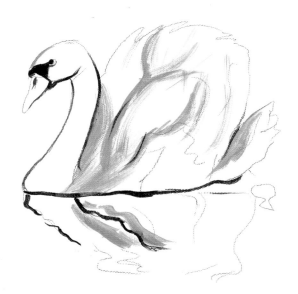

1 Begin With the Outlines

Use the no. 2 round and Ivory Black to fill in the eye and the black area around the beak. Outline some of the swan as shown. Be sure to add the line that separates the swan from the water. Mix Titanium White with a very small amount of Prussian Blue to create a light blue. Apply this to the feather area with the no. 2 round. Add some of this color to the reflection in the water below the swan.

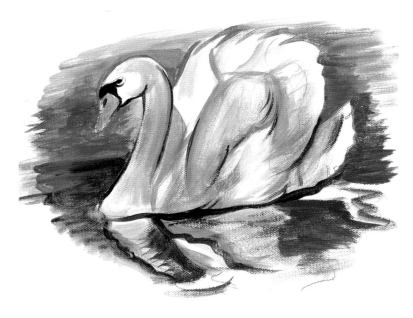

2 The Awkward Stage

Block in the colors of the composition with diluted paint. Mix a light brown by adding a dab of Burnt Umber to Titanium White. With the no. 2 round, apply this color to the neck area of the swan as well as to some of the shadow areas of the wings.

Burnt Umber is the primary background color. Mix Burnt Umber with Ivory Black for the darker areas and with Titanium White for the lighter areas. Use a no. 4 filbert and horizontal brushstrokes. Add the same colors to the water area below the swan. Notice how the patterns in the water form a mirror image of the shape of the swan. The dark edge of black you applied in step 1 separates the swan from its reflection.

Use the no. 2 round to fill in the beak with diluted Cadmium Red Medium. With diluted Cadmium Yellow Medium, fill in the small highlight area behind the neck of the swan.

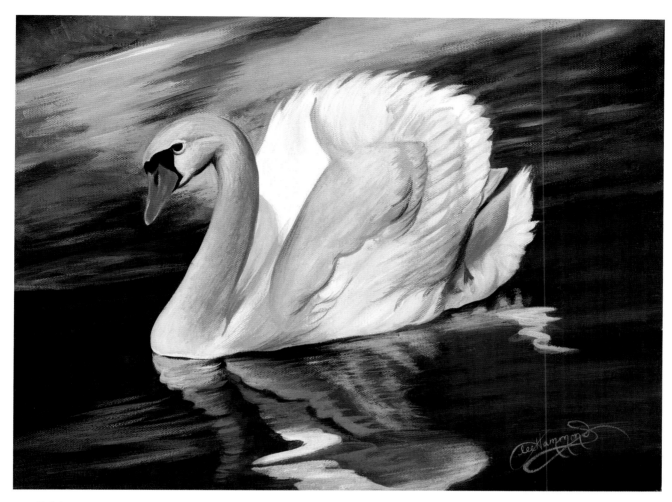

3 Finish

Apply thicker layers of color to finish. Your brushstrokes will form the textures. Look closely and you can see defined brushstrokes, especially in the background and the water reflection.

Base in the swan with Titanium White. You do not want the white of the canvas to show through. Next, layer the light brown and blue colors you used in steps 1 and 2. Use the no. 4 filbert, allowing your brushstrokes to create the form, texture and feathers of the swan.

For the shadow on the tail, mix a tiny amount of Ivory Black into the light blue color from step 1. On the back, draw in the feathers with the no. 2 round and the light brown. Edge the feathers with some of the blue.

Create the texture of the neck, where the feathers are not as distinct, with the dry-brush technique, alternating light brown and light blue over the white. Use the brown color to make the back of the neck quite dark.

Fill in the beak with pure Cadmium Red Medium, using the no. 2 round. Add a tiny bit of Ivory Black to the red, and apply the darker tone to the beak to make it look more realistic. Use a no. 3/0 round and Titanium White to add the reflected light along the edge of the beak.

Finish the background and the water with the no. 4 filbert, using the same colors you made in steps 1 and 2. Use horizontal strokes to create the textures of the background. Layer your colors from dark to light, using white last to create the look of light reflecting off the rocks.

Water reflections are fun to paint. Fill in the water with a thick layer of Burnt Umber. Add a small amount of Ivory Black to the Burnt Umber. Then apply it to the brown area for the dark streaks. With the light blue and white, create the reflections of the swan, keeping the mirror image in mind. The shapes of the swan reflect straight down, but the movement of the water makes the shapes appear squiggly.

Great Horned Owl

This photograph of an owl is another example of a stunning facial shot. I was fortunate enough to get up close and personal with many birds of prey at the Carolina Raptor Center in North Carolina. The center cares for birds that were injured in the wild. While visiting, I was able to take many gorgeous close-up photos. This great horned owl has incredible eyes. While studying the eyes, I realized that they have a striking resemblance to the eyes of a cat.

Materials List

PAINTS
Burnt Umber, Cadmium Red Medium, Cadmium Yellow Medium, Ivory Black, Prussian Blue, Titanium White

BRUSHES
no. 4 filbert, no. 4 flat, no. 2 round

SURFACE
canvas or canvas paper

OTHER
mechanical pencil, ruler, kneaded eraser

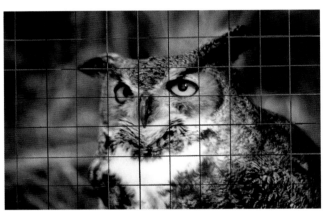

REFERENCE PHOTO
Use the grid method to capture the owl on your canvas paper.

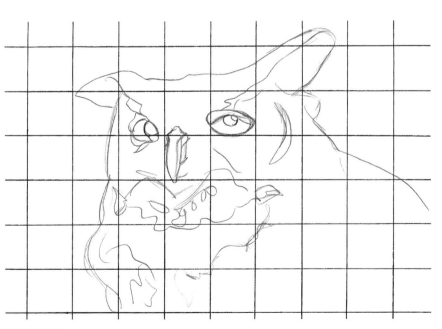

LINE DRAWING
When your line drawing looks like mine, erase the grid lines with a kneaded eraser. Be careful. Don't remove any of the details.

1 Begin With the Outlines

With Ivory Black and the no. 2 round, outline the eyes and fill in the pupils. Leave a small dot of white in the right eye for the catchlight. Fill in the inside of the ears and outline the basic shapes of the owl. Use the no. 2 round to fill in the irises with Cadmium Yellow Medium.

2 The Awkward Stage

Use the dry-brush technique to begin blocking in the colors. Start with the owl. With the no. 4 flat, scrub in Burnt Umber along the back, chest, and the left side of the body. Apply some Burnt Umber under the chin and to the top of the head. Scrub Ivory Black over these areas for more texture.

Mix a small amount of Cadmium Red Medium into some Burnt Umber, and add a touch of Titanium White. Apply this around the eyes, allowing an area of white to remain, and also apply the mixture around the beak. Next, drybrush the same color into the front area of the owl, allowing it to overlap into the brown. Dilute some of this reddish color. Then apply a shadow to the yellow of the eye with a no. 2 round. Create a blue-gray with Ivory Black, Titanium White and a touch of Prussian Blue. Apply it to the beak with the no. 2 round.

Using the no. 4 flat, scrub a blue-green mixture of Prussian Blue and Cadmium Yellow Medium into the background with a circular motion. Make an olive green with Ivory Black and Cadmium Yellow Medium and scrub it in above the head and along the side. Scrub some of the reddish color used for the owl's face into the background along the left side, above the head and along the back.

3 Finish

Apply thicker layers of paint to finish the piece. Use the no. 2 round to apply Titanium White around and above the eyes, around the beak and to the chest area. Add small dots of Titanium White to the eyes for the catchlights. In the left eye, that catchlight is in the yellow area of the iris. In the right eye, it is in the black of the pupil.

Study the painting to see how I used brushstrokes to create the feathers. They are made with curved, semicircular strokes and are layered somewhat like the shingles of a roof. Start with the deep brown and black colors, then layer the lighter colors on top. Create the lighter brown by mixing Cadmium Yellow Medium with Burnt Umber and some of the reddish color from step 2. Add these colors, using the semicircular strokes to build up the texture of the feathers. Use the same colors to texture the top of the head, but use straight brushstrokes.

Use the lighter reddish colors from step 2 in the area around the eyes. Use straight strokes that radiate outward from the edge of the eye like spokes in a wagon wheel. In the neck, this color alternates with black, making a very distinctive pattern.

Mix a very light blue with Titanium White and a touch of Prussian Blue. Then use a no. 4 flat and the dry-brush technique to apply this color on top of the white area of the chest, the dark areas of the feathers and the top of the head. This produces the effect of reflected light. Switch to the no. 2 round and paint a small edge of reflected light on the edges of the ears. Apply some streaks of this color to the beak to make it look shiny. Add small dots of Titanium White to enhance the look of the shine.

Complete the background by swirling the colors from step 2 into one another. Overlap them to achieve the out-of-focus effect.

Lion

The pose of this lion reminds me of the Sphinx. It has an air of command and dignity. The rich colors of the lion contrast strongly against the background colors. The red tones of the fur act as a complement to the green tones behind it.

Materials List

PAINTS
Alizarin Crimson, Burnt Umber, Cadmium Red Medium, Cadmium Yellow Medium, Ivory Black, Prussian Blue, Titanium White

BRUSHES
no. 4 filbert, no. 4 flat, no. 2 round

SURFACE
canvas or canvas paper

OTHER
mechanical pencil, ruler, kneaded eraser

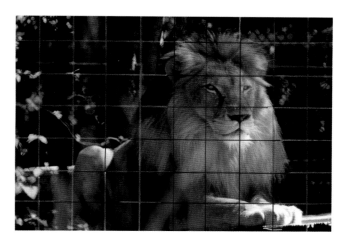

REFERENCE PHOTO
Use the grid method to capture the "King of Beasts" on your canvas paper.

Photo by Carol Rondinelli

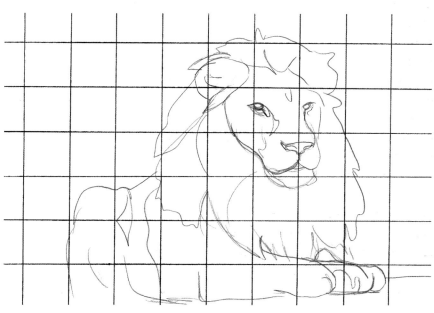

LINE DRAWING
When you are satisfied with the accuracy of your drawing, erase the grid lines with a kneaded eraser.

1 Begin With the Outlines
Use the no. 2 round to outline the shapes of the lion with Ivory Black. Do not outline the top of the head or the lower backside. These edges are light, so the background will create those edges instead.

2 The Awkward Stage
Use the no. 2 round and diluted paint to block in the colors. Apply a transparent layer of Burnt Umber to the sides of the face and to the nose and the area around it. Add some of this color to the top of the front leg.

Apply a thicker layer of Burnt Umber to the shadowed areas on the side and under the mane as well as on the top of the back. Add some Cadmium Yellow Medium to Burnt Umber to create a golden brown. Apply this color to the areas of the ear and mane, and fill in the eyes.

Add Cadmium Red Medium to Burnt Umber to make a rust color. Use this on the nose and under the chin. Then apply it to the lower edge of the front leg and paw, and fill in the side of the belly and the rear leg and thigh.

Make a green with Cadmium Yellow Medium and Prussian Blue, and fill in the background. The bottom is a deeper color with more Prussian Blue.

For the area under the lion, mix a gray from Ivory Black and Titanium White with just a touch of the green from the background to make it look more colorful.

3 Finish

Apply thicker layers of color to finish. This stage is all about the brushstrokes. Create the mane with long strokes that follow the direction of the fur. Layer the colors from dark to light. Use the Burnt Umber first, then the rust, and then the golden brown. To deepen and enrich the red tones of the fur, add some Alizarin Crimson to the rust. Use Titanium White for the highlights. These colors combined with the brushstrokes make the mane look thick.

Create the rest of the body with layers of the same colors. Study the finished example to see how I used the three colors to create the lights and darks of the fur. The strong light source provides a lot of contrast. All of the bright highlight areas are Titanium White. Use Titanium White and quick strokes to paint the whiskers.

Use the no. 4 filbert to apply thicker applications of green to the background in swirling brushstrokes. Vary the colors, using the light shades on the left side and the dark shades on the right and toward the bottom.

Create the surface that the lion is lying on with shades of gray. It is quite dark underneath the lion. Combine Burnt Umber, Ivory Black and Titanium White for this color. Use the no. 4 filbert. Then add to the gray a touch of Titanium White and a touch of the green from the background and streak the mixture into this area so that it won't look flat and boring. Streak some of the golden brown along the left edge of the ground to separate this surface from the background.

The top portion of the surface, which is to the right of the lion's front paws, is much lighter, due to the light source. Add a lot of Titanium White to the gray mixture and apply it here. Streak some medium gray into the mixture. Add a touch of Cadmium Red Medium to the light gray, and apply it to the top edge of the surface.

People

NOTHING IS MORE REWARDING THAN CREATING A REALISTIC PORTRAIT OF A SPECIAL person. I have specialized in portraiture for my entire career. I've created thousands of portraits of children, families, presidents and NASCAR drivers. My composite sketches and forensic illustrations help law enforcement officials capture criminals and solve "John Doe" mysteries. My first book was *How to Draw Lifelike Portraits From Photographs* (North Light Books, 1995). While people are a popular subject for a lot of artists, they are also considered one of the hardest subjects to portray in art.

The difficulty comes from the need to be totally accurate. If anything about the portrait is not right, the likeness of the person is lost. I always suggest that my students try drawing portraits before they attempt to paint them. Drawing is the best way to get a good solid understanding of facial anatomy. This chapter will give you some experience with portrait painting. You'll learn how to mix good hair and skin tones and what to look for in the anatomy of a face.

LeAnne
16" × 12" (41cm × 31cm)

Mixtures for Skin Tones

There is a myriad of skin colors in the world, each one made up of highlights and shadows. Study your picture carefully to see how colors change depending on the lights and shadows. Each picture and each face is different.

The swatches on this page will give you some of the most common skin tones and the formulas to use to paint them. Don't limit yourself to these; experiment. These swatches merrepresent merely a few of the different hues often seen in skin tones. Remember what I said about all people being unique—that goes for skin too!

All of these colors have a million variations from light to dark within them. The corresponding swatches show a value-scale approach, illustrating the wide range of color created by adding lights or darks.

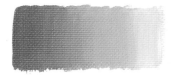

LIGHT COMPLEXION COOL

Create this very pink tone often seen in pale skin by mixing Titanium White with Alizarin Crimson and a touch of Cadmium Red Medium. Simply add more white to lighten the values further. Because of the Alizarin Crimson, the hue has a cool tone.

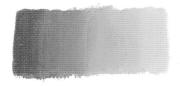

LIGHT COMPLEXION WARM

This mixture is used for many Caucasian skin tones. It is similar to the basic pink color, but it has more yellow, making it more of a warm peach. Mix Titanium White, Cadmium Red Medium and a touch of Cadmium Yellow Medium. Create the wide range of values by adding more white to make them lighter or more red to make them darker.

DARK COMPLEXION WARM

This skin tone is very deep. It is similar to the basic peach color, but the brown makes it darker. Mix Titanium White, Burnt Umber, Cadmium Red Medium and a touch of Cadmium Yellow Medium. The Cadmium Red Medium keeps the tones warm.

BROWN COMPLEXION WARM

This skin tone is very brown and warm. Mix Titanium White, Burnt Umber and a touch of Cadmium Red Medium.

DARK COMPLEXION COOL

This is a cool version of a deep skin color. Mix Titanium White, Alizarin Crimson, Burnt Umber and a touch of Prussian Blue. The addition of blue cools the mixture.

SHADOWS

This is a shadow color used with all of the skin tones. It is created by mixing Burnt Umber and Alizarin Crimson.

Nose

The nose is the simplest of all the features, so let's start there. This facial feature shares many elements with the sphere.

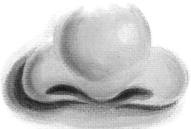
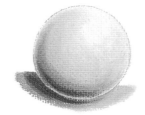

Look at this baby nose. The nose of a baby is so round, the sphere is actually replicated in the tip.

Nose Profile

Nose, Front View

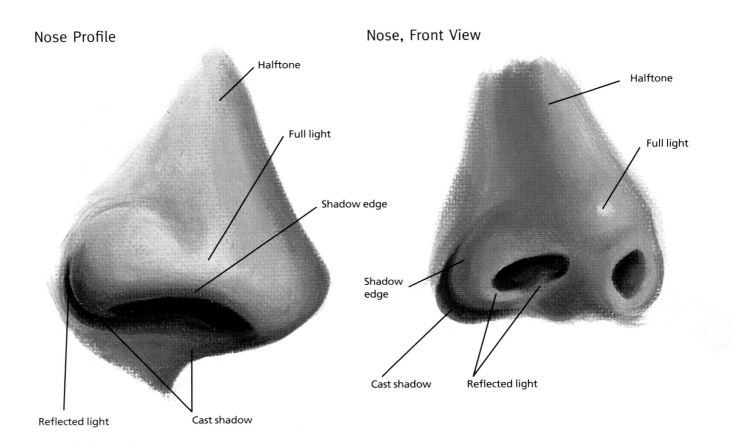

Halftone

Full light

Shadow edge

Reflected light

Cast shadow

Halftone

Full light

Shadow edge

Cast shadow

Reflected light

Download free bonus material at Artistsnetwork.com/LeeHammondsBigBookOfAcrylicPainting.

Monochromatic Nose

It is easier to learn to paint in a monochromatic color scheme, so you can concentrate strictly on blending tones.

Materials List

PAINTS
Ivory Black, Titanium White

BRUSHES
nos. 1 and 4 round

REFERENCE PHOTO
Study this nose carefully for shape and shading. Use the grid method to draw the nose on your canvas paper. Remove the grid lines with a kneaded eraser when the drawing is accurate.

GRAY SCALE
Match your tones to this gray scale.

1 Begin With Halftones
Place dime-sized blobs of black and white paint onto your palette. Add a touch of black to a small amount of white to get a light gray. Basecoat the entire nose with this mixture and the no. 4 round.

Add a touch more black to deepen the gray and fill the cast shadow on the left.

With the no. 1 round, add more black to make a dark gray for the nostril area, the edges of the nose, and the contour of the bridge.

2 The Awkward Stage
With the no. 4 round, add the shadow areas of the nose with a medium gray. The paint can be a little transparent. The painting looks a bit sloppy at this stage, and this is where many beginners put the brush down and quit. But don't! All paintings go through this stage. Continue adding tones to build the layers and create the form.

3 Finish
Use thicker paint and the dry-brush technique to rub in different gray tones. It may take many layers to get the look of this example. It is merely a process of adding light, medium and dark gray tones to the painting and fading them into one another. Place each tone according to the light source and the five elements of shading (see chapter three).

Mouth

The mouth is the feature that most expresses the mood of the individual, offering a smile for happiness and a frown for sadness. It can also exude anger, surprise, hesitation and joy. For an artist, the mouth can hold many challenges because of its structure.

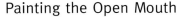

Tip: Do's and Don'ts of Painting Teeth

- **Don't paint teeth white.** Teeth, no matter how many treatments the dentist has applied, are not white! Even if they were, being inside the mouth, they're altered by the effects of shadows and reflected color. Most teeth will have a yellowish and gray cast to them.

- **Don't paint a hard line between each tooth.** A dark line actually represents space. A hard, dark line would mean the teeth were not touching and you were seeing between them. Use a soft color where the teeth touch.

- **Do keep the bottom teeth in shadow.** They are farther behind, so they will always be shadowed.

- **Do give each tooth a unique shape.**

- **Do create the gum line and the dark shapes below the teeth as shapes.** This helps maintain the tooth shape as you draw.

Painting a Closed Mouth

To paint the closed mouth remember two things:

- The upper lip is generally darker than the bottom because of the angle of the lips and the way they reflect light.

- The corners of the mouth create a dark comma shape called the "pit" of the mouth. It is important to capture this to keep the mouth from looking flat.

Painting the Open Mouth

The open mouth is full of complexities due to the teeth. It is crucial to capture the size, shape and placement of a person's teeth. If not, the likeness will be lost.

The position of your subject, as well as the subject's mood, will alter the view of the mouth. A mouth from the side has a protruding shape created by the teeth. The upper lip angles in and the lower lip angles out. This is what makes the upper lip appear darker. The angle of the bottom lip gathers more of the light source.

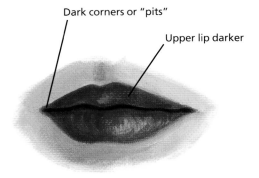

Dark corners or "pits"

Upper lip darker

CLOSED MOUTH

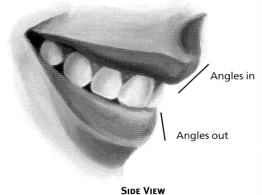

Angles in

Angles out

SIDE VIEW

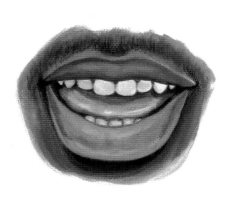

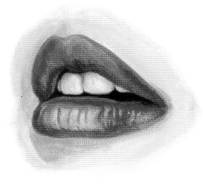

OPEN SMILE
Each person's teeth are unique. Capturing their exact form is essential to a realistic portrait.

Download free bonus material at ArtistsNetwork.com/LeeHammondsBigBookOfAcrylicPainting.

Monochromatic Mouth

Materials List

PAINTS
Ivory Black, Titanium White

BRUSHES
nos. 1 and 2 round

Now is the time to put what you've learned about the parts of the mount into practice. Once again, you will start with a monochromatic color scheme.

Notice how the upper lip and the pits on the sides appear darker. Create an accurate line drawing using the grid method. Carefully remove the pencil lines with a kneaded eraser when you are done.

GRAY SCALE
Match your tones to this gray scale.

1 Begin With Halftones
Dilute the gray tones to mix light, medium and dark gray. Start with the white first, and then gradually add some black to achieve the right value. Use the gray scale as a reference. With the no. 1 round, capture the main shapes with some of the dark gray. Add some of the medium gray to the upper lip.

2 The Awkward Stage
Continue adding tone with the no. 2 round using the light, medium and dark colors. The paint should still be fairly thin.

3 Finish
Use a thicker application of paint to cover the canvas entirely. Drybrush all the tones together.

Slight Smile

This mouth is slightly opened, revealing the teeth. It will give you an introduction to painting teeth, a little at a time.

Materials List

PAINTS
Alizarin Crimson, Burnt Umber, Cadmium Red Medium, Cadmium Yellow Medium, Titanium White

BRUSHES
nos. 1 and 2 round

REFERENCE PHOTO
Use the grid method to create an accurate line drawing on your canvas paper. The teeth must be absolutely exact in their size, shape and placement. When you are sure of the accuracy, remove the grid lines with a kneaded eraser.

DARK COMPLEXION WARM
Follow the instructions at the beginning of this chapter to mix light, medium and dark versions of this color. Use pure Burnt Umber or add more Burnt Umber to this mixture for the shadow areas.

1 Begin With Halftones
Fill in the area inside the mouth with Burnt Umber and the no. 1 round. This will help create the shape of the teeth. Create the corners (the pits), too.

With a mixture of white, Burnt Umber and Alizarin Crimson, block in some color around the mouth and upper lip.

Begin to block in the skin tones on the lips and face.

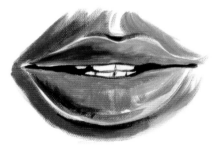

2 The Awkward Stage
Create a lighter value by adding some white to the mix, and continue filling in the lips using the no. 2 round. With Burnt Umber, add some shadow under the bottom lip and along the upper lip, and shape the teeth.

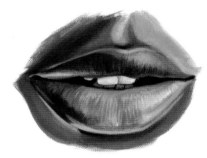

3 Finish
Drybrush using thicker applications of paint to build and blend the colors together. Add highlights to the bottom lip with the no. 1 round and quick strokes. Apply the edge of reflected light along the upper and lower lip as well.

In this example, the teeth are a very light brown. Mix a dab of Burnt Umber with white and fill in the teeth. Add a touch of Cadmium Yellow Medium.

Full Smile, Female

A full smile can be one of the most challenging things to paint. Every tooth must be perfect. If I painted a portrait of you, but painted the teeth in a general way, not paying attention to your unique tooth shape, the portrait would look similar to you, nothing more.

Materials List

PAINTS
Alizarin Crimson, Burnt Umber, Cadmium Red Medium, Cadmium Yellow Medium, Titanium White

BRUSHES
nos. 1 and 2 round

REFERENCE PHOTO
Use the grid method to capture this open mouth smile on your canvas paper. Be careful to see how each tooth is placed inside of its corresponding box. I used a ½-inch (13mm) grid to tighten up the accuracy. Take your time. When you are sure of the accuracy, carefully remove the grid lines with a kneaded eraser.

LIGHT COMPLEXION WARM
Follow the instructions at the beginning of this chapter to mix a light, warm complexion.

1 Begin With an Outline
With Alizarin Crimson and the no. 1 round, outline the lips, the gum line, and the shapes of the teeth.

2 The Awkward Stage
Begin adding color to the lips with full-strength Cadmium Red Medium to capture the color of the lipstick. Leave a small area on the bottom lip for the highlight. Use the no. 2 round and adiluted light peach color to paint in the skin tone around the mouth.

Add a hint of Burnt Umber to Titanium White to get an off-white color. Basecoat the teeth, making them getting darker as they recede into the mouth. Shadow the back teeth by adding more Burnt Umber to the mixture.

3 Finish
Add Alizarin Crimson to Cadmium Red Medium for a realistic darker color for the shadows. Leave the reflected light along the lower edge of the upper lip. Add the highlight on the bottom lip with Titanium White.

Deepen the skin color of the face by adding a touch of Burnt Umber and Alizarin Crimson to the peach mixture. Dry-brush over the existing application.

Add details to the teeth, one at a time. Each tooth contains many colors, so study the example carefully. Some will reflect the red of the lipstick. Some have white highlights. There are gray and brownish shadows, too. Work on them for as long as it takes to replicate this example.

Full Smile, Male

The more you practice the better you will become. You may still feel clumsy, but do not quit. It takes time to become proficient with anything. This exercise will give you more practice painting teeth.

Materials List

PAINTS

Alizarin Crimson, Burnt Umber, Cadmium Red Medium, Cadmium Yellow Medium, Titanium White

BRUSHES

nos. 1 and 2 round

PHOTO REFERENCE
This man's mouth is slightly turned, and the light source is not straight as it was on the female's full smile.

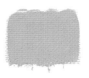

LIGHT COMPLEXION WARM
Follow the instructions at the beginning of this chapter to mix a light, warm complexion.

1 Paint Halftones and Outline the Gum Line

With Alizarin Crimson and the no. 1 round, outline the lips, the gumline, and the shapes of the teeth. Be sure to maintain their accuracy. With an off-white color that leans towards yellow, base in the teeth.

Basecoat the skin tones with a medium peach mixture, using the no. 2 round.

2 The Awkward Stage

Use the no. 2 round. Add a touch of Alizarin Crimson and Burnt Umber to the medium skin tone mixture and add color to the lips. Continue to build up the skin tone around the mouth. The colors are darker on the left side due to the light source; use more of the Alizarin Crimson and Burnt Umber mixture here.

Begin adding gray and brownish shadows to the teeth. The teeth are darker on the left side, reflecting the skin color. Add white highlights to the teeth on the right using the no. 1 round. Do not quit early; the more you do, the more realistic the teeth will look. Continue to build up the skin tone around the mouth.

3 Finish

Drybrush to build up the skin tones and refine the painting. Use Titanium White to add highlights that show the light is coming from the right.

Profile

Each of the facial features connects to the others. You have practiced drawing both the nose and the mouth separately. Now it is time to put the two together. This exercise will give you practice painting a profile and the natural connection of the nose to the mouth. Resist the urge to do an entire face at this stage. It is much better to learn the features a little at a time before trying to capture an entire likeness.

Materials List

PAINTS

Alizarin Crimson, Burnt Umber, Cadmium Red Medium, Cadmium Yellow Medium, Titanium White

BRUSHES

nos. 1 and 2 round

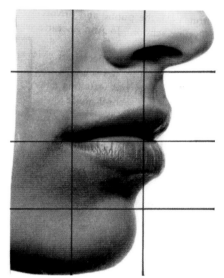

REFERENCE PHOTO
Use the grid method to capture these shapes on your canvas paper. When you are sure of the accuracy, remove the pencil lines with a kneaded eraser.

LIGHT COMPLEXION WARM
Follow the instructions on at the beginning of this chapter to mix a light, warm complexion. This skin has a touch more Burnt Umber to it, with not as much of the red tones. Each face is different. Adjust your paint mixtures accordingly.

1 Begin Halftones
With the light peach mixture, basecoat the skin tone using the no. 2 round. Fill in the nostril area with Burnt Umber and the no. 1 round. Fill in the upper lip with a diluted mixture of Alizarin Crimson and Burnt Umber. Leave the white of the paper showing on the majority of the bottom lip.

2 The Awkward Stage

Lighten the upper lip mixture with some Titanium White. Use the mixture to fill in the bottom lip and drybrush it into the skin tones to develop the face. Pay particular attention to the area between the nose and the mouth. This area connects the nose to the lips and is a part of the lips' overall shape. It differs from one face to the next, as far as how pronounced it will appear. In most cases, it resembles the shape of a teardrop. Here, it looks like an upside down V-shape due to the angle. Add a little more Burnt Umber to your mixture and begin the shadows.

3 Finish

Drybrush with a thicker application of paint to build the skin tones. Look for the five elements of shading in the rounded areas, such as the nose, lips and chin. Remember the reflected light around the rim of the nostril.

Use white for the highlights on the nose and lower lip and apply them with the no. 1 round.

Eyes

Eyes hold the essence of the portrait. It is essential to draw and paint eyes accurately. Any distortion or lack of detail will interrupt the believability of your work.

The eye can be a difficult thing to paint. Breaking down and memorizing the eye's separate, puzzlelike shapes will make it easier to include them in your work.

Twelve Crucial Eye Shapes

These shapes must always be included in your portraits:

1 The iris
2 The pupil
3 The sclera
4 The catchlight
5 The corner membrane
6 The upper eyelid
7 The lid crease
8 The lower-lid thickness
9 The lash line
10 The upper lashes
11 The lower lashes
12 The eyebrow

TWELVE SHAPES MAKE THE EYE
Commit each shape in the eye to memory.

EYES ARE THE MOST IMPORTANT PART OF THE PORTRAIT
Emotion is captured through the eyes. Without seeing the rest of the face, or even the other eye, you can feel the sadness and the pain of this subject.

Eye Color

One of the things I like best about painting eyes is capturing their beautiful colors. These are three examples of the most common eye colors, but there are variations of each.

Although each of these eyes is very different, they share the twelve key features.

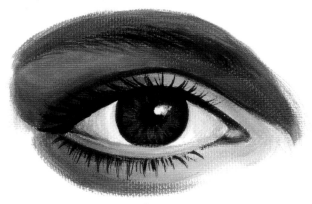

BURNT UMBER CREATES BROWN EYES
The iris of the eye contains patterns. The patterns radiate outward from the pupil, much like a wagon wheel. Brown eyes generally take a lot of Burnt Umber.

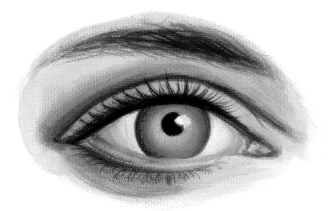

TOUCH PRUSSIAN BLUE INTO WHITE FOR BLUE EYES
Blue eyes do not have patterns like brown ones. They have a smoother, glassier appearance. A touch of Prussian Blue into Titanium White will make this shade of blue. Add a hint of Ivory Black to the mix for the darker outer rim.

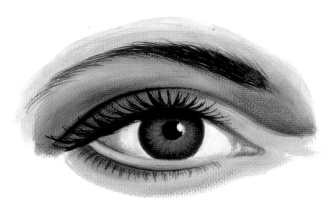

BRING OUT THE PALETTE FOR GREEN EYES
Green eyes are the most colorful and will have many colors within the iris. Study this eye closely and you will see yellow, blue and brown within the mix. Begin with a medium green made by mixing Prussian Blue, Cadmium Yellow Medium and a dab of Titanium White. Add some Ivory Black to the outside rim of the iris for the dark edge. Make the light patterns by adding more Cadmium Yellow Medium to the green mixture.

Eyebrows and Eyelashes

Any type of hair is always painted in last. This is true for facial hair, hair on the head, and the eyelashes and eyebrows. All the skin tones and detail must be completed first.

Before you begin the eye exercises, it is important to understand how to paint the lashes and brows. It is not as difficult as it seems. They are painted in layers.

Materials List

PAINTS

Burnt Umber, Cadmium Red Medium, Cadmium Yellow Medium, Titanium White

BRUSHES

no. 2 round, no. 3/0 liner

DON'T
These lines are too heavy and thick. Always use a quick stroke to make the lines taper at the ends.

Do
A quick stroke makes the hair look realistic. The ends must taper.

DON'T
Lashes must not be created with thick, harsh lines. Eyelashes grow in clumps.

Do
Quick, clumped strokes make lashes look realistic. The ends taper, just like the brows.

1 Create the Skin Tone
Skin tone must always be underneath the brow area before you apply the hairs. This is a light complexion.

2 Begin Strokes
With the no. 3/0 liner, layer very quick strokes with a very diluted Burnt Umber. Follow the growth and direction of the hairs. They all grow from a different spot.

3 Finish
Continue to build the brow with many layers.

1 Create the Skin Tone
As before, apply the skin tone underneath the brow area first. This is a light complexion. The lashes grow from the lash line. Use the no. 3/0 liner, diluted paint and very quick strokes.

2 Build the Clumps
Continue adding the lashes in small clumps.

3 Finish
Make the lashes longer on the outside edge. This is due to perspective. The ones in front seem shorter because they are being viewed from the front. We don't see the entire length.

Monochromatic Eye

To learn how to paint the eye, try one in black and white. A monochromatic scheme is always easier. It allows you to concentrate on the anatomy and details, without having to worry about color.

Materials List

PAINT

Ivory Black, Titanium White

BRUSHES

no. 2 round, no. 3/0 liner

GRAY SCALE
Match your tones to this gray scale.

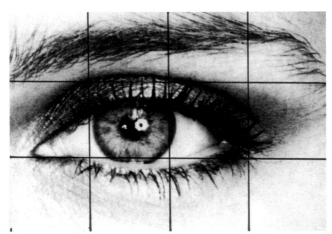

REFERENCE PHOTO
Locate and identify all twelve distinct parts of the eye. Refer back to the diagram earlier in this chapter of the twelve eye shapes if you need to. Knowing these shapes before you begin to draw is very important.

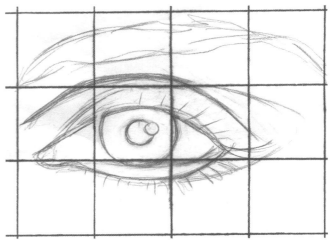

GRID DRAWING
Use the grid method to draw the eye on your canvas paper. Look for all twelve shapes that make up the eye. When you are sure of the accuracy, carefully remove the grid lines with a kneaded eraser. It is very important that the iris and the pupil are perfect circles. Place a circle template over your drawing that matches the size to the circle you drew with the grid. Make the edges of the iris crisp. Do the same with the pupil.

It is also essential that the pupil is perfectly centered within the circle of the iris. Leave a small area for the catchlight. Regardless of the photo reference, I always move the catchlight over so it is half in the pupil and half in the iris. If there is more than one catchlight in the photo, reduce the number to only one.

1 Create the Outline

With the no. 1 round, outline the iris and paint in the lash line and lid crease with pure black. Be sure to keep the iris a perfect circle. Fill in the pupil, leaving an area for the catchlight.

Refer to the gray scale to create a medium gray color and fill in the iris, above the lid crease and the eyebrow area. Add some medium gray below the eye to create the lower lid thickness.

2 The Awkward Stage

With dark gray and the no. 1 round, basecoat the entire upper eyelid. Add some of the same gray below the lower lid thickness. Add some Ivory Black to the iris to make it darker. Once the middle of the upper lid dries, drybrush some white over the middle to add a highlight. This represents the light source, which is coming from the front.

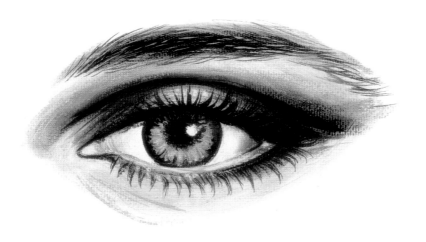

3 Finish

With the no. 3/0 liner, detail the patterns of the iris by alternating black and white paint. The pattern is darker toward the center and radiates outward like a wagon wheel. Use pure white for the catchlight.

Before adding the eyelashes and eyebrows, add some light gray around the eye to represent the skin tone. Then add the eyelashes and eyebrows with the no. 3/0 liner and Ivory Black. Dilute the paint with some water so you can achieve very quick strokes with the brush. Thin paint will help the lines taper at the ends.

Eyes and Ellipses

A circle is only a circle when seen from the front. The following examples show what happens when the eye is looking in a different direction.

When eyes are looking to the side or up or down, the iris and pupil seem less round and more narrow. They are condensed into either vertical or horizontal ellipses.

As with a circle, an ellipse can be drawn with a template. The shape should always be freehanded first and then cleaned up with the template for accuracy.

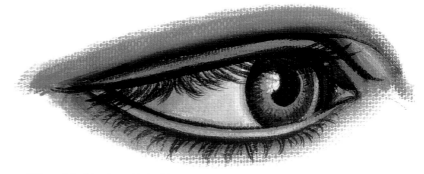

This eye is looking from side to side. That changes the iris and pupil into vertical ellipses.

VERTICAL ELLIPSES
This is what happens to a circle when viewed from a vertical angle.

This eye is looking up, which changes the circle of the pupil and the iris into horizontal ellipses. The circle appears flattened and wider from side to side.

HORIZONTAL ELLIPSES
This is what happens to a circle when viewed from a horizontal angle.

Profile: Eyes and Nose

It's time to draw the eye at a different vantage point, showing the connection between the eye and the nose.

Viewing the eye from this perspective changes everything we have learned about eye anatomy. From this angle, you can still see both the iris and the pupil; however, they appear elongated, not round at all. Their shape are circles in perspective.

Materials List

PAINTS

Alizarin Crimson, Burnt Umber, Cadmium Red Medium, Cadmium Yellow Medium, Ivory Black, Titanium White

BRUSHES

nos. 1 and 2 round, no. 6 filbert, no. 3/0 liner

REFERENCE PHOTO
Use the grid method to create the shape of this nose and eye on your canvas paper. Allow the boxes to guide you with the placement of the nose and eye. When you are happy with your line drawing and its accuracy, carefully remove the grid lines with your kneaded eraser.

LIGHT COMPLEXION WARM
Follow the instructions on at the beginning of this chapter to mix light, medium and dark versions of this peach color.

Add Burnt Umber and Alizarin Crimson to the mixture to create the shadows.

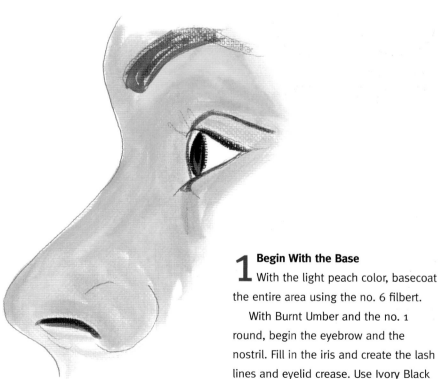

1 Begin With the Base

With the light peach color, basecoat the entire area using the no. 6 filbert.

With Burnt Umber and the no. 1 round, begin the eyebrow and the nostril. Fill in the iris and create the lash lines and eyelid crease. Use Ivory Black to fill in the pupil.

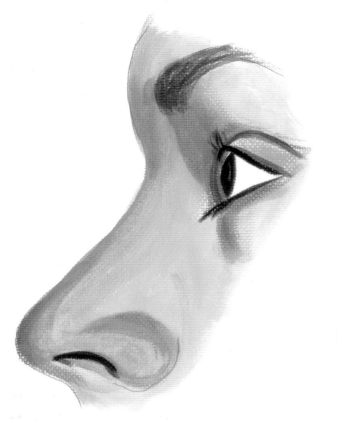

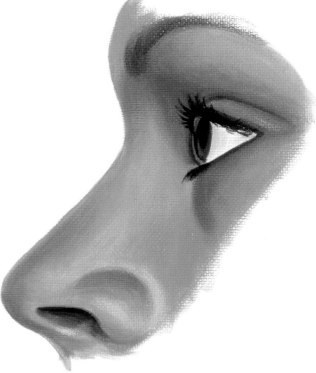

2 The Awkward Stage

Add some Burnt Umber and Alizarin Crimson to the light peach mixture and apply it down the bridge of the nose, the edge of the nostril, and between the brow and the eye using the no. 2 round.

At this angle, you can see the inside of the eyelid in front of the pupil. Create this reddish color with Cadmium Red Medium and a touch of Titanium White. Apply it with the no. 3/0 liner.

3 Finish

Using the no. 2 round and a thicker application of paint, continue drybrushing the mixtures together. Add some of the shadow color inside the nostril area. Add Titanium White to the highlighted areas and to the sclera area. Add a touch of Burnt Umber to the white for the light shadow in the sclera.

With the no. 3/0 liner and Ivory Black, add the eyelashes with quick, curved strokes.

Set of Eyes

Now that you have practiced painting the eye, it is important to learn how to put two eyes together. It is difficult to paint portraits without first practicing the key elements of doing this.

Let's begin with two eyes directly from the front and paint them in a monochromatic black and white.

Materials List

PAINTS

Ivory Black, Titanium White

BRUSHES

no. 1 round, no. 6 flat or filbert, no. 3/0 liner

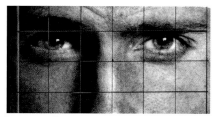

REFERENCE PHOTO

Use the grid method to create these eyes on your canvas paper. When you are happy with your line drawing and its accuracy, carefully remove the grid lines with a kneaded eraser.

With a template, clean up the edges of the iris and pupil. Use the same hole in your template for both eyes. It is very important when rendering two eyes together that the irises and pupils are exactly the same size in each eye.

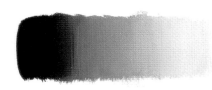

GRAY SCALE

Match your tones to this gray scale.

1 Begin With Outlines

With the no. 1 round, fill in the pupils, allowing a small area for the catchlights. The catchlights should be half in the pupil and half in the iris, and they should be in the same spot in each eye.

Switch to the no. 3/0 liner and outline the iris, the lash line and the eyebrow. Add some white to the black to make a medium gray, and outline the bridge of the nose. Paint in the line that represents the lower lid thickness. Refer to the gray scale.

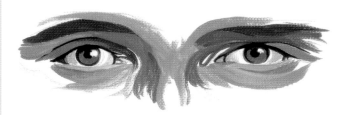

2 The Awkward Stage

With the no. 6 flat or filbert and medium gray, fill in the skin tone. Fill in the irises with the same mixture. Add more black to darken the medium gray mixture and fill in the eyebrows.

Add white to the sclera and shadow them with some light gray to make the eyes look rounded.

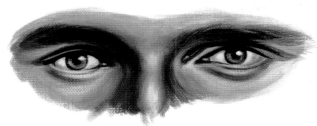

3 Finish

Continue adding layers. Use light, medium and dark gray to drybrush the colors together. Use white for the highlight areas.

Add the hairs of the eyebrow with the no. 3/0 liner, layering black and medium gray with quick strokes.

Develop the details of the irises by adding some highlights around the pupils. Add white for the catchlights.

Three-Quarter View of Eyes

The ¾-view is the most difficult because it involves a slight turn. Your brain will want you to draw these eyes straight on. You must resist the urge to make them symmetrical. You only see one side of the nose, and it blocks the view of the eye on the right. The pupils and irises are slight vertical ellipses. If you make them perfect circles, it will make the eyes look as if they are looking at you too much. Freehand the shapes. Then use an ellipse template to clean up the edges.

Materials List

PAINTS

Ivory Black, Titanium White

BRUSHES

nos. 1 round, no. 6 flat or filbert, no. 3/0 liner

GRAY SCALE
Match your tones to this gray scale.

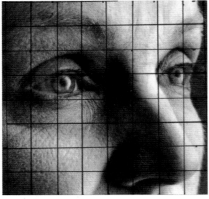

REFERENCE PHOTO
Use the grid method to create a line drawing. Then erase the grid lines with a kneaded eraser. Use a template to make the circles of the irises and pupils crisp.

1 Begin With Outline

With the no. 1 round, outline the features with black. Fill in the pupils, allowing a small area for the catchlights.

With black and medium gray, outline the major shapes using the no. 3/0 liner.

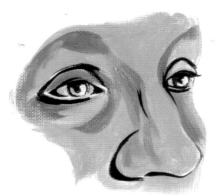

2 The Awkward Stage

With the no. 6 flat or filbert and medium gray, fill in the skin tone. Fill in the irises with the same color. Add black to darken the medium gray mixture and then fill in the eyebrows.

Add white to the sclera and shadow them with some light gray.

3 Finish

Continue adding layers. Use light, medium and dark grays to drybrush the values together. Use white for the highlight areas.

Add the hairs of the eyebrow with the no. 3/0 liner, layering black and medium gray with quick strokes.

Develop the details of the irises by adding some highlights around the pupils. Add white for the catchlights.

Other Characteristics of Eyes

The key to making eyes look realistic is to capture them as shapes. Look for the five elements of shading. Look at the white highlight areas. Look at black areas of glasses as shapes too. These shapes go together like a puzzle to create the overall form. The key is capturing what you actually see, not what you know it "should" look like.

PAINT IN LAYERS
Finding photos of interesting features will give you lots of good practice. The wrinkles and bushy eyebrow hairs here are aplied in layers with the no. 3/0 liner. Place the dark areas first and then place the light details.

GLASS SHADOWS AFFECT THE FACE
Glasses affect the look of the shadows and highlights, distorting part of the eye anatomy. Look for where light and dark patterns are transferred onto the face. Paint only what you see.

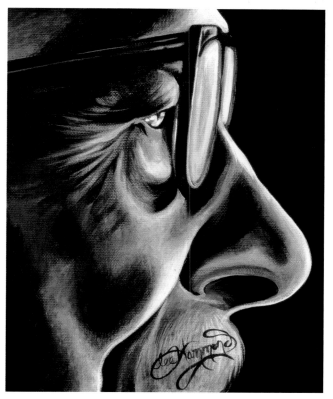

LOOK FOR LIGHT AND DARK PATTERNS IN GLASSES
Create a grid to practice drawing all the patterns you see in these glasses. Then try your hand at painting them.

Profile: Eyes With Glasses

This is a good project for learning how to paint eyeglasses. Rather than painting the entire portrait, I chose to focus on the eyeglasses. While they may seem somewhat difficult, you will see by the step-by-step approach that they can be simply created with abstract shapes and areas of color.

Materials List

PAINTS
Burnt Umber, Cadmium Red Medium, Cadmium Yellow Medium, Ivory Black, Prussian Blue, Titanium White

BRUSHES
Nos. 1 and 2 round, no. 4 filbert

LIGHT COMPLEXION WARM
Follow the instructions at the beginning of this chapter to make light, medium and dark versions of this skin tone.

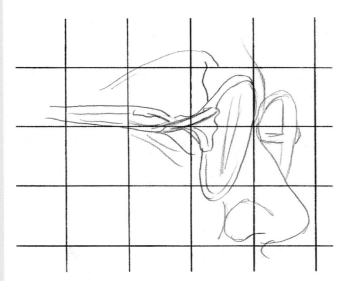

LINE DRAWING
Draw a grid on your canvas paper and copy the shapes you see in each box. Watch for the shapes within each box, and resist the urge to draw what you "remember" glasses to look like. See them purely as puzzle piece shapes!

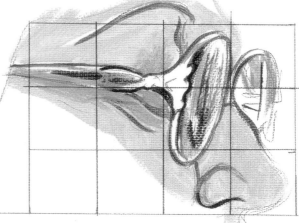

1 First Layers
Remove the grid lines from your canvas when you are sure of the accuracy. I left them in this illustration to help you see the abstract painted shapes in the glasses.

Use the no. 4 filbert to basecoat the skin with the light complexion warm middle tone. Switch to the no. 2 round and apply this mixture in the glass area, too. Use the no. 1 round to outline the shapes of the frames and the lenses with diluted Burnt Umber. Use the diluted Burnt Umber and the no. 1 round to add her eyebrow and the lines around her eye and nose as well.

With a mixture of Prussian Blue and Titanium White, apply some light blue to the frames using the no. 1 round. Add this light blue color inside the lens area, too. These shapes are mere streaks. Don't try to be overly exact. They represent reflections of color and are very abstract around the eyes.

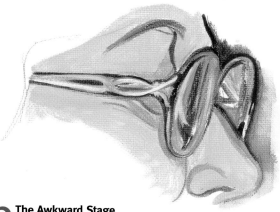

2 The Awkward Stage

Continue adding small nuances of color with the no. 1 round. The glasses reflect all of the surrounding colors of the skin and background. The colors overlap in puzzlelike shapes. This is the way to create the illusion of shine in both the frames and the glass. It is all about contrasts.

Work in the gold color of the frames using Titanium White, a touch of Cadmium Yellow Medium and a bit of Burnt Umber. Create the darkest areas of the glasses with pure black. Create the lightest highlights with pure white.

Begin the background with a diluted mixture of Prussian Blue and Ivory Black. Add this mixture into the patterns reflecting in the glass lenses. Use the background color to help create the light edges of the glasses on the right.

Begin the shadow underneath the glasses with the darker version of the skin tone mixture.

3 Finish

This is where the blending comes in. With a thicker application of paint, drybrush to layer and soften the colors together. Go back and forth adding light and dark colors until your glasses look as realistic as mine. Keep darkening the shadow on the skin that is created by the glasses. This is very important, and should not be overlooked. It is this shadow that makes the glasses appear to be resting on the face.

GLASS SHADOWS AFFECT THE FACE

Glasses affect the look of the shadows and highlights, distorting part of the eye anatomy. Look for where light and dark patterns are transferred onto the face.

A profile can be a great way to capture personality. My friend Trudy is one of the most interesting people I know. I took this picture during one of our trips together, and it captures her as she was working on her artwork, lost in thought. Even though you cannot see her eyes, you can feel her essence.

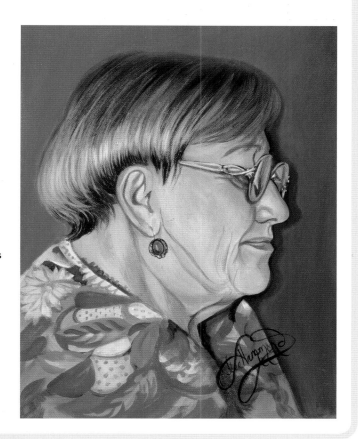

Ear

By now you've learned how important shapes are when drawing or painting. Look at anything you want to capture as interlocking puzzle pieces.

The ear is one of the facial features that will test that theory and your ability to implement it. My students are constantly telling me how difficult it is for them to accurately depict an ear. They find the shapes very difficult to capture.

Everyone's ears are unique. However, each one has the same fundamental structure, which you should commit to memory.

Keys to Painting Ears

The ear is multisurfaced and multidimensional. There is an inner ear and an outer ear.

- The outer ear overlaps the inner, creating a ridge that reflects light and casts a shadow.

- The "cup" of the ear has raised cartilage areas that resemble a curved Y-shape.

- Every raised area of the ears' surface will reflect light, so the contrasts can be extreme.

- Ears sit at a slight angle. Do not make them straight up and down.

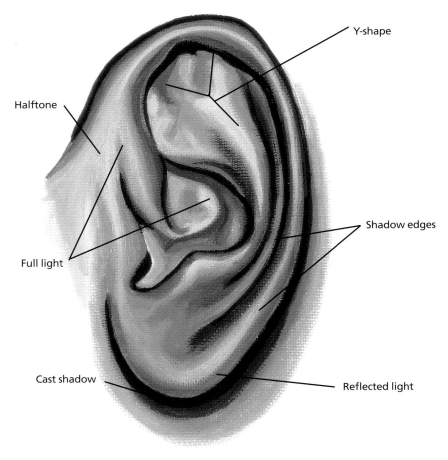

EAR PARTS TO REMEMBER
The ear is made up of multiple shapes within shapes. It is multidimensional with many overlapping surfaces. Though all ears are unique, they all share these basics.

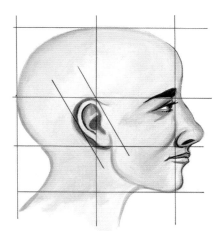

EAR PLACEMENT
Look at how the ear relates to the other facial features. The diagram lines show how the ear lines up with the eyes and the nose.

Monochromatic Ear

As we have for the other features, let's begin with a black-and-white study. Look for all the surfaces and overlapping shapes when creating the line drawing.

Materials List

PAINTS
Ivory Black, Titanium White

BRUSHES
nos. 1 and 2 round

REFERENCE PHOTO
The ear is made up of interlocking shapes. Use the grid method to capture this ear on your canvas paper.

GRAY SCALE
Match your tones to this gray scale.

1 Outline the Shapes
With the no. 1 round and black, outline the basic shapes of the ear to separate the surfaces.

2 The Awkward Stage
Mix a medium gray and fill in the entire ear with the no. 2 round. Fill in the cup with dark gray. Add a black cast shadow behind the ear to start the illusion of the ear rising away from the head.

3 Finish
The final stage is all about adding the five elements of shading to create the illusion of form. Apply shadow edges inside all the rims and edges you see to show the reflected light.

Add light, medium and dark tones to create the form, drybrushing to blend them together. The black background helps the light edges of the ear look more pronounced. Create the illusion of hair with a few loose brushstrokes. Add bright areas of highlight last with pure white.

Ear From the Back

The lighting here makes the highlight areas on the front of the ear intense and creates a beautiful cast shadow. Notice how the shape of the ear is replicated in the shape of the shadow.

Materials List

PAINTS

Alizarin Crimson, Burnt Umber, Cadmium Red Medium, Cadmium Yellow Medium, Ivory Black, Titanium White

BRUSHES

nos. 1 and 2 round, no. 3/0 liner

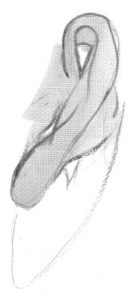

REFERENCE PHOTO
Use the grid method to capture this ear on your canvas paper.

LIGHT COMPLEXION WARM
Follow the instructions at the beginning of this chapter to mix light, medium and dark versions of this peach color.

Add Burnt Umber and Alizarin Crimson to the mixture to create the shadows.

This ear has a lot more light areas, so lighten the values accordingly by using more white.

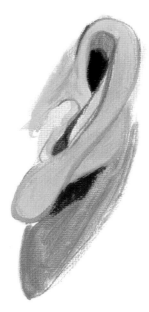

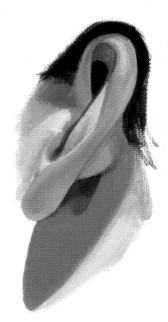

1 Halftones and Outline
With a diluted application of the medium peach mixture, base in the entire ear with the no. 2 round allowing the pencil lines to show. Add Alizarin Crimson and Burnt Umber to the mixture to get the cool shadow colors. With the no. 1 round, outline the inner shapes of the ear with the cool colors.

2 The Awkward Stage
Still using the no. 2 round, build the values with a thicker application of paint, making them lighter on the front of the ear. With a diluted mixture of Burnt Umber, Alizarin Crimson and a touch of white, apply the cast shadow of the ear.

3 Finish
Continue layering and blending the colors of the ear with the light complexion skin tones. Look for the areas of light and dark. Add the illusion of hair behind the ear with Burnt Umber and black.

Use white and the no. 3/0 liner to add the fine highlights to the edges, rims and areas that protrude.

Ear From the Front

Most portraits are viewed from the front, so this is the view you will most likely paint. Here, you will not use any of the standard skin tone mixtures from the beginning of this chapter. Just mix as you go for this variation.

Materials List

PAINTS
Alizarin Crimson, Burnt Umber, Ivory Black, Titanium White

BRUSHES
no. 1 round, no. 3 filbert

REFERENCE PHOTO

1 Outline
With the no. 1 round, outline the edges and shapes of the ear with black.

2 The Awkward Stage
Mix a diluted Burnt Umber with a touch of Alizarin Crimson. Wash in the skin tone using the no. 3 filbert. Wash in the background and hair area with pure Burnt Umber using the no. 3 filbert as well.

3 Finish
Using the no. 3 filbert and the skin tone colors from the previous step, cover the canvas as you create the shadows by adding more Burnt Umber to the skin tone mixture. Shadows occur wherever areas recede, such as the inside of the ear and on the shadow edge of the earlobe.

Switch to the no. 1 round and add a touch of white to the skin tone mix for the highlights on the edges of the ear and any areas that protrude.

Completely fill in the background and hair with Burnt Umber. Using a circular motion and the no. 3 filbert, add a touch of black.

Hair

Before you pull the entire face together into a portrait, it is important to know how to paint hair. No matter how well you paint the face, if the hair is not executed in a realistic way, the painting will look unfinished.

With all paintings, it is important to have the face finished first. You need to have the color of the skin underneath the hair. If the skin color does not show through, the hair will look like an afterthought.

It takes many, many, many layers to make hair look real. Like everything else about art, painting hair will require practice and patience!

Follow the step-by-step exercises to learn how to draw a variety of different hairstyles. While there are too many hairstyles to show everything possible, these will give you the foundation you need to create just about anything.

Hair Color

Even with a million styles and shades, the pigments that make up hair are relatively simple. Any of the following samples can be altered by adding or subtracting pigment. You can make a blonde lighter by adding more yellow or darker with more Burnt Umber. Study your subjects well, and really look at their individual hair colors. Chances are their hair is made up of multiple shades.

The more color something has in it, the more realistic it will appear. Do not be afraid of experimenting! The beauty of acrylic is that if you don't like what you've painted, you can cover it up!

DEPEND ON BRUSHSTROKES AND LAYERS FOR REALISTIC HAIR

The hair is built up in many layers. Brushstrokes replicate the hair direction and give the illusion of hair strands. The more layers that you apply, the fuller the hair will appear.

Tips: Painting Hair

- Light hits areas that protrude.

- Hair is very shiny and reflective, so highlights are bright.

- Shadows occur where hair curves.

- Create curves with brushstrokes. I use the no. 2 filbert for undertones, then the no. 3/0 liner for strand details.

Blonde Hair Mixtures

YELLOW UNDERTONE = TITANIUM WHITE + TOUCH OF CADMIUM YELLOW MEDIUM

I use this mixture for most blonde, light brown and red hair. I basecoat with this for blonde hair colors.

YELLOW UNDERTONE + BURNT UMBER

Hair colors will change according to how much light and shadow is on them. Use more Burnt Umber in darker areas. Use white for highlights.

YELLOW UNDERTONE + CADMIUM RED MEDIUM

This makes red hair. To deepen it, add a little Burnt Umber. Again, this color can be lightened or darkened by adding or subtracting color.

Brown Hair Mixtures

BROWN UNDERTONE = TITANIUM WHITE + TOUCH OF BURNT UMBER

I use this for brunette hair.

BROWN UNDERTONE + TOUCH OF CADMIUM RED MEDIUM

This creates warm brown hair. The dark areas are mostly pure Burnt Umber.

BROWN UNDERTONE + TOUCH OF IVORY BLACK

This makes deep brown hair. For both examples, use white for the highlight areas.

Gray Hair Mixtures

GRAY UNDERTONE = TITANIUM WHITE + TOUCH OF IVORY BLACK

This is the undertone for gray hair.

EVEN AMOUNTS OF BLACK AND WHITE

This gives the look of steel gray hair.

GRAY UNDERTONE + TOUCH OF BURNT UMBER

This makes a brownish cast for salt and pepper hair.

GRAY UNDERTONE + TOUCH OF PRUSSIAN BLUE

The blue cools the gray for bluish-gray hair.

Black Hair Mixtures

BLACK UNDERTONE = IVORY BLACK

The following examples show a warm black and a cool black.

IVORY BLACK + TOUCH OF BURNT UMBER

A warm black is a shade that has a touch of brown in it.

IVORY BLACK + TOUCH OF PRUSSIAN BLUE AND TITANIUM WHITE

When outdoors, very dark hair will reflect some blue from the sky, making a cool black.

Hair: Short and Straight

Straight hair that curves often shows up in children's styles. This style illustrates a very important feature that I refer to as the *band of light*. The highlights that encompass the shape of the head depicts the head's roundness. The dark areas are where the hair curls under or bends as it comes out of the part.

Materials List

PAINTS

Burnt Umber, Cadmium Red Medium, Titanium White

BRUSHES

no. 3 filbert, no. 3/0 liner

1 Undertones
Basecoat the hair in with a light mixture of Titanium White tinted with a touch of Cadmium Yellow Medium and Burnt Umber using the no. 3 filbert. Curve your brushstrokes with the shape of the hair.

2 The Awkward Stage
To establish the band of light, add a bit more Burnt Umber to the yellow mixture to create the dark areas. With the no. 3/0 liner, use quick strokes to add the dark mix to the top of the head where the part is. Develop the tone following the hair direction, stopping midway.

Now stroke upward from the tips of the hair to develop the curve. Leave the midsection light.

Add Titanium White to the band of light using the same brush and stroke.

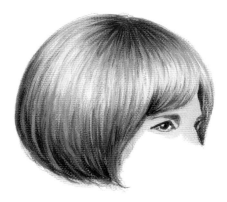

3 Finish
Keep using the no. 3/0 liner as you keep applying layers of light and dark until the two work together. Layer them together; do not allow them to stop abruptly. It must look smooth and continual. The more layers you add, the fuller the hair will appear.

Hair: Short and Gray

This is a typical short hairstyle. Even though it does not encompass the head like the style before, it still curves and has a band of light.

Materials List

PAINTS

Burnt Umber, Ivory Black, Titanium White

BRUSHES

no. 3 filbert, no. 3/0 liner

1 Undertone
Basecoat the shape of the hair with the gray undertone, using the no. 3 filbert. Even though this is a light application, make sure your strokes still represent the direction of the hair.

2 The Awkward Stage
This gray hair has the salt and pepper look. Add a touch of Burnt Umber to the mixture, and apply it to the darker areas using the no. 3/0 liner and quick strokes.

3 Finish
Still using the no. 3/0 liner, add layers of dark gray (gray undertone plus Burnt Umber) and Titanium White for highlights until the band of light is developed and the shape of the hair seems rounded and full. The brushstrokes must represent the length of the hair.

Hair: Wavy and Layered

This hair is a bit more complicated due to the layered cut and the natural wave. See how it curves over the ear? Let your brushstrokes create this look.

Materials List

PAINTS

Burnt Umber, Cadmium Red Medium, Cadmium Yellow Medium, Titanium White

BRUSHES

no. 3 filbert, no. 3/0 liner

1 Undertone
Add a touch of Burnt Umber to diluted Titanium White with the no. 3 filbert and diluted Burnt Umber to fill in the hair area with curved brushstrokes. Use less paint toward the back where the light hits.

2 The Awkward Stage
Switch to the no. 3/0 liner and add a little Cadmium Red Medium to the Burnt Umber for a reddish tint. Use curved brushstrokes. Begin the band of light in the curve by adding a touch of Cadmium Yellow Medium and Burnt Umber to Titanium White for a dull white.

3 Finish
Still using the no. 3/0 liner, add layers with quick strokes. Add more of the red and a little Cadmium Yellow Medium to the brown to make the hair look reflective and shiny. Overlap the ends to make it appear more wispy and layered.

Hair: More Layers

This hair is very similar in color to the previous exercise. Use quick brushstrokes to get this extremely layered look.

Materials List

PAINTS

Burnt Umber, Cadmium Red Medium, Cadmium Yellow Medium, Titanium White

BRUSHES

no. 3 filbert, no. 3/0 liner

1 Undertone

Basecoat the overall hair shape with diluted Titanium White with a touch of Burnt Umber using the no. 3 filbert. Make sure your brushstrokes go in the direction of the layers to create the foundation.

2 The Awkward Stage

With the no. 3/0 liner, add lights and darks. Add some Cadmium Red Medium to the brown mixture for a warm, reddish cast. Alternate light and dark using quick strokes to build the look of many layers.

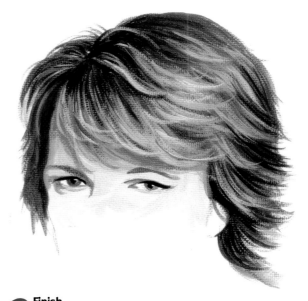

3 Finish

The band of light is visible on the right side. Mix Titanium White with a small touch of Cadmium Yellow Medium for the highlights. Use the no. 3/0 liner to add some Cadmium Red Medium to the light mixture for the red tones. The strokes must be quick at the tips to make the hair strands taper at the ends and appear wispy. You do not want harsh, thick strokes!

Hair: Long and Wavy

Long, wavy hair is approached a little differently. You want to begin depicting the many waves before laying in any undertone.

Materials List

PAINTS

Burnt Umber, Cadmium Red Medium, Cadmium Yellow Medium, Titanium White

BRUSHES

no. 3 filbert, no. 3/0 liner

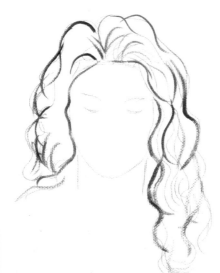

1 Create the Waves
Use the no. 3/0 liner with diluted Burnt Umber to create the curves and direction of the hair. Use curved brushstrokes to represent the waves.

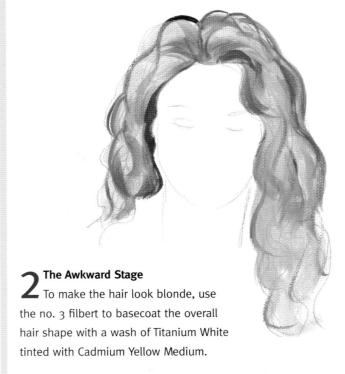

2 The Awkward Stage
To make the hair look blonde, use the no. 3 filbert to basecoat the overall hair shape with a wash of Titanium White tinted with Cadmium Yellow Medium.

3 Finish
Apply many layers alternating among the different blonde color mixtures (see the hair color samples earlier in this chapter) to make the hair look full and thick. Use the no. 3/0 liner, mimicking the waviness of the hair. Add Burnt Umber underneath to make it look shadowed around the neck and behind the ear.

To give the hair the frosted look, mix a little Burnt Umber into Titanium White.

Hair: Coarse and Dark

It is very important to establish the skin tone on the forehead and to allow it to show underneath the hair. Once the face is finished, you can base in the dark hair color.

Materials List

PAINTS

Alizarin Crimson, Burnt Umber, Ivory Black, Prussian Blue, Titanium White

BRUSHES

no. 3 filbert, no. 2 round

DARK COMPLEXION COOL
Follow the instructions at the beginning of this chapter to mix this skin tone.

1 Undertone
Use the dark complexion cool skin tone mixture and the no. 3 filbert and drybrush the color to the forehead (see Creating Texture in chapter three). Bring the color well up into the hairline and scalp area, for it will show through.

After scrubbing Burnt Umber into the hair area with circular strokes, repeat the process with some diluted black.

With the no. 3 filbert and diluted Burnt Umber, scrub in the entire hair area with small, circular strokes. Use the brush a little on the side.

2 The Awkward Stage
With thicker applications of Burnt Umber and Ivory Black, use the same approach to build up the hair thickness. The hair appears lighter as it goes to the outside edge. It is also a little lighter where it meets the face. Use less paint and a dry-brush application in these areas.

3 Finish
To make the hair appear full and fluffy, use less paint and dab the hair with a dry-brush approach. This type of hair is not as reflective, so there won't be an obvious band of light. But it still has subtle areas of light and dark. Dab some of the skin tone into the area where the hair meets the face. Lighten the Burnt Umber with a tiny bit of Titanium White and dab this into the top of the head using the no. 2 round.

Back View

This is a fairly easy project that requires little color and very few facial features, due to the pose.

Practice creating this value scale using the three colors before you begin.

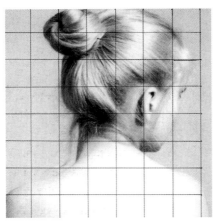

REFERENCE PHOTO
Look for the nonsense shapes within each box and reproduce them in your line drawing. Go slowly, concentrate on one square at a time, and forget you are drawing a person.

1 Undertone and Outline
First outline the entire form with diluted Burnt Umber and the no. 3/0 liner.

Using the no. 3 filbert, basecoat the entire form with a very light pink color made by mixing a small touch of Alizarin Crimson into Titanium White.

2 The Awkward Stage
Add more Alizarin Crimson and a touch of Burnt Umber to the pink mixture to create a shadow color. Use this and the no. 1 round to develop the shadows on the chin, behind and in the ear, and on the back of the neck. Use the no. 3/0 liner for smaller areas like along the edge of the chin and inside the ear.

With the same mixture, develop the direction of the hair, including the band of light on both the head and the bun.

3 Finish
Mix a brighter pink (Titanium White with more Alizarin Crimson than before) to make the skin tones seem warmer. Add this on the outside edges of the shadows to give the skin tone a warm glow and make the shadow areas seem less harsh.

Use a no. 2 flat to drybrush some white highlights into the face and shoulder areas to gently fade the white into the pink.

Detail the hair with the no. 3/0 liner and quick strokes that follow the hair direction. Use pure Burnt Umber for the dark areas and pure white for the bright highlights.

It will take many layers to create this hair, so do not quit too soon!

Elderly Man

Now it's time to capture the entire face. This portrait is a bit more complex.

GRAY SCALE
Match your tones to this gray scale.

Materials List

PAINTS
Ivory Black, Titanium White

BRUSHES
no. 2 flat, no. 3 filbert, no. 3/0 liner

REFERENCE PHOTO
Draw one box at a time. Turn the photo and your drawing upside down for more accuracy as you work.

1 Outline and Dark Tones
With the no. 3/0 liner and Ivory Black, outline the subject and details. Draw with the paint, using as much accuracy as possible. This pose makes the features appear distorted, so pay attention to detail and shape. For instance, the iris in the eye is a vertical ellipse.

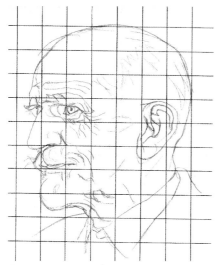

GRID DRAWING
When your drawing looks like this, you can remove your grid lines with a kneaded eraser.

2 Lay the Foundation
Create a medium gray by mixing black into white. Use the no. 3 filbert and a diluted application of paint to fill in the entire face and hair area. This is the foundation of your portrait. Fill in the shoulders of the jacket.

3 The Awkward Stage

This is somewhat of a rough-in stage where the tones and details are slowly evolving. Use thicker applications of medium and light gray to drybrush in the shadows and highlights of the face, using the no. 3 filbert. Use the no. 3/0 liner and some medium gray to draw in the lines and creases around the eyes and forehead.

Use various tones of gray for the background. Darker backgrounds will enhance the light areas of a portrait, so place dark gray behind the light edge of the neck. Lighter backgrounds will enhance darker areas of the portrait, so place the light gray behind that.

Using the no. 3/0 liner, add the shadow areas and the color of the eye. Remember, this is a vertical ellipse.

4 Finish

Use the no. 2 round as you take your time and slowly add the tonal changes using various shades of gray. Refer to the gray scale for comparison. Drybrush to soften each tone, creating a gradual blended appearance.

Continue building up and drybrushing together the tones of the face to get gradual transitions. Complete the background using the dark over light and light over dark technique that you began in step 3 before moving on. Allow your brushstrokes to show for an artistic look.

After you've finished the background, you can finish the moustache. Use various shades of gray to layer quick strokes of hairs with the no. 3/0 liner. Allow the small hairs to overlap into the background.

Complete the jacket, using the same light against dark technique and allowing your brushstrokes to show.

Baby

Now it's time to dive into a full-color situation. Even though the color mixtures may be a bit more difficult, the approach and procedure will remain the same. This baby has a dark complexion, but the youthfulness of the skin keeps it light.

Materials List

PAINTS

Alizarin Crimson, Burnt Umber, Cadmium Red Medium, Cadmium Yellow Medium, Ivory Black, Prussian Blue, Titanium White

BRUSHES

nos. 1 and 2 round, no. 3 filbert, no. 3/0 liner

LIGHT COMPLEXION COOL
Follow the instructions at the beginning of this chapter to mix light, medium and dark versions of this skin tone. Add more white to lighten the values further.

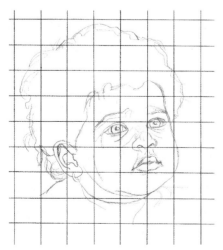

REFERENCE PHOTO
This baby will give you practice turning a black-and-white photo into a full-color painting.

GRID DRAWING

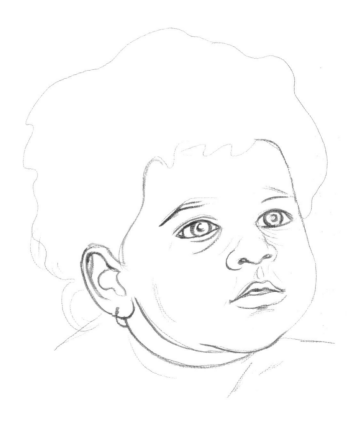

1 Outline
Make sure your line drawing is accurate and make any changes necessary. Then outline the features of the baby with diluted Burnt Umber using the no. 3/0 liner. Do not outline the face on the right side. This is a light edge in the finished piece, and you'll want it to look softer.

DEMONSTRATION

2 Create Base Tones

Mix a touch of Alizarin Crimson into Titanium White to get a base tone pink. Fill in the entire face and neck area with this color, using the no. 3 filbert.

With a diluted application of Burnt Umber, fill in the hair area, using the no. 2 round. Don't worry about the curls right now. They go in after the background color has been applied.

Use the no. 3/0 liner to fill in the iris of the eye with Burnt Umber and the pupil with black. Leave small areas unpainted for the catchlight. Fill in the inside of the ear with diluted Burnt Umber.

3 The Awkward Stage

This is where things look pretty choppy. You are building the five elements of shading for roundness. This baby's face strongly resembles a sphere. Add the contours with the cool shadow colors made by mixing Burnt Umber, Alizarin Crimson and Titanium White using the no. 2 round. Apply this to the neck and the contours of the face.

Mix an aquamarine color using Titanium White, Prussian Blue and a small amount of Cadmium Yellow Medium and lay in the background using the same brush. Basecoat the shirt with a lighter version of that background color. This makes it look like a light-colored shirt reflecting the surroundings.

Using the no. 1 round with Burnt Umber and Ivory Black, create the fullness of the hair and curls. Use pure Burnt Umber for the lighter areas, and add black to the paint for the shadow areas.

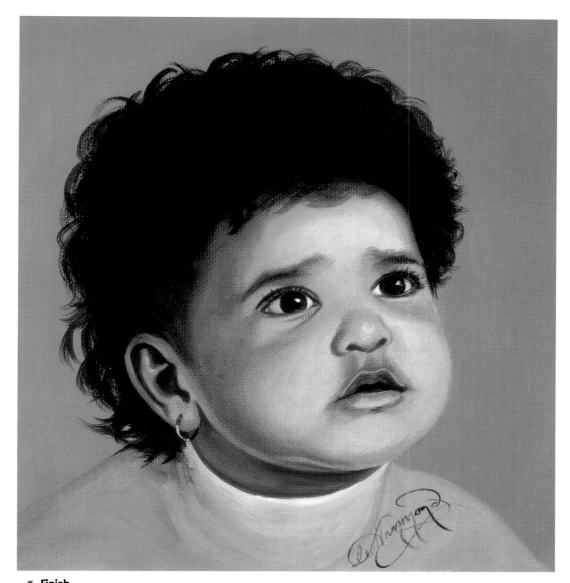

4 Finish

Continue adding and blending the colors for a soft look. This skin has a lot of Alizarin Crimson in it, which makes a beautiful pink. The shadow areas are made with Titanium White, Alizarin Crimson and a touch of Burnt Umber. Drybrush the colors together until the face looks smooth and spherical. Add white to Alizarin Crimson to create a reflected light mixture; use this along with pure Titanium White and the no. 1 round to add highlights to the front of the face and the tip of the nose. Be sure the reflected light is very obvious along the jaw line.

Deepen the color of the hair by adding some Ivory Black to Burnt Umber. Even though the hair is very dark with not many highlights, it is still important to apply the color in the direction of the hair. Bring the curls out into the background.

Toddler

Now you'll create another portrait of a youngster, but this one has a much deeper complexion. His face has more brown tones, rather than pink hues.

BROWN COMPLEXION WARM
Mix Titanium White, Burnt Umber and a touch of Cadmium Red Medium, as instructed at the beginning of this chapter.

Materials List

PAINTS
Alizarin Crimson, Burnt Umber, Cadmium Red Medium, Ivory Black, Prussian Blue, Titanium White

BRUSHES
nos. 1 and 2 round, no. 1 flat, no. 3 filbert, no. 3/0 liner

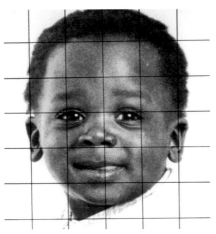

REFERENCE PHOTO
The expression of this adorable little guy is more difficult to capture than that of the baby in the previous demonstration, due to the slant of the mouth. Study the shapes carefully.

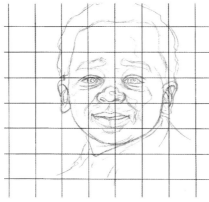

GRID DRAWING

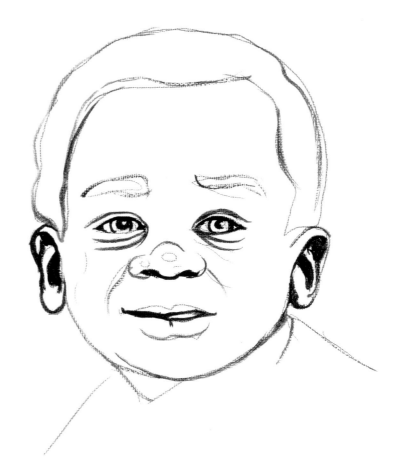

1 Outline
With the no. 3/0 liner and Ivory Black, outline the features and shapes of the little boy's face.

2 Undertone

With a diluted mixture of Burnt Umber and a touch of Titanium White, basecoat the entire portrait using the no. 2 round. Make the area of the hair a little darker.

Fill in the iris with Burnt Umber and the no. 1 round. Fill the pupil with Ivory Black using the no. 3/0 liner. Leave a small dot in the eye for the catch-light, which is half in the iris and half in the pupil.

3 The Awkward Stage

Using a thicker application of Burnt Umber and Titanium White and the no. 3 filbert, develop the shadow and high-lights of the face. Remember the five elements of shading. This stage of the painting creates the illusion of round-ness and form. The application is still loose and choppy.

Begin the background by washing in a diluted application of Prussian Blue, using the no. 3 filbert.

4 Finish

Use the five elements of shading to complete his sphere-like features. The light source is on the left, so make everything darker on the right side. You'll want to use more white in the mixtures for his left side. Add more layers of paint and drybrush the colors together for a smooth look.

Use the no. 1 flat to paint in the shadow areas; add a touch of Alizarin Crimson to the brown complexion warm mix. This gives his dark skin a warm glow and keeps it from looking monochromatic.

Make his hair fluffy using a no. 1 flat and a scrubbing motion for a dry-brush effect. Use just a little paint and a circular motion. Use Burnt Umber first, as a foundation. Add Ivory Black for volume. Repeat the process until it looks full and fluffy. Finally, dab some of the background color into it, as a reflecting color.

Leave his clothing as simple as possible. Using the light source as a guide, paint in a turtleneck using the no. 3 filbert and Prussian Blue mixed with Titanium White and Ivory Black. The right side is very dark, and the left side is very light.

Finish the background with the no. 3 filbert painting light over dark and dark over light.

Three-Quarter View, Adult Female

This is my daughter LeAnne; we'll use her portrait for our study of an adult profile. This is an example of a three-quarter turn, along with an extreme lighting situation. The face on the right side fades into the darkness of the background. This is my favorite type of portrait.

Materials List

PAINTS
Alizarin Crimson, Burnt Umber, Cadmium Red Medium, Cadmium Yellow Medium, Ivory Black, Prussian Blue, Titanium White

BRUSHES
nos. 1 and 2 round, no. 3 filbert, no. 2 flat, no. 3/0 liner

LIGHT COMPLEXION COOL
Follow the directions at the beginning of this chapter to mix light, medium and dark versions of this tone. Add more white to lighten the values further.

REFERENCE PHOTO
The three-quarter view is considered one of the most difficult poses to capture because our brains want to make everything symmetrical.

GRID DRAWING

1 Outlines and Dark Shadows

With the no. 2 round, detail the direction of the hair and the jaw line with a diluted Burnt Umber. Use straight Ivory Black and the no. 3/0 liner to draw in the shapes of the lips, eyebrow and eyelash area.

Base in the background with Ivory Black and the no. 3 filbert. Allow the hair to get lost on the right side.

2 Undertone

LeAnne's complexion is very pale. This painting is very cool in its coloration due to the very dark background. Mix a diluted application of her skin tone by adding a small amount of Alizarin Crimson into some Titanium White. Apply this mixture to the face area with the no. 3 filbert. Her blonde hair reflects the color of her skin, so streak some of the skin color into her hair on the left as well.

With the no. 1 round, apply the lip color with Alizarin Crimson.

Begin her hair with Burnt Umber and the no. 2 round. Follow the direction that the hair is going with your brushstrokes. Carry some of the Burnt Umber into the dark side of the hair on the right. Allow it to fade into the black background.

Loosely wash in the rest of her hair with Ivory Black and Burnt Umber.

3 The Awkward Stage

Using the no. 2 flat and a diluted mixture of the cool complexion colors plus a little Burnt Umber, develop the contours and shadow areas of the face as shown. Look for the shadow areas in the cheek, forehead, neck, and down the bridge of the nose.

Prepare a diluted Prussian Blue and Titanium White mixture for the turtleneck. Using the no. 2 round, curve the brushstrokes, replicating the sweater's form.

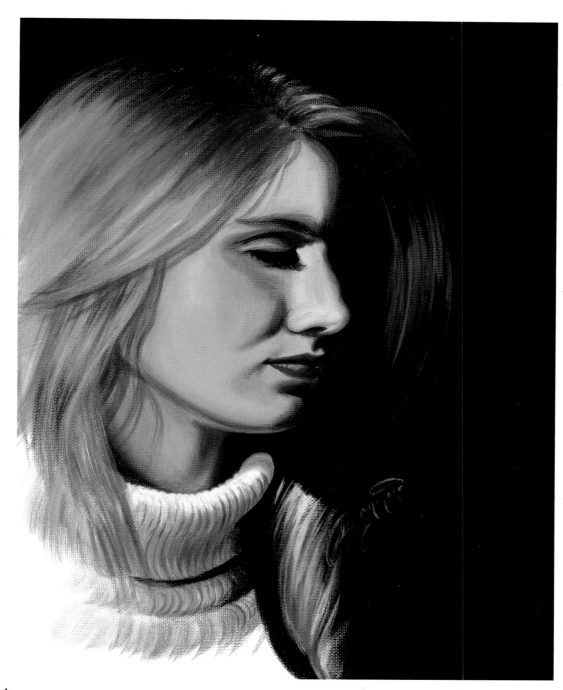

4 Finish

Use the no. 1 round for this step. Soften all of the colors together by drybrushing in thicker applications of paint.

Build up the Prussian Blue/Titanium White mixture for the turtleneck, allowing your strokes to replicate the ribbing of the sweater. Mix a bit of Alizarin Crimson into Titanium White to get the pink reflective color to add to the blue tones of the sweater.

Add more layers of color to her hair, allowing them to streak together to replicate hair strands. Alternate using the dark brown tones (Burnt Umber), and the lighter tones (Burnt Umber, Titanium White, Cadmium Yellow Medium and Cadmium Red Medium). Add those mixtures to the right side, too.

Asian Skin Tone

I love the look of porcelainlike skin. This photo of my student's sister-in-law is a wonderful example of an extremely pale, smooth complexion. Her delicate Asian features were a joy to paint.

Materials List

PAINTS
Burnt Umber, Cadmium Red Medium, Cadmium Yellow Medium, Ivory Black, Prussian Blue, Titanium White

BRUSHES
nos. 1 and 2 round, no. 4 filbert, no. 3/0 liner

LIGHT COMPLEXION WARM
Create a very light version of this mixture, beginning with Titanium White plus a touch of Cadmium Red Medium plus a touch of Cadmium Yellow Medium, as instructed at the beginning of this chapter.

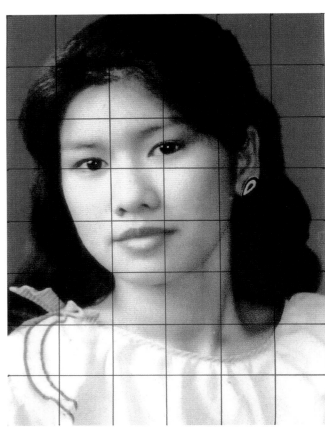

REFERENCE PHOTO
This portrait of Jemma, my student's sister-in-law, makes good use of complementary colors. The red background is a perfect enhancement for the green outfit, both of which accentuate the colors of the skin.

Carefully study the shapes of the photograph and draw what you see inside each box.

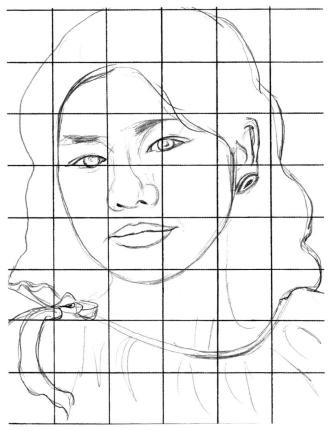

LINE DRAWING
Use the grid method to create an accurate line drawing on your canvas paper. When you have the shapes accurately drawn, remove the grid lines with a kneaded eraser.

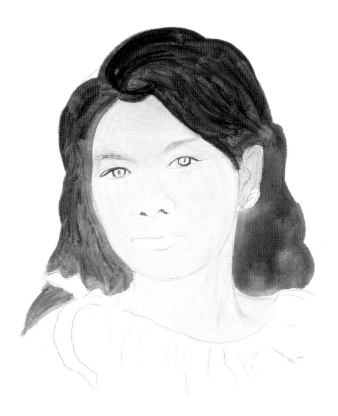

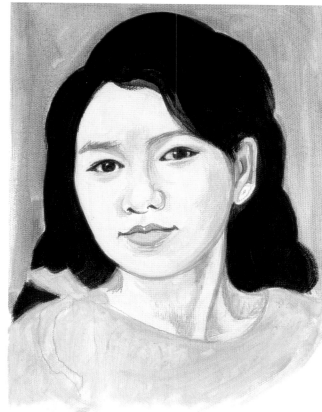

1 Apply First Layers

With the no. 1 round, paint in the lash line of the eyes and outside edges of the irises with diluted Ivory Black. This is done to make sure the direction of the gaze is accurate, which is very important. Fill in the nostril areas with the diluted black, too, so you don't lose track of them when painting in the skin color.

Base in the entire face with a diluted application of your very light, light complexion warm mixture using the no. 4 filbert. Mix Burnt Umber with Ivory Black for the hair. Fill in entire hair area with a diluted application of the hair mixture using the no. 4 filbert.

2 The Awkward Stage

Prepare a puddle of diluted Cadmium Red Medium for the background color. Use the no. 4 filbert to fill in the entire background area. Mix the pretty mint green color of her dress by adding a small amount of Prussian Blue into a puddle of Titanium White, then add a touch of Cadmium Yellow Medium. With the no. 4 filbert, fill in the entire area of her dress.

Use the no. 1 round to fill in her irises with Burnt Umber. Add pupils with Ivory Black. Make sure to center these in her irises and leave areas for the catchlight, half in the pupil and half in the iris. With the Burnt Umber, develop the shape of her eye. Use some diluted Burnt Umber to base in eyebrows, too.

Prepare a thicker puddle of her skin tone and apply it to her face again. Add more Cadmium Red Medium to that mixture to create a slightly deeper base. Apply it with the no. 2 round between the eyebrows, along the sides of the nose and along the right side of the face. Add some Burnt Umber to this mixture and develop the shadow areas of her neck and fill in the details of the ear.

Apply the background pigment to the upper lip and along the edge of the lower lip. Add some white to this mixture and fill in the bottom lip. Mix Burnt Umber with a touch of Alizarin Crimson and apply very thin lines between the lips and in the corner of the mouth, using the no. 3/0 liner.

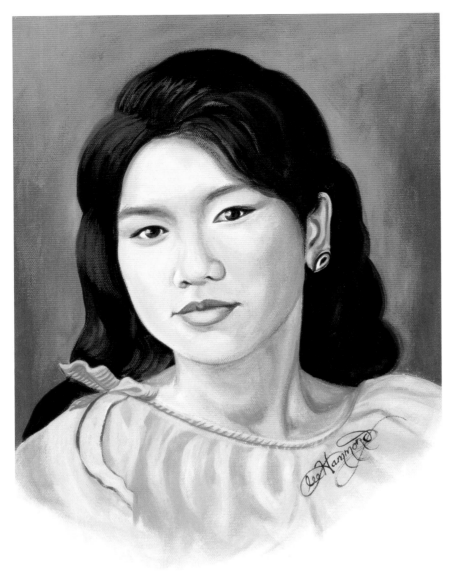

3 Finish

This final step is all about adding small details for realism with thicker paint applications. Fill in the hair once more with a thicker application of the black/brown mixture. Give the hair dimension by adding highlights with the no. 2 round and a mixture of Burnt Umber with a touch of white. Make sure your brushstrokes go along with the direction of the hair and its curves. Once the brown highlights dry, add more highlights on top of those with a light mixture of Prussian Blue and white.

Add white highlights to the bridge of her nose and above her eyelids to create more dimension. Add fullness to the upper lip using small light and dark shapes. The little dark shapes will seem to recede and the little light ones will seem to come forward. This creates form, just as in the sphere (see chapter three). Use the no. 1 round to add small patches of light and dark versions of the light complexion warm mixture. Build the shading gradually with small applications of paint. Don't quit until things appear smooth and the creation of form is completed. Go back and forth between adding shadows and highlights.

For the dress, create lighter and darker versions of the mint green you used in step 2. For the darker, add more Prussian Blue. For the lighter, add more white. Add the small pin stripes of the bow and neckline using the darker dress mixture and the no. 1 round. Notice how the stripes curve with the roundness of the fabric. Fill in the lights and darks of the rest of the dress using the no. 4 filbert.

To complete the painting, add the earring with black and white using the no. 1 round.

Adult Male

I selected this photo of my friend Mark for the wonderful lighting it provided. The deep shadows created by the outdoor setting give the painting an intensity that fully illustrates Mark's personality. When looking for photo references to use as artwork, I like shots like this. It gives me the "light over dark" (the right side of his face) and the "dark over light" (the left side) effect to work with, giving the painting balance.

Materials List

PAINTS

Burnt Umber, Cadmium Red Medium, Cadmium Yellow Medium, Ivory Black, Prussian Blue, Titanium White

BRUSHES

nos. 1 and 2 round, no. 4 filbert,

DEMONSTRATION

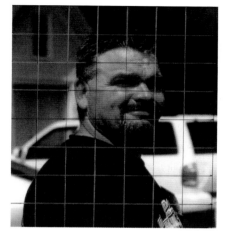

REFERENCE PHOTO
Use the grid method to capture the shape of Mark's face on your canvas paper. Remove the grid lines from your drawing with a kneaded eraser when you are done.

LIGHT COMPLEXION WARM
Follow the instructions at the beginning of this chaptur to prepare light, medium and dark versions of this peach color.

1 Outline and Tone
Because of the intense lighting and deep shadows of this piece, carefully draw in the details with diluted Burnt Umber and the no. 1 round. This will keep you from losing your line drawing when you begin to paint. Wash in the shadow areas above the eyes, under the nose, along the right side of the face and on the neck. Place some of Burnt Umber inside the ear, behind the ear and in the hair as well to establish the light source.

2 Basic Shapes and Hair
With a medium version of your skin tone color and a diluted application, wash in the basic shapes of the face, ear and neck with the no. 4 filbert. Add a bit more red to the mix and apply it to the sides of the face and forehead.

With diluted Burnt Umber, continue filling in the hair.

3 The Awkward Stage

Continue adding tone to the canvas paper with the no. 4 filbert using the light, medium and dark skin tone mixtures. Create the contours of the face keeping the paint very thin. Watch for the five elements of shading and how the shadow areas are creating the roundness and form of the face.

Even though the eyes are heavily shadowed and appear quite dark, it is important to create the illusion of an iris and pupil. You can envision where the iris is because of the subtle bulge it creates along the lower lid.

With a deeper application of Burnt Umber, strengthen the tones of the hair and facial hair using the no. 2 round. Use strokes that replicate the hair direction.

Wash in some diluted background color with the no. 4 filbert and pure Prussian Blue on the left side and Prussian Blue with a touch of Ivory Black on the right. Use diluted Ivory Black to fill in the shirt.

4 Finish

Continue refining color and shapes with many layers of thicker applications of the different values of paint you have prepared. Use drybrushing to blend the colors. Keep the pigments warm in the highlight and halftone areas and cool in the shadows.

Add the reflected light along the bottom edge of the nose, along the bottom edge of the lower lip and along the crease of his neck. Paint in subtle blue highlights reflected onto the black of the shirt as well.

To finish the hair, use the no. 1 round to apply quick, thin strokes of a combination of Burnt Umber, a touch of pure Titanium White, as well as light blue (Prussian Blue and Titanium White). Apply a little shadow to the skin in the hairline area. To finish, build up and soften the background colors using thicker paint and the no. 4 filbert.

People Together

Nothing is more special than capturing true emotion in your artwork. This piece shows the true love shared between a mother and her newborn child. (In this case, it is my daughter and grandchild.) While the emotions conveyed in the painting are deep and complex, creating the painting is not.

Materials List

PAINTS
Alizarin Crimson, Burnt Umber, Cadmium Red Medium, Ivory Black, Prussian Blue, Titanium White

BRUSHES
no. 2 round, no. 4 filbert

LIGHT COMPLEXION COOL
Follow the instructions at the beginning of this chapter to mix light, medium and dark versions of this skin tone.

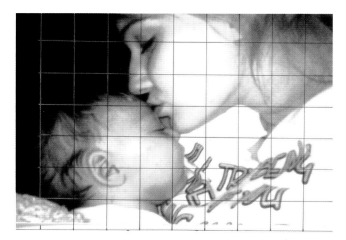

REFERENCE PHOTO
Use the grid method to acquire an accurate line drawing on your canvas. Study the photo carefully.

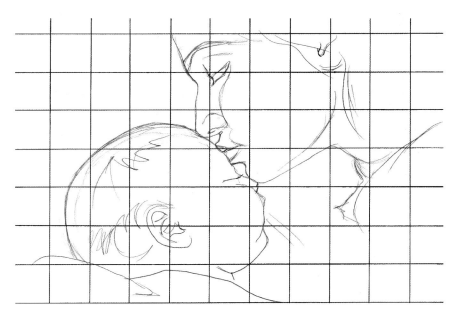

LINE DRAWING
When you have the shapes accurately drawn, your line drawing should look like this. When you are sure of the accuracy, remove the grid lines with a kneaded eraser, leaving the image behind.

1 Begin With Skin Tone

With the no. 4 filbert, base in the skin tones of both the mother and baby with the light complexion cool color. Their skin tones are very pink and delicate. Keep the mixture light.

2 The Awkward Stage

With the no. 2 round, add the dark detail lines of the features, using a diluted mixture of Burnt Umber and Alizarin Crimson. Make sure the brushstrokes on the baby's head follow the direction of the hair and the way it grows.

To describe the edges of the head and face, add the darkness of the background using the no. 4 filbert and a diluted mixture of Ivory Black and Prussian Blue. Add Titanium White to that background mixture and use it to block in the clothing undertones. Remember that this is just the undertone and first layer of color. You will add most of the detail in the next step.

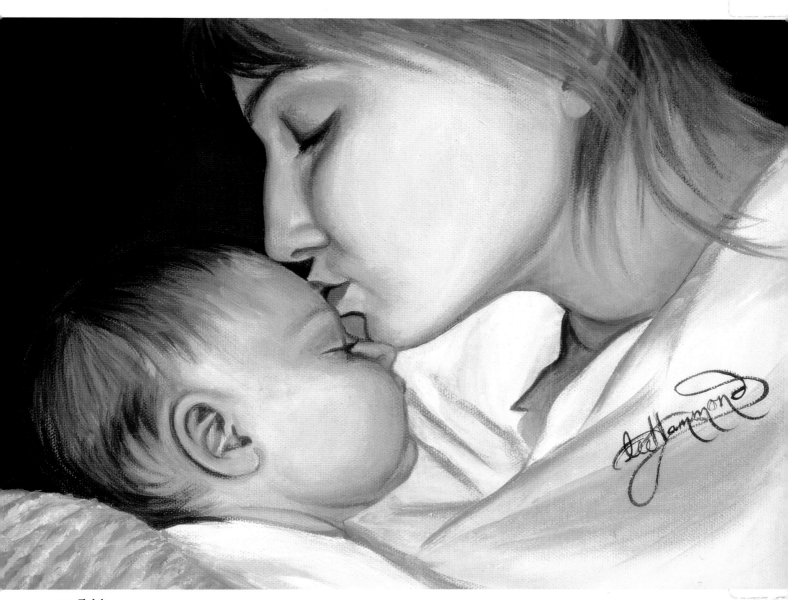

3 Finish

Use thicker paint applications for the last stages. Prepare two puddles of pigment. One should be the light complexion cool mixture with only Titanium White and Cadmium Red Medium. Leave out the Alizarin Crimson at first to give you a warmer tone. Create another puddle with that mixture, plus small amounts of Burnt Umber and Alizarin Crimson for a nice shadow color.

Fill in the faces with the skin tone mixture until the canvas is completely covered, using the no. 4 filbert. Then add the darker shadow colors and gently blend them into the skin tone colors using the no. 2 round. Apply this shadow mixture to the jawlines, the fronts of the cheeks, the neck and the lips. Apply darker versions of this mixture to the inside details of the baby's ear. Make sure to get the cast shadows behind the edge of the ear. Refer to the ear practice earlier in

this chapter. Use the techniques from the sphere exercises in chapter three to create the roundness of the faces by carefully transitioning the color from light to dark.

Use the no. 4 filbert to go over the fabric with Titanium White. Add Titanium White to the background mixture (Ivory Black and Prussian Blue) to make the gray color for details. Make the creases and folds with simple brushstrokes.

Add a touch of Alizarin Crimson to that gray fabric mixture to create a lavender for the blanket. Basecoat the blanket with a deep version of this mixture, then add white to the mixture to get a lighter pink. Dab in the paint to create a knitted look. Add some Titanium White on top of that to give it a thick look.

To complete the painting, thicken the background color (Ivory Black and Prussian Blue) and fill it in until the color is smooth and the canvas is completely covered.

Index

The following artwork appeared in previously published North Light Books (the initial page numbers given refer to the original artwork; numbers in parenthesis refer to pages in this book):

Hammond, Lee. *Acrylic Painting with Lee Hammond* © 2006. Pages 6–7 (4–5), 10–11 (8–9), 16-22 (15–20), 24–41 (22-39), 49–51 (40–42), 81–85 (43–47), 112 (132)

Hammond, Lee. *Paint Landscapes in Acrylic with Lee Hammond* © 2009. Pages 38–47 (48–57), 49 (58), 53–55 (59–61), 58–59 (62–63), 62–64 (64–66), 66 (67), 68–69 (68–69), 71 (70), 73–77 (71–75), 82–85 (76–79), 88–93 (80–85), 96–97 (86–87), 109–114 (88–93), 118–119 (94–95), 126–1127 (96–97), 136–139 (98–101)

Hammond, Lee. *Paint Realistic Animals in Acrylic with Lee Hammond* © 2007. Pages 45 (102), 52 (103), 5, 30, 46, 64, 96, 104, 121 (104), 48 (105), 50 (106), 56–61 (107–112), 66–70 (113–117), 80–82 (118–120), 92–93 (121–122), 116–121 (123–128), 102–104 (129–131)

Hammond, Lee. *Paint People in Acrylic with Lee Hammond* © 2007. 23 (133), 40 (100), 41 (171), 42 (174), 43 (177), 45–46 (134–135), 51–52 (136–137), 55–64 (138–147), 69–73 (148–152), 80–84 (153–157), 86–95 (158–167), 97 (168), 100–118 (169–187)

Other fine North Light Books are available from your favorite bookstore, art supply store or online supplier. Visit our website at fwmedia.com.

media

15 14 13 5 4 3 2

DISTRIBUTED IN CANADA BY FRASER DIRECT
100 Armstrong Avenue
Georgetown, ON, Canada L7G 5S4
Tel: (905) 877-4411

DISTRIBUTED IN THE U.K. AND EUROPE
BY F&W MEDIA INTERNATIONAL LTD Brunel House, Forde Close, Newton Abbot, TQ12 4PU, UK
Tel: (+44) 1626 323200, Fax: (+44) 1626 323319
Email: enquiries@fwmedia.com

DISTRIBUTED IN AUSTRALIA BY CAPRICORN LINK
P.O. Box 704, S. Windsor NSW, 2756 Australia
Tel: (02) 4577-3555

Edited by Holly Davis
Designed by Guy Kelly
Production coordinated by Mark Griffin

About the Author

A professional artist and instructor for more than thirty years, Lee Hammond has authored more than twenty North Light Books, including *How to Draw Lifelike Portraits from Photographs*, *Lifelike Drawing With Lee Hammond* and *Lifelike Drawing in Colored Pencil With Lee Hammond*. She conducts drawing and painting seminars, gives school lectures and mentors nationwide. A certified police composite artist on call for the Kansas City metro area, she has also worked with *America's Most Wanted*, been a contributing writer for *The Artist's Magazine* and was licensed with many of NASCAR's racing teams to produce art and prints. Viist her website at leehammond.com.

Metric Conversion Chart

To convert	to	multiply by
Inches	Centimeters	2.54
Centimeters	Inches	0.4
Feet	Centimeters	30.5
Centimeters	Feet	0.03
Yards	Meters	0.9
Meters	Yards	1.1

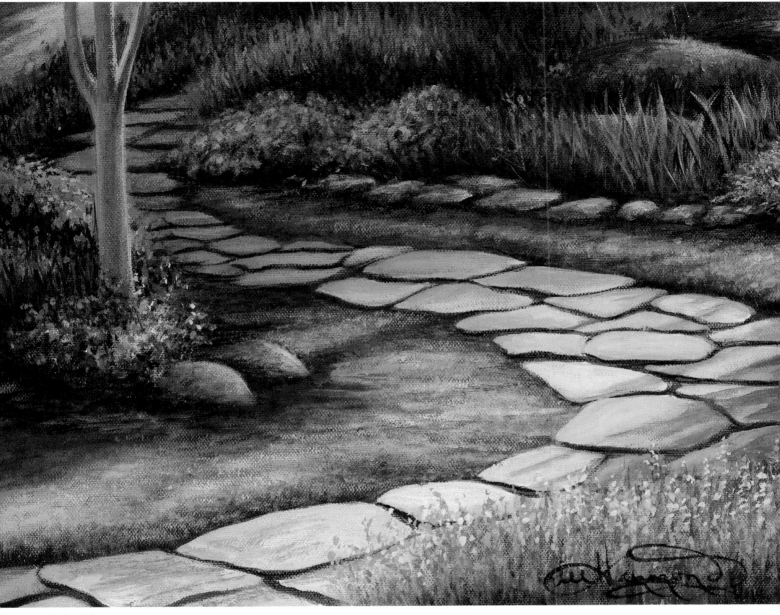

Garden Walkway
9" × 12" (23cm × 30cm)

Ideas.
Instruction.
Inspiration.

Find the latest issues of *The Artist's Magazine* on newsstands, or visit artistsnetwork.com.

These and other fine North Light products are available at your favorite art & craft retailer, bookstore or online supplier. Visit our websites at **artistsnetwork.com** and **artistsnetwork.tv**.

Visit artistsnetwork.com and get Jen's North Light Picks!

Get free step-by-step demonstrations along with reviews of the latest books, videos and downloads from Jennifer Lepore, Senior Editor and Online Education Manager at North Light Books.

FOLLOW US!